NIKO
D800 & C

THE EXPANDED GUIDE

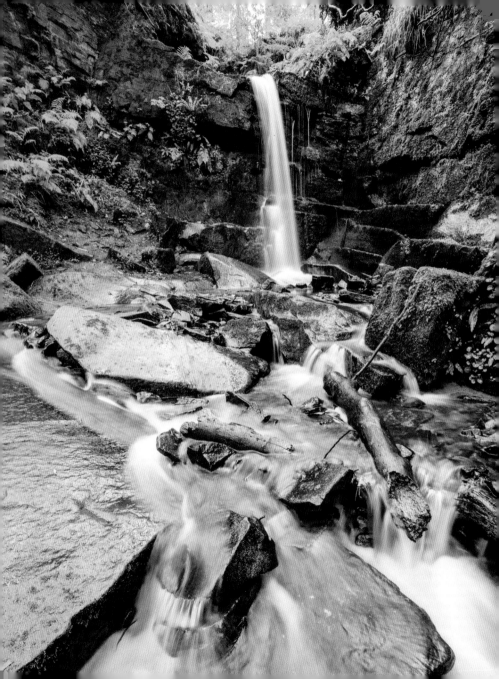

NIKON
D800 & D800E

THE EXPANDED GUIDE

Jon Sparks

AMMONITE
PRESS

First published 2012 by
Ammonite Press
an imprint of AE Publications Ltd
166 High Street, Lewes, East Sussex, BN7 1XU, UK

Text © AE Publications Ltd, 2012
Images © Jon Sparks, 2012 (unless otherwise specified)
© in the Work AE Publications Ltd, 2012

ISBN 978-1-90770-886-2

British Library Cataloging in Publication Data: A catalog
record of this book is available from the British Library.

Editor: Rob Yarham
Series Editor: Richard Wiles
Design: Fineline Studios

Typefaces: Giacomo
Color reproduction by GMC Reprographics
Printed and bound in Leo Paper Group

《 PAGE 2
The Nikon D800 doesn't just
have the ability to capture
masses of fine detail, it also
has exceptional dynamic
range, allowing it to retain
detail in both highlights and
shadows. *14mm, 1.3 sec., f/11,
ISO 400, tripod.*

» CONTENTS

Chapter 1
OVERVIEW

1 OVERVIEW

The D800 has proved to be Nikon's most high-profile launch since that of the D3 in 2007. The D3 was the first Nikon DSLR to feature an FX-format ("full-frame") sensor, and the D800 shares the sensor format but triples the pixel count. This has created a great deal of interest, not all of it well-informed. Nikon's primary aim has been to create a camera with exceptional image quality which, in a relatively light and compact form, makes it a real alternative to cumbersome, expensive "medium-format" cameras. The D800, and its almost-identical twin, the D800E, certainly deliver, but only for users whose lenses and technique measure up.

» EVOLUTION OF THE NIKON D800

Among major camera makers, Nikon has always been noted for continuity as well as innovation. When the main manufacturers introduced their first viable autofocus 35mm cameras in the 1980s, most of them jettisoned their existing lens mounts, but Nikon stayed true to its tried and tested F-mount system. It's still possible to use the vast majority of classic Nikon lenses with

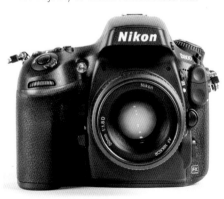

the latest digital cameras like the D800, though some camera functions may be lost.

For this and other reasons, "evolution" accurately describes the development of Nikon's digital cameras. Nikon's first digital SLR was the E2s. Sporting a then-impressive 1.3-megapixel sensor, its body design was based on the F801 35mm SLR. However, the true line of descent of the D800 begins with the 2.7 megapixel D1, of 1999. Its sensor adopted the DX format (see opposite), which remained in use with every Nikon DSLR prior to the D3.

Following the introduction of the D3 as Nikon's first full-frame DSLR, the D700 used the same sensor but in a smaller, lighter body. On the outside, the D800 appears a direct descendant of the D700, but its 36-megapixel sensor is unique; the top-of-the-range D4 has a 24-megapixel sensor. It will appear odd to some that Nikon's top

camera has a lower pixel count, but Nikon has always recognized that pixel numbers are only one benchmark; the D4 scores on speed, high-ISO performance and all-round ruggedness. The D800 is specifically targeted at those specialist photographers who can genuinely exploit its exceptional resolution, but it's also a highly versatile camera for those (the majority) who don't really need 36 megapixels.

› The Nikon FX format sensor

The DX format sensor, measuring approximately 23.6 x 15.8mm, was used in every Nikon DSLR prior to the D3, but the

number of pixels squeezed into that tiny area has risen from 2.7 million (D1) to 16.2 million (D7000). The D3 (of 2007) was the first Nikon DSLR to adopt a "full-frame" sensor, which Nikon designates FX. Its dimensions are almost exactly the same as a standard 35mm film frame (measuring 36 x 24mm). More than doubling the area of the DX sensor, the FX gathers more light and, crucially, each individual photosite (pixel) is larger—the D800's 36 million pixels each occupy about the same area as those in the D7000. This unprecedented pixel count offers exceptional ability to capture fine detail, but it should be noted that this can only be fully realized when

Nikon D200 (2005) ⊗
This camera proved enormously popular with pro and semi-pro users, delivering 10.2-megapixel resolution in a body significantly lighter and less cumbersome than the then top-of-the-line D2x.

Nikon D3 (2007) ⊗
Nikon's first "full-frame" DSLR took the world by storm, its blistering speed, super-rugged build and unprecedented low-light ability proving far more significant for many users than its conservative pixel count.

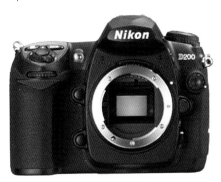

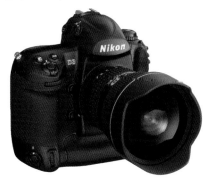

using the very best lenses and impeccable technique. The flagship D4, released just before the D800, boasts "only" 16.2 megapixels; its much larger photosites give it the ability to capture exceptionally low-noise images even at high ISO ratings. Its maximum "standard" ISO is 12,800, with an extension to 204,800.

CMOS (Complementary Metal Oxide Semiconductor) sensors are now used across Nikon's DSLR range. Although cheaper and less power-hungry, CMOS sensors' image quality was once considered inferior, and much research and development have gone into making them suitable for critical use. The D800's CMOS sensor, with 36.3 million effective pixels, produces images at a native size of 7360 x 4912 pixels.

Nikon D700 (2008) ⌄
Nikon's second FX DSLR offered the same sensor and same superb image quality as the D3 in a lighter and more compact body.

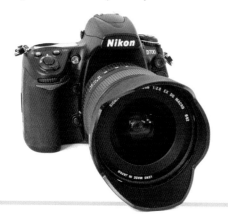

» ABOUT THE NIKON D800

Superficially, the Nikon D800 closely resembles the D700, the most obvious difference being a taller and deeper pentaprism housing; it's also heavier, but nowhere near the bulk or weight of the D4. Conspicuous on the rear of the camera is a 3.2in. (or 81mm) LCD panel, marginally larger than that on the D700. More importantly, the LCD's wider color gamut aids critical assessment of images in the field. Another welcome improvement over the D700 is that the viewfinder shows 100% of the image—a major step forward in helping the photographer to frame the image accurately in-camera.

While the 36.3-megapixel CMOS sensor has more than double the D4's pixel count, many of the "under the hood" features are common to both cameras, including the new EXPEED 3 processing engine and 51 autofocus points. However, the maximum shooting rate of 4 frames per second (when shooting FX) is substantially slower than the D4; professional sports photographers will undoubtedly opt for the latter camera, but most other users will find the D800 more than fast enough.

Another set of features that the D800 shares with the D4 is its high-quality video capabilities: 1080p video at 30, 25 or 24 frames per second, up to 24Mbps, with uncompressed HDMI output and audio monitoring options. This is almost exactly

the same video specification as the more expensive D4, but in a more compact, lighter, and cheaper body. The D800 even has a movie shooting button on the top plate, next to the shutter-release button, just like the D4. Although this book is primarily about using the D800 for still photography, the D800's movie capabilities are covered in chapter 6 *(see page 182)*.

One point that must be emphasized is that, as a 36-megapixel camera, the D800 produces huge image files, especially if you choose to shoot RAW, and this can demand extra investment in fast, high-capacity, memory cards and—more painfully—upgraded computer hardware and software to enable you to process and store your images efficiently.

Like all Nikon DSLRs the D800 is part of a vast system of lenses, accessories and software, some of which are covered in this book: lenses are featured in chapter 7 *(see page 196)*, accessories—including Nikon's external Speedlight flashguns—in chapter 8 *(see page 216)*, and software in chapter 9 on connection and care *(see page 226)*.

This *Expanded Guide* to the Nikon D800 will guide you through all aspects of the camera's operation, and its relation to the system as a whole.

Nikon has taken an unprecedented step with the parallel introduction of the D800 and D800E. The two cameras are identical in almost every respect, but the crucial difference lies in the filter which sits immediately in front of the sensor itself. Usually referred to as a "low-pass" or "anti-aliasing" filter, this is actually a complex optical sandwich. As well as physically protecting the (extremely delicate) sensor, this has the effect of blurring the image slightly. This may seem counter-intuitive, but digital images can be susceptible to effects such as moiré and aliasing *(see page 146)* and most digital cameras employ a low-pass filter to reduce these artefacts.

The D800 has a normal low-pass filter, while in the D800E the array is still there

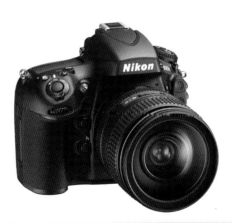

but its anti-aliasing effect has been neutralized. If you're familiar with polarizing filters *(see page 220)*, you'll know that their effect can be made very much stronger or weaker simply by rotating the filter; this is analogous to what Nikon has done with the D800E.

This means that the D800E can record fine detail with even sharper resolution than the D800, but also that it is more susceptible to moiré effects. This makes it a camera best suited to the specialist photographer, who understands these issues and is willing and able to review images in detail as a shoot progresses. Even more than the "ordinary" D800, the D800E is a direct challenge to existing medium-format cameras.

In terms of features and functions, the two cameras are identical and throughout this book, any reference to "D800" can be taken to apply also to the D800E unless explicitly stated otherwise.

» MAIN FEATURES

Sensor
36.3 effective megapixel FX-format RGB CMOS sensor measuring 35.9 x 24mm and producing a maximum image size of 7360 x 4912 pixels. Crop function allows capture in 1.2x, DX and 5x4 formats. Self-cleaning function.

Image processor
EXPEED 3 image processing system featuring 14-bit analog-to-digital (A/D) conversion with 16-bit image processing.

Focus
51-point autofocus system covering most of the image area, supported by Nikon Scene Recognition System, which tracks subjects by shape, position and color. Three focus modes: (S) Single-servo AF; (C) Continuous-servo AF; (M) Manual focus. Three AF-area modes: Single-area AF; Dynamic-area AF (with option of 3D tracking); and Auto-area AF. Rapid focus point selection and focus lock.

Exposure
Four metering modes: matrix metering; center-weighted metering; average metering; spot metering. 3D Color Matrix Metering III uses a 91,000-pixel color sensor to analyze data on brightness, color, contrast and subject distance from all areas of the frame. With non-G/D type lenses, standard Color Matrix Metering III is employed. Four exposure modes: (P) Programmed auto; (A) Aperture-priority auto; (S) Shutter-priority auto; (M) Manual. ISO range between 100 and 6400,

with extensions to 50 and 25,600. Exposure compensation between −5 Ev and +5 Ev; exposure bracketing facility.

Shutter

Shutter speeds from 1/8000th sec. to 30 sec., plus B. Max frame advance 4fps (5fps in DX crop mode; 6fps possible with external power supply).

Viewfinder and Live View

Bright viewfinder with 100% coverage and 0.7x magnification. Live View available on rear LCD monitor.

Movie Mode

Continuous feed in Live View mode allows movie capture in .MOV format (MPEG-4 compression) with image size (pixels) of: 640 x 424; 1280 x 720; 1920 x 1080. Frame rates of 30/25/24fps at large size; 60/50/30/25fps at mid-size; 24fps at small size.

Buffer

Buffer capacity allows up to 40 frames (JPEG fine, large) to be captured in a continuous burst at 4fps, approx 17 NEF (RAW) files.

Flash

Pop-up flash (manually activated) with Guide Number of 12 (m) or 39 (ft) at ISO 100 supports i-TTL balanced fill-flash for DSLR (when matrix or center-weighted metering is selected and Standard i-TTL flash for DSLR (when spot metering is selected). Five flash-sync modes: Front-curtain sync; Red-eye reduction; Slow sync; Red-eye reduction with slow sync;

Rear-curtain sync. Flash compensation from −3 to +1 Ev; FV lock.

LCD monitor

High-definition 3.2-in., 921,000-pixel TFT LCD display with wide color gamut (close to sRGB) and 100% frame coverage.

Custom functions

Over 50 parameters and elements of the camera's operations can be customized through the Custom setting menu.

File formats

The D800 supports NEF (RAW) (14-bit and 12-bit); TIFF and JPEG (Fine/Normal/Basic) file formats.

System back-up

Compatible with more than 60 current and many more non-current Nikkor lenses (functionality varies with older lenses); SB-series flashguns; Multi-Power Battery Pack MB-D12; Wireless Transmitter WT-4 and many more Nikon system accessories. Software Supplied with Nikon View NX2; compatible with Nikon Capture NX2 and many third-party imaging applications.

1 » FULL FEATURES AND CAMERA LAYOUT

FRONT OF CAMERA

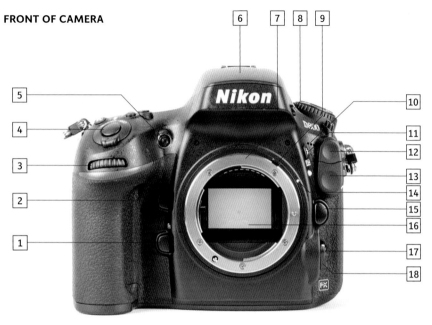

1	Fn button	10	Built-in microphone
2	Depth-of-field preview button	11	Flash/Flash mode/Flash compensation button
3	Sub-command Dial	12	Flash sync terminal cover
4	Shutter-release button	13	Ten-pin remote terminal cover
5	AF-assist illuminator/Self-timer/Red-eye reduction lamp	14	Mounting index
6	Built-in flash	15	Lens-release button
7	Lens mount	16	Mirror
8	Flash pop-up button	17	AF-mode button
9	Meter coupling lever	18	Focus mode selector

BACK OF CAMERA

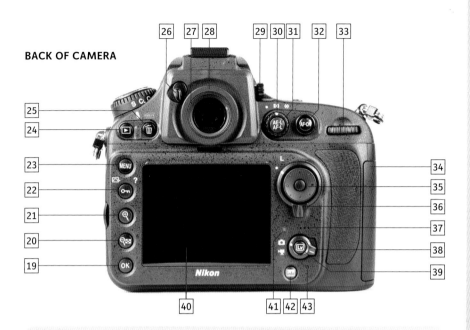

19	OK button	32	AF-ON button
20	Thumbnail/playback zoom out button	33	Main Command Dial
21	Playback zoom in button	34	Memory card slot cover
22	Protect/Picture Control/Help button	35	Multi-selector
23	MENU button	36	Focus selector lock
24	Playback button	37	Speaker
25	Delete/Format button	38	Live view selector
26	Eyepiece shutter lever	39	Live view button
27	Viewfinder	40	LCD monitor
28	Viewfinder eyepiece	41	Ambient brightness sensor for automatic monitor brightness control
29	Diopter adjustment dial	42	INFO button
30	Metering selector	43	Memory card access lamp
31	AE-L/AF-L button		

1 » FULL FEATURES AND CAMERA LAYOUT

TOP OF CAMERA **LEFT SIDE**

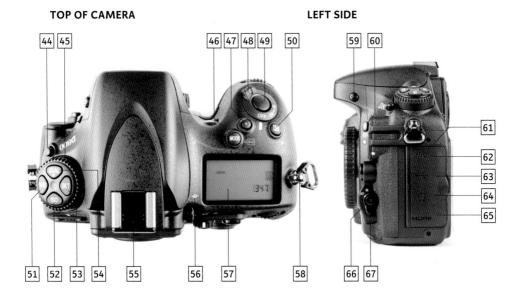

44 Release mode dial lock release	**51** White Balance button	**59** Flash pop-up button	
	52 ISO/Auto ISO button	**60** Flash/Flash mode/Flash compensation button	
45 Release mode dial	**53** Bracketing button	**61** Connector cover	
46 Exposure mode/Format button	**54** Image quality/Image size/two-button reset button	**62** External microphone connector	
47 Movie record button		**63** USB connector	
48 Power switch	**55** Accessory hotshoe	**64** Headphone connector	
49 Shutter-release button	**56** Focal plane mark	**65** HDMI mini-pin connector	
50 Exposure compensation/ two-button reset button	**57** LCD control panel	**66** AF-mode button	
	58 Camera strap mount	**67** Focus mode selector	

BOTTOM OF CAMERA

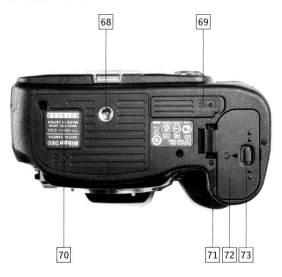

RIGHT SIDE

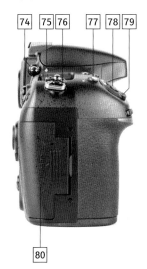

68	Tripod socket (¼in)
69	Contact cover for optional MB-D12 battery pack
70	Camera serial number
71	Power connector cover
72	Battery compartment
73	Battery compartment release lever

74	Diopter adjustment dial
75	Focal plane mark
76	Camera strap mount
77	Exposure compensation/ two-button reset button
78	Shutter-release button
79	Power switch
80	Memory card slot cover

1 » VIEWFINDER DISPLAY

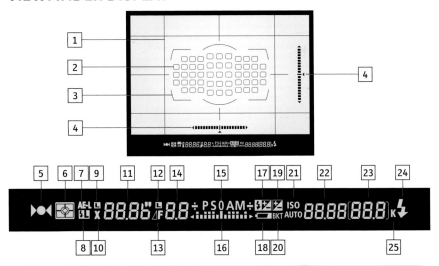

1 Framing grid	**16** Exposure indicator or Exposure compensation display
2 Focus points/AF-area mode	
3 AF area brackets	**17** Flash compensation indicator
4 Virtual horizon display	**18** Low battery warning
5 Focus indicator	**19** Exposure compensation indicator
6 Metering	**20** Exposure and flash, WB, or ADL bracketing indicator
7 Autoexposure (AE) lock indicator	
8 FV lock indicator	**21** Auto ISO sensitivity indicator
9 Shutter speed lock indicator	**22** ISO sensitivity/Preset white balance (WB) recording indicator/Flash compensation value/Active D-Lighting (ADL) bracketing amount/AF-area mode
10 Flash sync indicator	
11 Shutter speed/Autofocus (AF) mode	
12 Aperture lock indicator	
13 Aperture stop indicator	**23** No. of exposures remaining/in buffer/ Exposure or Flash compensation value
14 Aperture (f no. or no. of stops)	
15 Exposure mode	**24** Flash-ready indicator
	25 "K" (when over 1000 exposures remain)

» LCD CONTROL PANEL

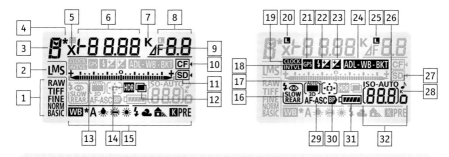

1 Image quality	aperture (non-CPU lenses)/PC mode indicator	**23** Exposure compensation indicator
2 Image size	**9** Aperture stop indicator	**24** Exposure and flash, WB, or ADL bracketing, or ADL indicator
3 Exposure mode	**10** CF card indicator	
4 Flexible program indicator	**11** SD card indicator	**25** Aperture lock icon/HDR or Multiple exposure (series) indicator
5 Flash sync indicator	**12** Multiple exposure indicator	
6 Shutter speed/Exposure or Flash compensation value/ WB fine-tuning/Color temperature/WB preset no./No. of shots in exposure and flash bracketing sequence or in WB bracketing sequence/ HDR exposure differential/ No. of shots in multiple exposure/No. of intervals for interval timer photography/Focal length (non-CPU lenses)	**13** Exposure, Exposure compensation, PC connection indicator	**26** ISO or Auto ISO sensitivity indicator
	14 HDR indicator	**27** "Beep" indicator
	15 WB/WB fine-tuning indicator	**28** "K" (when over 1000 exposures remain)
	16 Flash mode	**29** Autofocus mode
	17 AF-area mode, Auto-area AF, or 3D-tracking indicator	**30** MB-D12 battery indicator
		31 Battery indicator
	18 Interval timer indicator/ Time-lapse indicator	**32** No. of exposures remaining/No. of shots remaining in buffer/ISO sensitivity/Preset WB recording indicator/ADL bracketing amount/Time-lapse recording indicator/ Manual lens no./Capture mode indicator
7 Color temp. indicator	**19** "Clock not set" indicator	
8 Aperture (f-no. or no. of stops)/Bracketing increment/No. of shots in ADL bracketing sequence or per interval/Maximum	**20** Shutter speed lock icon	
	21 GPS connection indicator	
	22 Flash compensation indicator	

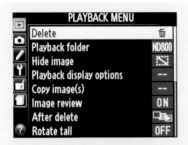

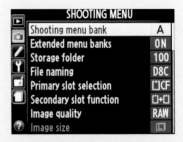

The Playback Menu
- › Delete
- › Playback Folder
- › Hide image
- › Playback display options
- › Copy image(s)
- › Image review
- › After delete
- › Rotate tall
- › Slide show
- › DPOF print order

The Shooting Menu
- › Shooting menu bank
- › Extended menu banks
- › Storage folder
- › File naming
- › Primary slot selection
- › Secondary slot function
- › Image quality
- › Image size
- › Image area
- › JPEG compression
- › NEF (RAW) recording
- › White balance
- › Set Picture Control
- › Manage Picture Control
- › Color space
- › Active D-Lighting
- › HDR (high dynamic range)
- › Vignette control
- › Auto distortion control
- › Long exposure NR
- › High ISO NR
- › ISO sensitivity settings
- › Multiple exposure
- › Interval timer shooting
- › Time-lapse photograhy
- › Movie settings

CUSTOM SETTING MENU

Custom settings bank A
a Autofocus
b Metering/exposure
c Timers/AE lock
d Shooting/display
e Bracketing/flash
f Controls
g Movie

The Custom Setting Menu
> Custom setting bank
> **a: Autofocus**
> a1 AF-C priority selection
> a2 AF-S priority selection
> a3 Focus tracking with lock-on
> a4 AF activation
> a5 AF Point illumination
> a6 Focus point wrap-around
> a7 Number of focus points
> a8 Built-in AF-assist illuminator
> **b: Metering/exposure**
> b1 ISO sensitivity step value
> b2 EV steps for exposure cntrl
> b3 Exp./flash comp. step value
> b4 Easy exposure compensation
> b5 Center-weighted area
> b6 Fine-tune optimal exposure
> **c: Timers/AE Lock**
> c1 Shutter-release button AE-L
> c2 Auto meter-off delay
> c3 Self-timer delay
> c4 Monitor off delay
> **d: Shooting/display**
> d1 Beep
> d2 CL mode shooting speed
> d3 Max. continuous release

> d4 Exposure delay mode
> d5 File number sequence
> d6 Viewfinder grid display
> d7 ISO display and adjustment
> d8 Screen tips
> d9 Information display
> d10 LCD illumination
> d11MB-D12 battery type
> d12 Battery order
> **e: Bracketing/flash**
> e1 Flash sync speed
> e2 Flash shutter speed
> e3 Flash control for built-in flash
> e4 Modeling flash
> e5 Auto bracketing set
> e6 Auto bracketing (Mode M)
> e7 Bracketing order
> **f: Controls**
> f1 ☀ switch
> f2 Multi selector center button
> f3 Multi selector
> f4 Assign Fn button
> f5 Assign preview button
> f6 Assign **AE-L/AF-L** button
> f7 Shutter spd & aperture lock
> f8 Assign **BKT** button
> f9 Customize command dials
> f10 Release button to use dial
> f11 Slot empty release lock
> f12 Reverse indicators
> f13 Assign MB-D12 AF-ON
> **g: Movie**
> g1 Assign Fn button
> g2 Assign preview button
> g3 Assign **AE-L/AF-L** button
> g4 Assign shutter button

1 » MENU DISPLAYS

The Setup Menu
> Format memory card
> Monitor brightness
> Clean image sensor
> Lock mirror up for cleaning
> Image Dust Off ref photo
> HDMI
> Flicker reduction
> Time zone and date
> Language
> Auto image rotation
> Battery info
> Wireless transmitter
> Image comment
> Copyright information
> Save/load settings
> GPS
> Virtual horizon
> Non-CPU lens data
> AF fine tune
> Eye-Fi upload
> Firmware version

The Retouch Menu
> D-Lighting
> Red-eye correction
> Trim
> Monochrome
> Filter effects
> Color balance
> Image overlay
> NEF (RAW) processing
> Resize
> Quick retouch
> Straighten
> Distortion control
> Fisheye
> Color outline
> Color sketch
> Perspective control
> Miniature effect
> Selective color
> Edit movie
> Side-by-side comparison

MY MENU

File naming	D8C
a1 AF-C priority selection	⬡
Primary slot selection	⬚CF
Storage folder	100
Add items	--
Remove items	--
Rank items	--
Choose tab	🗐

My Menu/Recent Settings
> Add items
> Remove items
> Rank items
> Choose tab

VIEW TO A HILL ⤬

My Menu helps you to access the camera's features and recent settings quickly to save you precious time when you're in a hurry to catch the light. *85mm, 1/80th sec., f/6.3, ISO 1600.*

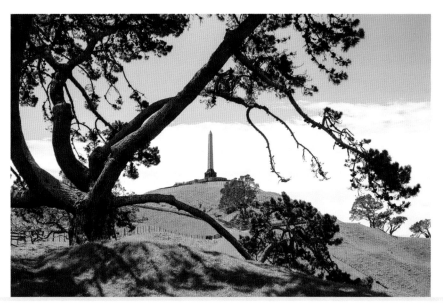

Chapter 2
FUNCTIONS

2 FUNCTIONS

Most users of the D800 will presumably have some previous experience of digital SLRs. In such case, and particularly if you've previous experience with Nikon, the D800 will feel familiar enough. To the newcomer, however, a camera like the D800, with all its buttons and dials, naturally appears complex and perhaps daunting. Complex it certainly is, but "powerful" is a better word—there is an awful lot that you can do with the D800.

Also, more of its power is on the surface. You can access most key functions instantly through the buttons and dials, without having to delve into menus. If you know what you want to do, this is a big advantage. Cameras which make you use menus to change routine settings are slower and more cumbersome in operation.

More than with most previous cameras, however, Nikon expects that the D800 will attract experienced digital photographers. In fact they have specifically targeted the camera at photographers who have previously used cumbersome medium-format equipment.

Tip

If you do feel the need to ease yourself in gently, you can leave the camera in Program mode and use default settings across the board. You can also restore the camera to default at any time by simultaneously pressing the 🄯 *and* 🔍 *buttons (marked with green dots). See page 63 for a list of settings to which this applies.*

Either way, there is a great deal to the D800, and this chapter aims to provide a step-by-step introduction to its key features and functions. It would be impossible, even in a book twice the length, to fully explore every last detail, so we'll focus on the areas which will be most relevant to the majority of photographers.

FIRST TIME OUT «
When you unpack a new camera, it's tempting to start shooting right away, but do read this book first, to ensure you understand the features and functions. *42mm, ¼ sec., f/11, ISO 200, tripod.*

» CAMERA PREPARATION

Operations like changing lenses or memory cards may seem trivial, but it can be crucial to perform them efficiently in awkward situations or when time is short.

› Attaching the strap

To attach the strap, ensure the padded side faces inwards (so the maker's name faces outwards). Attach one end to the appropriate eyelet at top left or right side of the camera. Loosen the strap where it runs through the buckle, then pass the end of the strap through the eyelet. Bring the end of the strap back through the buckle, at the side furthest from the eyelet, then double back through the other side of the buckle. Adjust the length as required, but leave a decent "tail" for security. When satisfied, tighten the strap firmly and slide up the sleeve to keep the "tail" tucked away. Repeat on the other side.

› Adjusting the diopter

The D800 offers dioptric adjustment, between −3 and +1 m^{-1}, to allow for individual variations in eyesight. Check this is optimized for you before using the camera—if you wear glasses or contact lenses, keep them on. The diopter adjustment control is to the right of the viewfinder. With the camera switched on, pull out the knob and rotate it until the viewfinder display (i.e. readouts and focus points) appears sharpest. Push the knob in.

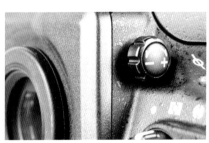

ADJUSTING THE DIOPTER ⌃
The diopter adjustment knob.

ATTACHING THE STRAP «
The strap is shown correctly threaded, but not yet tightened.

› Mounting lenses

Switch the camera OFF before changing lenses. Remove the rear lens cap and the camera body cap (or a lens if one is already mounted). To remove the lens, press the lens-release button and turn the lens clockwise (as you face the front of the camera). To attach another lens, align the index mark on the lens with the one on the camera body (white dot), insert the lens gently into the camera and turn it anti-clockwise until it clicks home. Do not use excessive force; if the lens is correctly aligned it will mount smoothly.

Most Nikon F-mount lenses can be used on the D800; *see page 210* and the maker's manual for detailed information. For lenses

Tip

Take care when changing lenses, especially in crowds or other awkward situations. Dropping the lens or the camera is definitely to be avoided! Take extra care in dusty or windy environments. Hold the camera pointing down and stand with your back to any wind. In really bad conditions (such as sandstorms) it's best not to change lenses at all. Avoid touching the electrical contacts on the lens and camera body. Replace the lens or body cap as soon as possible.

› Inserting and removing memory cards

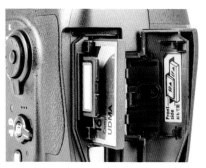

The D800 has dual memory card slots ⌃

with an aperture ring, rotate this to minimum aperture before use on the D800.

The D800 has dual card slots. One accepts Secure Digital (SD) cards, such as high-capacity SDHC and SDXC cards. The other takes Type I Compact Flash cards.

Switch OFF the camera and check that the green access lamp (on the back of the camera below the Lv Live View switch) is not lit. Slide the card slot cover on the right side of the camera gently to the rear, until it springs open. To remove a CF card, press the gray eject button located below the card slot. Pull the card out gently. To remove an SD card, press the card gently into its slot and it will then spring out slightly. Pull the card out gently.

Insert memory cards with their label side facing the rear and the rows of terminals along the card edge facing into

the slot. Slide the card into the appropriate slot until it clicks into place. In the case of CF cards, the eject button will spring out fractionally. The access lamp will light up for a moment. Close the card slot cover.

› Formatting a memory card

It's always recommended to format a new memory card, or one that has been used in another camera, before use with the D800. This is also the quickest way to erase existing images: for this very reason formatting needs to be done with caution—always confirm first that images have been saved elsewhere.

One way to format a card is to press and hold the two **FORMAT** buttons (🗑 and **MODE**) for about two seconds. A blinking **FOR** appears in the Viewfinder and Control Panel. If both card slots are occupied, the card in the primary slot *(see page 84)* will

be formatted first, and its icon will blink in the displays. Turn the Main Command Dial to select Slot 2 instead. Release the two buttons and press them again to format the card. Press any other button to exit without formatting the card.

You can also format the card through the Setup menu *(see page 107)* This route makes it instantly obvious which card slot will be formatted.

› Inserting the battery

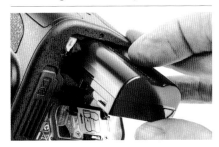

Inserting the battery ⌄

The Nikon D800 is supplied with an EN-EL15 li-ion rechargeable battery, as used in the D7000 and the Nikon J1 and V1. The battery needs to be fully charged before first use *(see Battery charging, page 30)*.

Turn the camera upside down and locate the battery compartment below the handgrip. Release the latch to open the compartment. Insert the battery, contacts first, with the flat side facing towards the lens. Use the battery to nudge the gold-colored battery latch aside, then slide the

battery gently down until the latch locks into position. The green access lamp on the camera back will illuminate briefly. Shut the battery compartment cover, ensuring it clicks home.

To remove the battery, switch OFF the camera, and open the compartment cover as above. Press the orange latch to release the battery and pull it gently out.

› Battery charging

Use the supplied MH-25 charger to charge the battery. Connect the power cord to the charger and insert the plug into a mains outlet. Align the battery, terminals first, with the slot on the charger. The battery will only fit the slot when correctly orientated. Slide the battery into the slot until it snaps home. The Charge lamp will blink while the battery is charging, and shine steadily when charging is complete. A fully discharged battery will take around 2½ hours to recharge fully.

› Battery life

Battery life depends on various factors. Nikon do not recommend using the camera at temperatures below 0°C or above 40°C *(but see page 241)*. Other important factors that can reduce battery life include heavy use of the LCD screen, use of the built-in flash, long auto meter-off delays, and continuous use of

autofocus (as when tracking a moving subject). Extensive use of Live View/movie shooting is particularly draining. Under stringent (CIPA) conditions you can expect around 1000 shots from a fully charged EN-EL15 battery; many users will do considerably better than this.

The control panel gives an approximate indication of how much charge remains; for more detail see Battery Info in the Setup menu. The control panel icon blinks when the battery is exhausted, and a low battery icon appears in the viewfinder when it is approaching exhaustion.

For information on alternative batteries and mains adapters, see Accessories, Chapter 8 *(see pages 222–223)*.

Tips

Even when not in use your camera battery will gradually lose charge over a period of time. If the camera is to remain unused for a long period it is suggested that you remove the battery. Storing the battery after it is fully recharged may lower the battery's performance.

The battery charger can be used abroad (100–240 V AC 50/60 Hz) with a commercially available travel plug adapter. Do not attach any form of voltage transformer.

» BASIC CAMERA FUNCTIONS

Key camera functions are principally accessed through the two command dials, the Mode Dial and the Release Mode Dial. Menu navigation is principally via the Multi-selector.

› Switching the camera on

Power switch and shutter-release button ☆

The power switch has three settings:
OFF The camera will not operate.
ON The camera operates normally.
:☼: Move the power switch beyond the **ON** setting and release (it will not lock in this position). This illuminates the control panel for approximately 5 seconds. Custom setting d8 allows you to keep the panel illuminated permanently, which may be useful for night shooting but reduces battery life.

› Operating the shutter

The shutter-release button operates in two stages. Pressing it lightly, until you feel slight resistance, activates exposure and focus functions. Full pressure releases the shutter and takes the picture, using focus and exposure settings established by the half-pressure. If image playback or camera menus are active, these are canceled by half-pressure on the release button, making the camera instantly ready to shoot.

› Release mode

Release Mode Dial ☆

"Release mode" determines whether the camera takes a single picture, shoots continuously, or delays a shot. The Release Mode Dial has six positions. To prevent accidental switching between the modes the dial is provided with a lock button.

2

RELEASE MODE OPTIONS

Setting	Description
S Single Frame	The camera takes a single shot each time the shutter release is fully depressed.
CL Continuous Low-speed	The camera fires continuously as long as the shutter release is fully depressed. The default frame rate is 2fps, but this can be varied between 1 and 5fps using Custom Setting d2.
CH Continuous High-speed	The camera fires continuously at the maximum possible frame rate as long as the shutter release is fully depressed. The maximum rate is between 4 and 6fps, depending on both power source and image size settings *(see page 55).*
Q Quiet shutter- release	Shoots as normal but there are no alert beeps and the mirror-return after each shot is damped to provide a quieter release.
☉ Self-timer	The shutter is released at a set interval after the release button is depressed. Can be used to minimize camera shake and for self-portraits. The default interval is 10 sec. but 2 secs., 5 secs., or 20 secs. can be set using Custom Setting c3 *(see page 96).*
MUP Mirror up	The mirror is raised when the shutter-release button is fully depressed; press it again to take the picture. Useful for minimizing vibration caused by "mirror slap," but now superseded in many circumstances by Live View mode.

Tip

CL and CH release are not available when the built-in flash is raised.

The buffer

Images are initially stored in the camera's internal memory, or "buffer", before being written to the memory card(s). The maximum number of images that can be recorded in a continuous burst depends upon image quality setting, drive mode, memory card speed and capacity. The figure for the number of burst frames possible at current settings is shown in the viewfinder at bottom right. If **(0)** appears, the buffer is full, and the shutter will be disabled until enough data has been transferred to the memory card to free up space in the buffer. In practice, this is rare with the D800, and is only likely to occur when shooting long bursts in CH or CL release mode. Even then it is more likely to be noticed as a slowdown to 1 or 2 fps rather than a complete standstill.

› Control panel and Information display

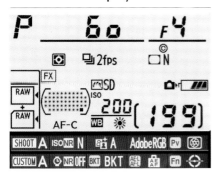

The Information display on the main LCD screen. ⌃

All key shooting information is displayed in the control panel on the top right side of the camera. Much the same information can also be viewed on the rear LCD screen by pressing the **INFO** button. The larger display makes it easier to read the information. The Information display can be particularly helpful when working on a tripod.

Key menu settings can also be changed directly from the Information display screen: press **INFO** again to highlight the entries at the bottom of the screen. Move through them with the Multi-selector and press ⊙ to enter the corresponding menu item.

› Command dials

The Main and Sub-command Dials are fundamental to the operation of the D800. Their function is flexible, varying according to the operating mode at the time. The plethora of different options may appear daunting but operation in practice turns out to be much more intuitive than a description in print might suggest. By default, when used on their own, the dials operate as follows.

2

Main Command Dial

In Shutter Priority or Manual mode, rotating the Main Command Dial selects the shutter speed. In Program mode it will engage program shift, changing the combination of shutter speed and aperture. In Aperture Priority mode it has no effect.

Sub-command dial

In Aperture Priority or Manual mode, rotating the Sub-command Dial selects the aperture. In Shutter Priority or Program mode it has no effect.

Both dials, especially the Main Command Dial, have a range of other functions when used in conjunction with other buttons. Hold down the appropriate button while rotating the dial to make a selection.

Multi-selector

The Multi-selector, on the camera back, is also an important part of the control system. Its primary uses are in navigating through images in playback *(see page 69)*, navigating through the menus *(see page 76)* and in selecting the focus point, especially in single-servo AF mode *(see page 47)*. The Multi-selector allows

The Multi-selector ⌄

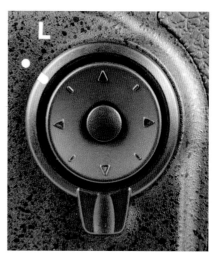

The Main Command Dial ⌃

The Sub-command Dial ⌄

Principal uses of the command dials in conjunction with other buttons

Command dial	Other button	Function
Main	🔲	Selects level of exposure compensation *(see page 43)*.
Main	⚡	Selects flash mode *(see page 160)*.
Sub	⚡	Selects level of flash compensation *(see page 163)*.
Main	**QUAL**	Selects image quality *(see page 51)*.
Sub	**QUAL**	Selects image size *(see page 56)*.
Main	**ISO**	Selects ISO sensitivity *(see page 60)*.
Main	**WB**	Selects white balance setting *(see page 58)*.
Sub	🔲	Selects white balance preset *(see page 60)*.

movement horizontally, vertically and diagonally.

The collar around the Multi-selector has an **L** (for Lock) position. Even when this is locked, the Multi-selector can still be used for playback and menu navigation, but the focus point cannot be moved. To enable control of the focus point, unlock the collar by moving it to the unlocked position (white dot).

›› EXPOSURE MODES

› Exposure warning

In any mode except M, if the camera determines that predetermined exposure limits are exceeded, the shutter speed and/ or aperture digits will blink in the viewfinder and control panel. It's usually possible to achieve an acceptable exposure by adjusting ISO sensitivity *(see page 60)*.

GOING UNDERGROUND ⯆
Programmed auto mode allows for a quick response but also some creativity. *85mm,1/80th sec., f/6.3, ISO 1600.*

› (P) Programmed auto

In P mode the camera sets a combination of shutter speed and aperture that will give correctly exposed results in most situations. This is ideal for snapshots and when time is of the essence, but reduces creative control. However, there is still considerable room for user intervention in P mode through flexible program, exposure lock and exposure compensation, and auto bracketing.

1) Select Programmed auto mode by pressing **MODE** and rotating the Main Command Dial until **P** is displayed in the viewfinder and control panel.

2) Frame the picture.

3) Half-press the release button to activate focusing and exposure. The focus point(s) will be displayed in the viewfinder image. Shutter speed and aperture settings will appear at the bottom of the viewfinder.

4) Fully depress the shutter-release button to take the picture.

Flexible program

Without leaving P mode you can vary the combination of shutter speed and aperture by rotating the Main Command Dial to engage flexible program. When flexible program is in effect the **P** indication in the control panel (but not the viewfinder) changes to **P***.

> **Note:**
> Programmed auto mode is not available with older lenses lacking a CPU. If a non-CPU lens is attached, the camera will switch to Aperture Priority mode. The **P** indicator in the control panel will blink and **A** will be displayed in the viewfinder.

› (A) Aperture-priority auto

In A mode, you control the aperture while the camera sets a shutter speed to correctly expose in most situations. This is particularly useful for controlling depth of field *(see page 125)*. The available range of apertures is set by the lens, not the camera. Fine-tune exposure with exposure lock and compensation, and auto bracketing.

1) Select Aperture-priority mode by pressing **MODE** and rotating the Main Command Dial until **A** is displayed in the viewfinder and control panel.

2) Frame the picture.

3) Half-press the release button to activate focusing and exposure. The focus point(s) will be displayed in the viewfinder. Shutter speed and aperture settings will appear at the bottom of the viewfinder. Rotate the Sub-command Dial to alter the aperture; the shutter speed will adjust automatically.

4) Fully depress the release button to take the picture.

> **Note:**
> Aperture-priority auto is available with older lenses lacking a CPU. Specify the maximum aperture of the lens using the Non-CPU lens data item in the Setup menu.

› (S) Shutter-priority auto

In Shutter-priority (S) mode, you control the shutter speed while the camera sets an appropriate aperture that will give correctly exposed results in most situations. Control of shutter speed is particularly useful when dealing with moving subjects *(see page 128)*. Shutter speeds between 30 sec. and 1/8000th sec. can be set. Fine-tuning of exposure is possible through exposure lock, exposure compensation, and possibly auto bracketing.

1) Select Shutter-priority mode by pressing **MODE** and rotating the Main Command Dial until **S** is displayed in the viewfinder and control panel.

2) Frame the picture.

3) Apply half-pressure to the release button to activate focusing and exposure. The focus point(s) will be displayed in the viewfinder image. Shutter speed and aperture settings will appear at the bottom of the viewfinder. Rotate the Main Command Dial to alter the shutter speed; the aperture will adjust automatically.

4) Fully depress the shutter release to take the picture.

CORNERING SPEED «
I set a fast shutter speed to freeze both the rider and the spray flying up from the wet road.
85mm, 1/1250th sec., f/5.6, ISO 800.

> **Note:**
> Shutter-priority auto is not available with older lenses lacking a CPU. If a non-CPU lens is attached, the camera will switch to Aperture Priority mode. The **S** indicator in the control panel will blink and **A** will be displayed in the viewfinder.

› (M) Manual mode

In M mode, you control both shutter speed and aperture for maximum creative flexibility. The Main Command Dial controls shutter speed and the Sub-command Dial controls aperture. Manual mode is most comfortably employed when shooting without pressure of time or in fairly constant light conditions. Many experienced photographers use it habitually to retain complete control.

Shutter speeds can be set between 30 sec. and 1/8000th sec., plus B or "bulb" (in which the shutter remains open indefinitely while the release is depressed). The range of apertures that can be set is determined by the lens that's fitted.

1) Select Manual mode by pressing **MODE** and rotating the Main Command Dial until **M** is displayed in the viewfinder and control panel.

2) Frame the picture.

3) Half-press the release to activate focus and exposure. The focus point(s) will be

displayed in the viewfinder and shutter speed and aperture settings will appear below the image. Check the analog exposure display in the viewfinder (and/or the playback histogram), and if necessary adjust settings to achieve correct exposure.

4) Fully depress the shutter-release button to take the picture.

› Using analog exposure displays

In Manual mode, an analog exposure display appears in the center of the viewfinder readouts and in the information display. This shows whether the photograph would be under- or overexposed at current settings. Adjust shutter speed and/or aperture until the indicator is aligned with the **0** mark in the center of the display: the exposure now matches the camera's recommendations. The D800's excellent metering means that this will generally be correct, but if time allows it is always helpful to review the image and check the histogram display *(see Playback, page 71)* after taking a shot. If necessary, adjustments can then be made for creative effect or to achieve a specific result.

> ### Tip
>
> *B ("bulb"), with its unlimited exposure duration, is only available in M mode, making this the only possible choice for really long exposures.*

POT SHOT

Here I used manual mode and viewed the histogram on playback to check the exposure. *62mm, 1/60th sec., f/8, ISO 1600.*

» METERING MODES

Metering mode selector is a collar round the AE-L/AF-L button.

Nikon metering has long been admired. The Nikon D800 provides three different metering modes, which should cover any eventuality. Switch between them using the selector just to the right of the viewfinder. The viewfinder and information display both show which metering mode is in use.

› 3D color matrix metering III

Using a 91,000-pixel color sensor, 3D Color Matrix Metering II analyzes data on the brightness, color and contrast of the scene. When used with Type G or D Nikkor lenses, the system also uses information on the distance to the subject to further refine its reading. With other CPU lenses, this range information is not used (Color Matrix Metering III). If non-CPU lenses are to be used, color matrix metering can still be employed provided the focal length and maximum aperture are specified using

the **[Non-CPU lens data]** item in the Setup Menu.

Matrix metering is recommended for the vast majority of shooting situations and will generally produce excellent results.

› Center-weighted metering

This is a very traditional form of metering which is familiar to many experienced photographers. Here the camera meters from the entire frame, but gives greatest weight to the central area. At default setting this area is a circle 12mm in diameter. Provided a CPU lens is attached, this can be changed to 8, 15 or 20mm using Custom Setting b5. This also allows you to choose Average metering, which meters equally from the whole frame area.

Center-weighted metering is useful in areas such as portraiture, where the main subject occupies the central portion of the frame.

› Spot metering

In this mode the camera meters purely from a circle 4mm in diameter (just 1.5% of the frame). If a CPU lens is in use, this circle will be centered on the current focus point, allowing you to meter from an off-center subject. If a non-CPU lens is attached, or Auto-area AF is in use,

the metering point will be the center of the frame.

Effective use of spot metering requires some experience, but in critical conditions it offers unrivalled accuracy. Spot metering attempts to reproduce the metered area as a mid-tone and this must be allowed for (e.g. by using exposure compensation) if the subject is significantly darker or lighter than a mid-tone.

LEAF LIGHT ⋎

Spot metering helped me capture good detail in the leaves without the background going completely black. *85mm, 1/40th sec., f/11, ISO 400, tripod.*

» EXPOSURE COMPENSATION AND BRACKETING

› Using exposure compensation

Exposure compensation button

The range of metering options, and the incredible sophistication of matrix metering in particular, means that the D800 will produce accurate exposures under most conditions. Still, no camera is infallible, nor can it read your mind or anticipate your creative intent.

All metering systems are still partly based on the assumption that key subject

Tip

Active D-Lighting (see page 72) and D-Lighting (page 113) can help to achieve better results in tricky lighting conditions. Shooting NEF (RAW) images also provides more options later on.

areas have a middling tonal value and should be recorded as a mid-tone. Most photographers have seen the results which sometimes arise, such as snow scenes appearing unduly dark. Where very light tones predominate, the metering will tend to reproduce them as mid-tones, i.e. darker than they should be. Where very dark tones predominate, the converse is true.

In the days of film, considerable experience was needed to accurately anticipate the need for exposure compensation. With their instant feedback on exposure, digital cameras smooth the learning curve. It's always helpful—time permitting—to check the image, and specifically the histogram, after shooting *(see page 71)*. However, the basic principle is simple enough: to make the subject lighter (to keep light tones looking light), increase exposure using positive compensation. To make the subject darker (to keep dark tones looking dark), reduce exposure using negative compensation.

If this judgement is difficult, or lighting conditions are particularly extreme, an extra level of "insurance" is available through exposure bracketing *(see page 45)*. Shooting RAW gives extra room for maneuver in post-processing, both to adjust overall tonal values and to recover

detail apparently lost in both shadows and highlights. However, it's still best to aim for accurate exposure in the first place.

1) Exposure compensation can be applied in increments of ⅓ Ev (default), ½ Ev or 1 Ev. Use Custom setting b2 to change the increment. Note that any such change will also apply to flash compensation.

2) Press the ⌿ button and rotate the Main Command Dial to set the negative or positive compensation required; the chosen value will be displayed in the

control panel and viewfinder. Exposure compensation can be set between −5 Ev and +5 Ev.

3) Release the ⌿ button. The ⌿ symbol will appear in both control panel and viewfinder, and the **0** at the center of the Analog Exposure Display will flash. The chosen exposure compensation value is shown in the viewfinder display, and can be confirmed on the control panel by pressing the ⌿ button again.

4) Take the picture as normal. If time allows, check that the results are satisfactory.

5) To restore normal exposure settings, press the ⌿ button and rotate the Main Command Dial until the displayed value returns to **0.0**.

Tips

Always reset exposure compensation when you've finished shooting that particular scene; otherwise it will apply to later shots which don't need it. Exposure compensation is not reset automatically even when the camera is switched off. However, it will be restored to neutral by a two-button reset (see page 62).

Don't use exposure compensation in Manual mode. It doesn't affect the actual shutter speed/aperture values but can give misleading exposure readouts.

Note:
Exposure compensation will vary both aperture and shutter speed in P mode. In A mode, only the shutter speed varies, and in S mode only the aperture. Exposure bracketing works similarly.

› Exposure bracketing

Often the quickest and most convenient way to ensure that an image is correctly exposed is to take a series of frames at differing exposures, and select the best one later. The D800's bracketing facility

The BKT button

allows this to be done very quickly, especially if **CL** or **CH** release mode is selected.

1) Select the type of bracketing required using Custom setting e5. Select "**AE only**" to ensure that only exposure values are varied. If flash is not active, "**AE & Flash**" has the same effect.

2) While pressing the BKT button, rotate the Main Command Dial to select the number of shots required for the bracketing burst. You can choose between 2, 3, 5, 7 and 9 shots; the selected number is displayed in the control panel.

−1 Ev

0 Ev

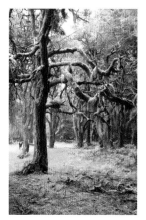

+1 Ev

2

Often the quickest and most convenient way to ensure that an image is correctly exposed is to take a series of frames at differing exposures, and select the best one later. The D800's bracketing facility allows this to be done very quickly, especially if **CL** or **CH** release mode is selected.

1) Select the type of bracketing required using Custom setting e5. Select "**AE only**" to ensure that only exposure values are varied. If flash is not active, "**AE & Flash**" has the same effect.

2) While pressing the BKT button, rotate the Main Command Dial to select the number of shots required for the bracketing burst. You can choose between 2, 3, 5, 7 and 9 shots; the selected number is displayed in the control panel.

3) Still pressing the **BKT** button, rotate the Sub-command Dial to select the exposure increment between each shot in the sequence. You can choose between ⅓ Ev, ½ Ev or 1 Ev. This increment is also displayed in the control panel. A **BKT** icon is displayed in the control panel and **BKT** blinks in both viewfinder and control panel.

4) Frame, focus and shoot normally. The camera will vary the exposure with each frame until the sequence is completed. A progress indicator is displayed in the

> **Tips**
>
> *The D800 offers other forms of bracketing: choose between them using Custom setting e5. The options are **AE and flash**, **AE only**, **Flash only**, **WB bracketing** and **ADL bracketing**. **AE only** is discussed in detail above. **AE and flash** varies both the exposure and the flash level. **Flash only** varies the flash level without changing the base exposure. **WB bracketing** varies the white balance setting. **ADL bracketing** varies the level of Active D-Lighting applied (see page 72).*

control panel, a segment disappearing as each frame is taken.

5) To cancel bracketing and return to normal shooting, press the **Fn** button and rotate the Main Command Dial until **0F** appears in the control panel. The bracketing increment you chose using the Sub-command Dial will remain in effect next time you initiate bracketing.

If the memory card(s) become full before the sequence is complete, the camera will stop shooting. Replace a card or delete images to make space; the camera will then resume the sequence. If the camera is switched off before the sequence is finished, it will resume when next switched on.

» FOCUSING

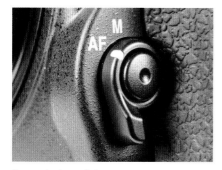

Focus selector switch

The D800's focusing capabilities are as flexible and powerful as its other features. To switch between manual focus and autofocus use the focus selector switch on the front of the camera close to the lens mount. To choose the AF mode, press the AF-mode button, in the center of the focus mode switch, and rotate the Main Command Dial. The viewfinder and Control Panel show which mode is in operation.

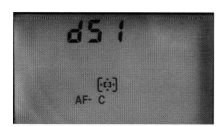

Focus mode selection on control panel

› (S) Single-servo AF

The camera focuses when the shutter release is pressed halfway. Once focus is acquired, the focus indicator (a green dot) shows in the viewfinder. Focus remains locked on this point as long as the shutter release remains partially depressed. By default, the shutter cannot release to take a picture until focus has been acquired (**focus priority**). This can be changed to **release priority** (Custom setting a2), allowing the camera to take a picture even if perfect focus has not been acquired.

› (C) Continuous-servo AF

In this mode, the camera continues to seek focus as long as the shutter release is depressed: if the subject moves, the camera will refocus. The default setting here is **release priority**, allowing the camera to take a picture even if perfect focus has not been acquired. This can be changed to **focus priority**, or to a hybrid setting of **release + focus**, in Custom setting a1.

> ### Tip
>
> *Some lenses have an A/M switch: make sure this is set to M.*

The D800 employs predictive focus tracking; if the subject moves while Continuous servo AF is active, the camera analyzes the movement and attempts to predict where the subject will be when the shutter is released.

> (M) Manual focus

In time-honored fashion, focusing is done manually using the focusing ring on the lens. The D800's sophisticated AF capabilities might seem to make manual focus redundant, but many photographers still appreciate the extra level of control and involvement. Also, certain subjects and circumstances can bamboozle even the best AF systems. The D800's bright, crisp viewfinder makes manual focusing straightforward. The process hardly requires description: set the focus mode selector to **M** and use the focusing ring on the lens to bring the subject into focus.

The electronic rangefinder

When focusing manually, you can still take advantage of the camera's focusing technology thanks to the electronic rangefinder, which confirms when a subject is in focus. Focusing this way can be more precise than just relying on the viewfinder image. It requires a lens of f/5.6 or faster (f/8 when using the central focus points), and light levels that would allow AF to be used.

The rangefinder requires an appropriate focus area to be selected as if you were using one of the AF modes. When the subject in that area is in focus a green dot appears at far left of the viewfinder readout.

> AF-area modes

When using autofocus, the AF-area mode determines which focus point or points the camera will employ. To choose the AF-area mode, press the AF-mode button, in the center of the focus mode switch, and rotate the Sub-command Dial. Control panel and viewfinder icons show which mode you're selecting.

Single-area AF [ɪ]

In this mode, you select the focus area, using the Multi-selector to move quickly through the 51 focus points. The chosen focus point is illuminated in the viewfinder.

This mode is best suited to shooting relatively static subjects.

Dynamic-area AF [⋮⋮]

This mode is more complicated, as it has several sub-modes. These can only be selected when using Continuous-servo AF. Press the AF-mode button, in the center of the focus mode switch, and rotate the Sub-command Dial to page through the options.

In all dynamic-area AF modes, the initial focus point is still selected by the user, as in Single-area AF, but if the subject moves, the camera will then employ other focus points to maintain focus. The sub-mode options determine the number of focus points that will be employed for this: 9, 21 or the full 51 points. The final option is 51 points (3D tracking), which uses a wide range of information, including subject colors, to track subjects that may be moving erratically. As you rotate the Sub-command Dial to make this selection, the viewfinder display briefly illuminates the appropriate focus points (for 3D tracking a stylized "3D" is displayed).

Auto-area AF [■]

This mode makes focus point selection fully automatic; in other words, the camera decides what the intended subject is. The camera employs face-detection technology, and if a human face is detected it will prioritize it for focusing—

which is fine if this is indeed what you want it to do.

› Focus points

The D800's 51 focus points cover the central part of the frame, corresponding almost to the DX crop area. This allows quick and accurate selection to cover most subjects, whether it's a static focus point when using AF-S or the initial focus point when using AF-C. Understandably, you

PRETTY IN PINK ⌄
The ability to select focus points is most helpful with off-center subjects. *200mm, 1/320th sec., f/8, ISO 400.*

2

Focus selector lock

can't manually select the focus point when [■] Auto-area AF is engaged.

Focus point selection

1) Make sure the focus selector lock (which surrounds the Multi-selector) is in the unlocked position (opposite the white dot).

2) Using the Multi-selector, move the focus point to the desired position. The chosen focus point is briefly illuminated in red in the viewfinder and then remains outlined in black. (Illumination can be switched off using Custom setting a5.) Pressing the center of the Multi-selector selects the central focus point.

3) Press the shutter-release button halfway to focus at the desired point; depress it fully to take the shot.

› Focus lock

Though the D800's focus points cover a wide area, they do not extend right to the edges of the frame—unless you're shooting in DX-crop, when they do cover virtually the entire image frame. If you need to focus on a subject that does not naturally coincide with any of the focus points, the simplest procedure is as follows:

1) Adjust framing so that the subject falls within the available focus area.

2) Select an appropriate focus point and focus on the subject in the normal way.

3) Lock focus. In Single-Servo AF mode, this can be done either by keeping half-pressure on the shutter-release button, or by pressing and holding the **AE-L/ AF-L** button. In Continuous-Servo AF, only the **AE-L/AF-L** button can be used to lock focus.

4) Reframe the image as desired and press the shutter-release button fully to

Note:
Custom setting a6 allows you to opt for focus **point wrap-around**, which means that if you move the focus point to the edge of the available area, a further press on the Multi-selector in the same direction takes it to the opposite edge of the area.

» IMAGE QUALITY

take the picture. If half-pressure is maintained on the shutter-release button (in Single-Servo AF), or the **AE-L/AF-L** button is kept under pressure (in either AF mode), focus will remain locked for further shots.

The viewfinder displays the available focus areas as well as an in-focus indicator at the left of the menu bar.

Note:
At its default setting, the **AE-L/AF-L** button locks exposure as well as focus, but this behavior can be changed using Custom setting f7.

Image quality settings are not some miraculous way of ensuring great pictures; that's still ultimately down to the eye of the photographer. "Image quality" refers to the file format, or the way that image data is recorded. The D800 offers a choice of three file types: NEF (RAW), TIFF and JPEG. The essential difference is that TIFF and JPEG files undergo significant processing in-camera to produce files that should be usable right away (for instance, for direct printing from the memory card), without the need for further processing on computer.

› Setting image quality

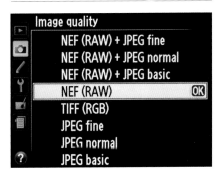

Image quality dialog

There are two ways to set image quality:

1) Hold down the **QUAL** button and rotate the Main Command Dial until

the required setting is displayed in the control panel. This is usually felt to be the easier method.

2) In the Shooting menu, select **Image quality** using the Multi-selector, then highlight and select the required setting.

To determine whether NEF (RAW) files are recorded at 12-bit or 14-bit depth, select **NEF (RAW) recording** in the Shooting menu, then select the desired option.

Tips

Historically TIFF was regarded as giving better quality images than JPEG, but in reality it's hard to detect any difference between TIFF and JPEG Fine. However, TIFF produces much larger files, quickly filling up memory card (and hard disk) space. Unless you have some very specific reason to shoot TIFF, the real choice is between JPEG and RAW. You can always convert JPEGs to TIFFs on the computer if they need editing (see page 232).

NEF (RAW) files record the raw data from the camera's sensor "as is", giving much greater scope for further processing to achieve exactly the desired pictorial qualities. This requires suitable software such as Nikon Capture NX2 or Adobe Photoshop (see Chapter 9, pages 232, 234). RAW or Camera RAW is a generic term for this

kind of file; NEF is a specific RAW file format used by Nikon. NEF files can be recorded in either 12-bit or 14-bit depth. 14-bit files capture four times more color information, but produce larger file sizes, which may mean that the camera takes fractionally longer to write them to the card. Any such slow-down is only likely to be noticeable when shooting at high frame rates.

*As a further refinement, the D800 allows two versions of the same image to be recorded simultaneously, one NEF (RAW) and one JPEG. The JPEG can be used as a quick reference file while the NEF (RAW) version can be processed later for the ultimate result. It's possible to opt for the JPEG version to be saved to one memory card and the RAW version to the other (see **Secondary slot function** in the Shooting menu).*

Image quality options

NEF (RAW) 12- or 14- bit NEF (RAW) files are recorded for the ultimate quality and creative flexibility. There are three further options; compressed, lossless compressed or uncompressed. Select **with NEF (RAW) recording** in the Shooting menu.

TIFF 8-bit uncompressed TIFF files are recorded.

JPEG fine 8-bit JPEG files are recorded with a compression ratio of approximately 1:4; suitable for demanding applications.

JPEG normal 8-bit JPEG files are recorded with a compression ratio of approximately 1:8; suitable for many less critical uses.

JPEG basic 8-bit JPEG files are recorded with a compression ratio of approximately 1:16, suitable for transmission by email or website use but not recommended for printing.

NEF (RAW) + JPEG fine Two copies of the image are recorded simultaneously, one NEF (RAW) and one JPEG.

NEF (RAW) + JPEG normal Two copies of the image are recorded simultaneously, one NEF (RAW) and one JPEG.

NEF (RAW) + JPEG basic Two copies of the image are recorded simultaneously, one NEF (RAW) and one JPEG.

The D800 offers multiple options for both Image area and Image size. It's important to distinguish between them. Image area refers to the portion of the sensor used to capture the image; Image size refers to the pixel count of the final image file.

> ### Image area

The D800 normally captures images using the whole of its 35.9 x 24mm FX format sensor (labelled **36 x 24** for brevity). Alternative settings can be chosen through the Shooting menu: select **Image area**,

then **Choose image area**. The **DX (24 x 16)** setting captures images using the central 24 x 16mm area of the sensor, equivalent to a DX format sensor. This allows the use of DX lenses (see below), and may also be used to achieve a higher frame rate. **5:4 (30×24)** captures images from an area 30mm wide; the 5:4 aspect ratio is closer to many standard print sizes. The **1.2× (30×20)** setting crops the image slightly while maintaining the standard

IN THE FRAME ⌄

The range of possible image area selections, superimposed on the full FX frame.

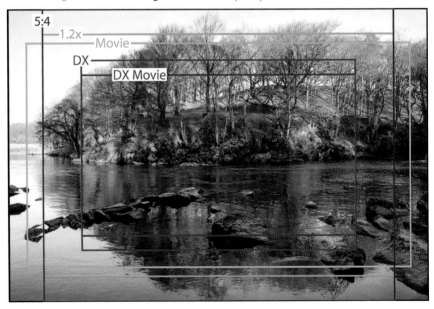

aspect ratio. The viewfinder display adapts to image area selection by showing a heavy outline around the chosen area. The area excluded by the selection can also be shown grayed out, which makes framing easier, but only when **AF point illumination** (Custom Setting a5) is **Off**.

› Using DX lenses

DX lenses are designed for optimum performance with the smaller DX format sensor. They do not cover the full area of the FX format sensor and therefore the corners of the frame are blacked out.

By default, the D800 automatically detects when DX lenses are fitted and sets a DX format crop. This option can be turned off (though most of us will never do so) using the **Auto DX crop** item under **Image area** in the Shooting menu.

Tip

Arguably, the D800 is the first DSLR where DX crop is fully usable; in both overall pixel numbers and pixel size, the images are close to those from the Nikon D7000. DX crop also boosts the effective focal length of your lenses (see page 200), and focus sensors cover nearly the whole DX frame—useful for fast, unpredictable action.

› Image size

At each image area, the D800 offers three options for image size.

When image area is set to FX, **Medium** is roughly equivalent to a 20-megapixel camera. **Small** is roughly equivalent to a 9-megapixel camera. The smaller sizes take up much less space on memory cards and computer hard drives, but in almost every

Image size

Image area	Size (large)	Size (medium)	Size (small)
FX (36 × 24)	7,360 × 4,912	5,520 × 3,680	3,680 × 2,456
5:4 (30 × 24)	6,144 × 4,912	4,608 × 3,680	3,072 × 2,456
1.2× (30 × 20)	6,144 × 4,080	4,608 × 3,056	3,072 × 2,040
DX	4,800 × 3,200	3,600 × 2,400	2,400 × 1,600

respect these images will be far superior to those produced by most smaller cameras. Even Small size images exceed the maximum resolution of almost all computer monitors and are far beyond the (approximately) 2 megapixels of an HD TV. They can yield good quality prints to at least A4 size. However, if you habitually use these image size settings you might have to ask what was the point of buying a 36-megapixel camera in the first place?

Setting image size

There are two ways to set image size:

1) Hold down the **QUAL** button and rotate the Sub-command Dial until the required setting is displayed in the control panel. This is usually felt to be the easier method.

2) In the Shooting menu, select **Image size** using the Multi-selector, then highlight and select the required setting.

> **Note:**
> These options only apply to TIFF and JPEG images; NEF (RAW) files are always recorded at the maximum size for the Image area in use.

» WHITE BALANCE

Light sources, both natural and artificial, vary enormously in color. The human eye and brain compensate for this very well (though not perfectly), seeing objects in their "true" colors under widely varying conditions, so that we nearly always see grass as green, and so on. With film, especially slide film, achieving accurate color often required the careful use of filters. Digital imaging allows extensive compensation for the varying colors of light. Used correctly, the D800 can produce natural-looking colors under almost any conditions you'll ever encounter.

The D800 has a sophisticated system for determining white balance automatically, which produces very good results most of the time. For finer control, or for creative effect, the D800 also offers a wide range of user-controlled settings.

> **Tip**
>
> When shooting RAW, the in-camera WB setting is not crucial, as white balance can be adjusted in post-processing. However, it's still helpful to get it right as it affects how images look on playback and review.

Incandescent

Flash

Cool-white fluorescent

Cloudy

Direct sunlight

Shade

THE RIGHT BALANCE

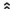

Six otherwise identical shots, taken seconds apart, demonstrate how radically white balance settings can change the overall effect.

> Setting white balance

There are two ways to set white balance:

1) Hold down **WB** and rotate the Main Command Dial until the required symbol is displayed in the control panel.

2) In the Shooting menu, select **White balance** using the Multi-selector, then highlight and select the required setting. In most cases, a graphical display appears, with which you can fine-tune the setting using the Multi-selector. Or just press **OK** to accept the standard value.

When you select **Auto** in the Shooting menu, there are two sub-options: **Normal**, which keeps colors correct as far as possible, and **Keep warm lighting colors**, which does not correct the warm hues generated by incandescent lighting (and could be worth experimenting with for sunsets as well).

When you select **Fluorescent**, a sub-menu appears from which you can select the appropriate variety of fluorescent lamp.

> **Tip**
>
> *Sometimes "correct" color is not desirable. A classic example is shooting landscapes by the warm light of early morning or late evening, where the reddened hue of the sunlight is part of the appeal. Auto White Balance may neutralize this effect. To avoid this, try the Direct sunlight setting, or better still, shoot RAW images.*

Notes:

If you use **WB** and Main Command Dial to select **Fluorescent**, the precise value will be whatever was last selected in the sub-menu under the Shooting menu. (The default is **4: Cool-white fluorescent**).

Energy-saving bulbs, which have extensively replaced traditional incandescent (tungsten) bulbs in domestic use, are compact fluorescent units. Their color temperature varies but many are rated around 2700°K, equivalent to Fluorescent setting **1 Sodium-vapor lamps**. With any unfamiliar light source it's always a good idea to take test shots if possible, or allow for later adjustment by shooting NEF (RAW) files.

Icon	Menu option		Color temperature	Description
AUTO	Auto	Normal Keep warm lighting colors	3500–8000	Camera sets white balance automatically, based on information from imaging and metering sensors. Most accurate with Type G and D lenses.
☀	Incandescent		3000	Use in incandescent (tungsten) lighting, e.g. traditional household lamps.
	Fluorescent:		**Submenu offers seven options:**	
	1 Sodium-vapor lamps		2700	Use in sodium-vapor lighting, often used in sports venues.
	2 Warm-white fluorescent		3000	Use in warm-white fluorescent lighting.
	3 White fluorescent		3700	Use in white fluorescent lighting.
☀	4 Cool-white fluorescent		4200	Use in cool-white fluorescent lighting.
	5 Day white fluorescent		5000	Use in daylight white fluorescent lighting.
	6 Daylight fluorescent		6500	Use in daylight fluorescent lighting.
	7 High temp. mercury-vapor		7200	Use in high color temperature lighting, e.g., mercury vapor lamps.
☀	Direct sunlight		5200	Use for subjects in direct sunlight.
⚡	Flash		5400	Use with built-in flash or separate flashgun. Value may require fine-tuning with large-scale studio flash.
☁	Cloudy		6000	Use in daylight, under cloudy/overcast skies.
⌂	Shade		8000	Use on sunny days for subjects in shade.
K	Choose color temp.		2500–10,000	Select color temperature from list of values.
PRE	Preset Manual		n/a	Derive white balance direct from subject or light-source, or from an existing photo.

» ISO SENSITIVITY SETTINGS

You can set the white balance to precisely match any lighting conditions, by taking a reference photo of a neutral white object. Frankly, this is a complicated procedure that few of us will ever employ (see the Nikon Reference manual for details; it takes three full pages). It's normally much easier to shoot RAW and tweak the white balance later; a reference photo can also be helpful for this when high precision is required. The RAW route is not only easier in itself, it avoids the pitfall that the Preset Manual setting will go on being applied to shots when it's no longer appropriate.

The ISO sensitivity setting governs the sensor's response to greater or lesser amounts of light. At higher ISO settings, less light is needed to capture an acceptable image. As well as accommodating lower light levels, higher ISO settings are also useful when you need to use a small aperture for increased depth of field *(see page 125)* or to use a fast shutter speed to freeze rapid movement *(see page 128)*. Conversely, lower ISO settings are useful in brighter conditions,

> ### Tip
>
> *The endpapers of this book are designed to serve as "gray cards", ideal for reference photos for both these purposes.*

NIGHT TRAM »
To shoot this Helsinki tram at night (even on a light night in high summer) demanded a high ISO setting. *80mm, 1/60th sec., f/4, ISO 1600.*

and/or when you want to use wide apertures or slow shutter speeds.

The D800 offers ISO settings from 100 to 6400. Image noise inevitably increases at higher settings, though the D800 manages it very well. In addition there are **Hi** and **Lo** settings outside the standard range, but it's recommended that these are used with caution. There are Lo settings of **Lo0.3** (equivalent to 80 ISO), **Lo0.7** (equivalent to 64 ISO) and **Lo1.0** (equivalent to 50 ISO). The Hi settings are **Hi0.3** (equivalent to 8000 ISO), **Hi0.7** (equivalent to 10000 ISO), **Hi1.0** (equivalent to 12,800 ISO) and **Hi2** (equivalent to 25,600 ISO).

Tip

The higher ISO speeds represent a real alternative to using flash under most conditions, but increased image noise will undoubtedly take the edge off the D800's ability to capture super-fine detail. Viewed at 100%, images may appear pretty dreadful; this is a good time to remember that 100% "pixel peeping" is not normal viewing and images may still be perfectly acceptable for full-screen viewing and printing at a large size. Experiment with these settings to see what level of image noise is acceptable for your needs.

› Setting ISO

The most convenient way to set the ISO is normally by pressing **ISO** and rotating the Main Command Dial until the desired setting is shown in the control panel and viewfinder. Alternatively, use the **ISO sensitivity settings** item in the Shooting menu. **Easy ISO** is another option. If enabled in Custom setting d3, this allows the ISO to be set simply by rotating the Main Command Dial (in Aperture-priority mode) or Sub-command Dial (in Shutter-priority or Program mode).

Auto ISO

The **ISO sensitivity settings** item in the Shooting menu has a sub-menu called **Auto ISO sensitivity control**. If this is set to **ON**, the D800 will automatically depart from the ISO you have selected if it determines that this is required for correct exposure. Extra options within this menu allow you to limit the maximum ISO and minimum shutter speed which the camera can employ when applying Auto ISO sensitivity control.

The **Minimum shutter speed** sub-menu governs the shutter speed which the camera can set in P and A modes; in M and S modes, you set the shutter speed yourself. The **Auto** setting attempts to avoid camera shake *(see page 130)* by setting a minimum speed value based on the focal length of the lens in use.

» COLOR SPACE

The D800 offers a choice between sRGB and Adobe RGB color spaces; these define the range (or gamut) of colors which are recorded. To select the color space, use the **Color space** item in the Shooting menu.

sRGB (the default setting) has a narrower gamut but images often appear initially brighter and more punchy. It's typically used, for example, on the Internet and in photo printer stores. It is a safe choice for images that will be used or printed straight off, with little or no later processing, and for images destined solely for online use.

Adobe RGB has a wider gamut and is commonly used in professional printing and reproduction. It's a better choice for images that are destined for professional print applications or where significant post-processing is anticipated.

» TWO-BUTTON RESET

The D800 offers a quick way to reset the following camera settings to default values.

› To carry out two-button reset

Hold down **QUAL** and 🔲 buttons (marked with green dots) together for at least 2 seconds. The control panels will blank out briefly while the reset is completed.

> **Note:**
> Two-button reset only affects settings in the current Shooting menu bank. Other banks remain unaffected *(see page 82)*.

Default setting

Focus point	Center
Exposure mode	(P) Programmed auto
Flexible program	Off
Exposure compensation	Off
AE lock hold	Off
Aperture lock	Off
Shutter-speed lock	Off
Bracketing	Off
AF mode	AF-S
AF-area mode	Viewfinder: single-point AF Live View and Movie: Normal-area AF
Flash mode	Front-curtain sync
Flash compensation	Off
FV lock	Off
Exposure delay mode	Off
+ NEF (RAW)	Off
Image quality	JPEG Normal
Image size	Large
White balance	Auto (Normal)
Picture Control	Current Picture Control reset to base settings
HDR	Off
ISO sensitivity	100
Auto ISO	Off
Multiple Exposure	Off
Interval timer shooting	Off

2 » LIVE VIEW

Live View activation switch

Until now, Live View on a DSLR has been seen as an adjunct to the viewfinder, not a substitute for it. The SLR is essentially designed around the viewfinder and it still has many advantages for the majority of picture-taking; it's more intuitive and offers the sense of a direct connection to the subject, carries much less risk of camera shake, and viewfinder-based autofocus is faster.

However, the D800 changes the equation, at least for those who really aim to exploit its massive resolution to the fullest extent. Such critical users will use tripods more regularly, and using a tripod removes much of the ergonomic benefit of using the viewfinder. Also, Live View focusing, though it's slower than when using the viewfinder, is more precise.

Live View is also the jumping-off point for shooting movies with the D800. Movies are covered in Chapter 6 *(see page 182)*. However, familiarity with Live View gives you a head start when you first move into shooting movies.

Live View info	Details
Information on	Information bars superimposed at top and bottom of screen.
Information off	Top information bar disappears, key shooting information still shown at bottom.
Framing guides	Grid lines appear, useful for critical framing.
Histogram	(Available in exposure preview only.)
Virtual horizon	Displays a horizon indicator on the monitor to assist in leveling the camera.

› Using Live View

To activate Live View, make sure the **Lv** switch on the rear of the camera is set to the 📷 still photography position. Press the button at its center to start shooting. The mirror flips up, the viewfinder blacks out, and the rear monitor screen displays a continuous live preview of the scene.

Press the release button halfway to focus, fully to take a picture, as when shooting normally. If you're shooting in CH or CL release mode, the mirror stays up, and the monitor remains blank between shots, making it hard to follow moving subjects. To exit Live View press the **Lv** center button again.

A range of shooting information is displayed at the top and bottom of the screen, partly overlaying the image. Pressing **INFO** changes this information display, cycling through a series of screens as shown in the table.

› Exposure preview

Normally the Live View display shows the scene at normal brightness, just as the viewfinder does. However, the D4 and D800 are the first Nikon DSLRs to give you the option of a live preview, showing the effect of current exposure settings on the final image. To activate this preview, simply

Display options include a "live" histogram.

press **OK** during Live View shooting. If the results look under- or overexposed, you can use Exposure Compensation *(see page 43)* to rectify matters. (In Mode M, just adjust aperture, shutter speed or ISO.)

There are some limitations: for obvious reasons, the preview can't show what the results will be if you're planning to use flash for the actual shot, or if bracketing is in effect. It may also be less than 100% accurate if Active D-Lighting or HDR are being used.

› Screen brightness and hue

Screen brightness and hue (color balance) can be adjusted in Live View. These adjustments only affect the screen image—they have no effect on the exposure level or white balance of the actual images you shoot. Hue adjustment is mainly useful if you're shooting with flash, as the color balance of the flash may be very different from the ambient light you're using to view and frame the shot.

Press and hold ⊖✎ and use ◀/▶ to toggle between the hue indicator (on the left: labelled **Lv WB**) and brightness (on the right). If Exposure Preview is On, you can still adjust hue but not brightness.

› Focusing in Live View

Focusing in Live View operates differently from normal shooting because the mirror is locked up, the usual focusing sensors are unavailable. Instead, the camera takes its focus information directly from the main

image sensor. This is significantly slower than normal AF operation—so Live View is often unsuitable for fast-moving subjects—but it is very accurate. You can zoom in on the scene for a critical focus check: this can be extremely useful when ultra-precise focusing is required, as in macro work. However, it all means that Live View has its own set of autofocus options. There are two AF modes and four AF-area modes.

Live View AF mode

The AF-mode options are Single-servo AF (AF-S) and Full-time servo AF (AF-F). AF-S corresponds to AF-S in normal shooting: the camera focuses when the shutter release is pressed halfway, and focus remains locked as long as the shutter release remains depressed.

AF-F corresponds roughly to AF-C in normal shooting. The camera continues to seek focus as long as Live View remains active. When the shutter-release button is pressed halfway the focus will lock, and remains locked until the button is released, or a shot is taken. Select the Live View AF mode as follows:

1) Activate Live View.

2) Press the AF-mode button (center of the focus selector) and use the Main

RED SQUARE　　　　　　　　　　》
The focus area (a red rectangle, which turns green when focus is acquired) can be positioned anywhere on screen.

AF Mode	Description
〔◉〕 Face priority	Uses face detection technology to identify portrait subjects. Double yellow border appears outlining such subjects. If multiple subjects are detected, the camera focuses on the closest.
〔≡〕 WIDE Wide-area	Camera analyzes focus information from area approximately ⅛ th the width and height of the frame; area is shown by red rectangle.
〔≡〕 NORM Normal area	Camera analyzes focus information from a much smaller area, shown by red rectangle. Useful for precise focusing on small subjects.
〔◉〕 Subject tracking	Camera follows selected subject as it moves within the frame

Command Dial to toggle between AS-F and AF-F, highlighted in yellow on the monitor screen.

Live View AF-area mode

AF-area modes determine how the focus point is selected. Live View AF-area modes do not correspond to the ones used in normal shooting. See the table for details of the four Live View AF-area modes.

Select the Live View AF-area mode as follows:

1) Activate Live View.

2) Press the AF-mode button (center of the focus selector) and use the Sub-command Dial to select the AF-area mode (highlighted in yellow) on the monitor screen.

Using Live View AF
〔≡〕 WIDE Wide-area AF and 〔≡〕 NORM Normal area AF

In both these AF-area modes, the focus point (outlined in red) can be moved anywhere on the screen, using the Multi-selector in the usual way. Pressing 🔍 zooms the screen view—press repeatedly to zoom closer. Helpfully, this zoom centers on the focus point. This gives ultra-precise focus control, which is ideal for macro photography (see page 174). Once the focus point is set, autofocus is activated as normal by half-pressing the shutter-release button. The red rectangle turns green when focus is achieved.

Tip

The ability to move the focus point anywhere on screen is useful for off-center subjects, especially when using a tripod. In normal handheld shooting it's generally quicker and easier to use the viewfinder and employ focus lock (see page 50).

Face-priority AF

When this mode is active, the camera automatically detects up to 35 faces and selects the closest. The selected face is outlined with a double yellow border. You can focus on a different person by using the Multi-selector to shift the focus point to a different face.

IVY LEAGUE

Normal area AF is the best choice for precision and accuracy, for instance when depth of field is minimal. *56mm, 1/50th sec., f/8, ISO 200, tripod.*

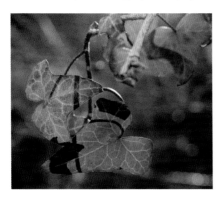

Warning!

Subject tracking isn't fast enough for fast-moving subjects. Viewfinder shooting is more effective for these.

Subject tracking

When Subject tracking is selected, a white rectangle appears at the center of the screen. Align this with the desired subject using the Multi-selector, then press ⊙. The camera "memorizes" the subject and the focus target turns yellow. It will track the subject, and can even reacquire it if it temporarily leaves the frame. To focus, press the shutter-release button halfway; the target rectangle blinks green and then becomes solid green as the camera focuses. If the camera fails to focus the rectangle blinks red. Pictures can still be taken but focus may not be correct. To end focus tracking press ⊙ again.

Manual focus

Manual focus is engaged with M as in normal shooting *(see page 48)*. However the Live View display continues to reflect the selected Live View AF mode. It's helpful to have Wide-area AF or Normal-area AF selected, as the display still shows a red rectangle of the appropriate size. If you zoom in for more precise focusing, the zoom centers on the area defined by the rectangle. You can scroll to any point on the screen using the Multi-selector.

» IMAGE PLAYBACK

The D800's large, bright, high-resolution LCD screen makes image playback both pleasurable and highly informative. As with the D4, the screen is a fraction larger than on earlier models, but more importantly it has a wider color gamut, close to the sRGB color space, which means that the monitor image gives an excellent indication of how the final image will look on a computer screen or in print.

If **Image review** in the Playback menu is **On**, the most recent image is automatically displayed immediately after shooting, as well as whenever ▶ is pressed. (If **CH** or **CL** release modes are in use, playback begins after the last image in a burst has been recorded.)

› Viewing additional pictures

To view images on the memory card, other than the last one taken, scroll through them using the Multi-selector. Scroll right to view images in the order of capture, scroll left to view in reverse order ("go back in time").

› Viewing photo information

The D800 records masses of information about each image taken, and this can also be viewed on playback—up to seven pages of information can be displayed. The Multi-selector is used to scroll between them. For full description see **Playback display options** in the Playback menu *(see page 78).*

› Highlights

When in full-frame playback, the D800 can be set to display a flashing warning over any areas of the image with "clipped" highlights, i.e. areas that are completely white with no detail recorded *(see page 146).* This is another way of obtaining a quick check that an image is correctly exposed, and more objective than just relying on a general impression of the image on the monitor.

SURF'S UP ⩒
The highlight display was useful in ensuring that there was minimal clipping in the backlit water. *200mm, 1/1600th sec., f/10, ISO 100.*

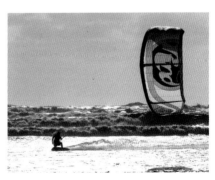

› Playback zoom

To assess sharpness, or for other critical viewing, it's possible to zoom in on a section of an image.

1) Press the \oplus button to zoom in on the image currently displayed (or the selected image in thumbnail view). Press repeatedly to increase the magnification. A small navigation window appears briefly, with a yellow outline indicating the area currently visible in the monitor.

2) Use the Multi-selector to view other areas of the image, scrolling in any direction, including diagonally. Again, the small navigation window appears briefly as you scroll.

3) Rotate the Main Command Dial to view corresponding areas of other images at the same magnification.

4) To return to full-frame viewing, press **OK**.

Maximum magnification is reached after 11 presses, but the last two stages are pixelated and of debatable value. Even pressing nine times is a tedious process, so it's useful to know that you can enable a shortcut. Do this through Custom setting f2 **Multi selector center button**: select **Playback mode**, then **Zoom on/off.** There's a further choice between **Low**, **Medium** and **High magnification**.

Medium equates to nine presses on \oplus, making it the obvious choice. The zoom display centers on the focus point which was active when the picture was taken. Pressing the center button again reverts to full-frame playback.

› Viewing images as thumbnails

To view multiple images, press \ominus▣ repeatedly to display 4, 9 or 72 images. Use the Multi-selector to scroll up and down to bring other images into view. The currently selected image is outlined in yellow. To return to full-frame view, press **OK**.
Memory card selection
 A small icon at bottom left on the playback screen shows which memory card slot is being used for playback. To switch between card slots, display 72 images as above, then press \ominus▣ again to show a dialog which allows you to select the memory card. If there are multiple folders on the card(s) you can also use this dialog to choose between them.

Note:
To conserve the battery, the monitor will turn off automatically after a period of inactivity. The default period is 10 seconds but intervals from 4 seconds to 10 minutes can be set using Custom setting c4.

› Deleting images

To delete the current image, or the selected image in thumbnail view, press 🗑. A confirmation dialog appears. To proceed with deletion press 🗑 again. To cancel, press ▶.

› Protecting images

To protect the current image or the selected image in thumbnail view against accidental deletion, press 🔑. To remove protection, press 🔑 again.

› Histogram displays

The histogram is a graphic depiction of the distribution of dark and light tones in an image. As a way of assessing if an image is correctly exposed it's much more precise than just looking at the full-frame playback, especially in bright conditions, which make it hard to see the screen image clearly. A single histogram is always available during playback, in the overview

Tip

Protected images will be deleted when the memory card is formatted.

page. By selecting **Playback display options** in the Playback menu and checking **RGB histogram**, you gain access to a more detailed display which shows individual histograms for the three color channels (red, green and blue). The histogram display is arguably the most useful single feature of image playback and it's certainly the one that I view most often. Learning to interpret the histogram is key to getting the best results from your D800, as it reveals a great deal both about overall exposure and about shadow and/or highlight clipping *(see page 146).*

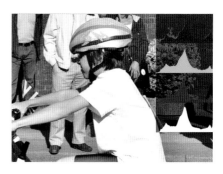

MAKING HISTOGRAM »
A fairly typical RGB histogram. This is taken from Nikon View NX2, but the principles are exactly the same. It shows a good spread of tones from dark to light, and small differences between the red, green and blue color channels, but there is some highlight clipping, indicated by a spike at extreme right.

2 » IMAGE ENHANCEMENT

The D800 provides powerful facilities for you to adjust and enhance images in various ways in-camera. It's crucial to distinguish between adjustment options which are applied before shooting an image, and changes which can be made to images already on the memory card. In particular, confusion could arise between the similarly-named Active D-Lighting (applied before shooting) and D-Lighting (applied after shooting). D-Lighting, and various other adjustments which can be applied to images which are already on the memory card, are accessed from the Retouch menu *(see page 112)*.

Note:
These settings are useful for improving the quality of TIFF and JPEG images. Although they can be accessed while shooting NEF (RAW) files, they have no effect on the basic raw data. Picture Control settings can be subsequently applied to NEF (RAW) files when they are opened using Nikon View NX or Nikon Capture NX software. However, other manufacturers' software will not recognize them. These settings also affect the appearance of review and playback images on the monitor, even when the base image is RAW.

› Pre-shoot controls

Of course all the regular user-controlled settings—exposure, white balance, and so on—affect the qualities of the final image. However the Nikon D800 provides yet more ways to control the qualities of the final image. There are two main ways to do this—Active D-Lighting and Nikon Picture Controls.

› Active D-Lighting

Active D-Lighting is designed to enhance the D800's ability to capture detail in both highlights and shadows, where scenes show a wide range of brightness (dynamic range). In simple terms, it reduces the overall exposure in order to improve capture in the brightest areas, while mid-tones and shadows are subsequently lightened as the camera processes the image. Because of its effect on the overall exposure, it does have an impact on RAW files too.

1) In the Shooting menu, select **Active D-Lighting**.

2) From the available options, select **Off**, **Low**, **Normal**, **High**, **Extra high** or **Auto** to determine the strength of the effect. Press **OK**.

› Nikon Picture Controls

Picture Controls allow the user to determine how JPEG and TIFF images will be processed in the camera. The D800 offers six pre-loaded Picture Controls: **Standard**, **Neutral**, **Vivid**, **Monochrome**, **Portrait** and **Landscape**—all fairly self-explanatory. Each has preset values for **Sharpening**, **Contrast** and **Brightness**. For color images, there are also settings for **Saturation** and **Hue**; the Monochrome Picture Control has **Filter effects** and **Toning** instead.

It's possible to fine-tune the values of the various settings within each Picture Control. You can also create and save your own custom Picture Controls, and further ready-made Picture Controls are available for download from Nikon websites.

TAKING CONTROL ⌄
The same subject shot using Neutral (L) and Vivid (R) Picture Controls.

Selecting Nikon Picture Controls

1) From the Shooting menu, select Set Picture Control.

2) Use the Multi-selector to highlight the required Picture Control and press **OK**.

In Live View there's quick access to Picture Controls by pressing ⊡.

Modifying Picture Controls

Both pre-loaded Nikon Picture Controls and custom Picture Controls from other sources can be changed in-camera. Use Quick Adjust to make across-the-board changes or to adjust specific parameters (such as Sharpening and Contrast).

1) From the Shooting menu, select **Set Picture Control**.

2) Use the Multi-selector to highlight the required Picture Control and press ▶.

3) Scroll with the Multi-selector to select **Quick Adjust** or a specific parameter. Use ▶ or ◀ to change the value.

4) When all parameters are as required, press **OK**. The modified values are retained until that Picture Control is modified again, or reset to default.

> **Note:**
> You can exit this process at any time by pressing **MENU**. The new settings will not be saved.

Creating Custom Picture Controls

You can create up to nine additional Picture Controls, either in-camera or using the Picture Control Utility included with Nikon View NX. Custom Picture Controls can also be shared with other Nikon DSLRs. For further details see the D800 manual and the Help pages within Picture Control Utility.

Creating Custom Picture Controls in-camera

1) From the Shooting menu, select **Manage Picture Control**.

2) Select **Save/edit** and press ▶.

3) Use the Multi-selector to highlight an existing Picture Control and press ▶.

4) Edit the Picture Control (as described above under Modifying Picture Controls). When all parameters are as required, press **OK**.

5) On the next screen, select a destination for the new Picture Control. By default, the new one takes its name from the existing Picture Control on which it is based, with the addition of a two-digit number (e.g. VIVID-02) but you can give it a new name (up to 19 characters long) using the Multi-selector to select text. *(For more on text entry see page 83.)* Finally, press **OK** to store the new Picture Control.

» HDR

The D800 can create high dynamic range (HDR) images (TIFF or JPEG) in-camera by merging two separate shots of different exposures, one for shadows and one for highlights. HDR can be combined with Active D-Lighting for even greater range.

1) From the Shooting menu, select **HDR** (not available if Image quality is set to **RAW**). Select **HDR mode** and press ▶.

2) Select **On (series)** to take a series of HDR images. Select **On (single photo)** to take just one. An HDR icon appears in the control panel.

3) Choose the exposure differential. **Auto** determines this automatically, or you can select **1Ev**, **2Ev** or **3Ev**.

4) Choose the smoothing level. This influences the blending between the two source images. If extraneous bright or dark "halos" appear in the final image, try again with a higher smoothing level.

5) Shoot as normal. The camera will automatically shoot two images in quick succession. It then combines them and displays the results. During this interval **Job Hdr** appears in the viewfinder and you can't take further shots.

6) If you selected **On (single photo)** at step 2, HDR shooting is automatically canceled. To shoot more HDR images, repeat the process from Step 1.

DYNAMIC RANGE ⌃
An HDR image (above) and two (simulated) source frames (left).

2 » USING D800 MENUS

Though numerous, the options that you can access through buttons and command dials are little more than the tip of the iceberg. By delving into its menus, you can customize almost every aspect of the D800 and make it exactly the camera you want it to be. There are six main menus: Playback menu, Shooting menu, Custom Setting menu, Setup menu, Retouch menu and My Menu. There isn't a separate Help menu as such; instead you can access help from within the other menus by pressing the [⊙┐] button. Help information is available when a **?** icon appears in the bottom left corner of the monitor.

The Playback menu is outlined in blue and is used to control functions related to playback, including viewing, naming or deleting images. The Shooting menu is outlined in green and is used to control shooting settings, such as ISO speed or white balance (most of these are also accessible via buttons and dials) as well as Picture Controls and Active D-Lighting. The Custom Setting menu is outlined in red and is where you can fine-tune and personalize many aspects of the camera's operation. The Setup menu is outlined in orange and is used for a range of other functions such as LCD brightness, language and time settings. The Retouch menu is outlined in purple and is used to create modified copies of images already on the

memory card. Finally, My Menu is outlined in gray; it is a handy place to store items from the other menus that you find yourself using regularly, and can also become a Recent Settings menu.

› Navigating menus

The general procedure is as follows:

1) To display the menu screen, press **MENU**.

2) Scroll up or down with the Multi-selector to highlight the different menus in the left-hand column. To enter the desired menu, press ▶ or **OK**.

3) Scroll up or down with the Multi-selector to highlight the different menu items. To select a particular item, press ▶ or **OK**. In most cases this will take you to a further set of options.

4) Scroll up or down with the Multi-selector to choose the desired setting. To select, press ▶ or **OK**.

5) To return to the previous screen, press ◀ or press **MENU**. To exit the menus completely without effecting any changes, semi-depress the shutter-release button.

» PLAYBACK MENU

The D800's Playback menu contains options which affect how images are viewed, stored, deleted and printed. It is only accessible when a memory card is present in the camera.

› Delete

This function allows images stored on the memory card to be deleted, either singly or in batches.

1) In the Playback menu, highlight **Delete** and press ▶.

2) In the menu options screen, choose **Selected**. Images in the active playback folder or folders (see next page) are displayed as thumbnail images.

3) Use the Multi-selector to scroll through the displayed images. Press and hold the ⊕ button to view the highlighted image

Tip

Individual images can also be deleted when using the Playback screen, and this is usually more convenient (see page 71).

full-screen. Press 🔘 to mark the highlighted shot for deletion. It will be tagged with a 🗑 icon. If you change your mind, highlight a tagged image and press 🔘 again to remove the tag.

4) Repeat this procedure to select further images. (To exit without deleting any images, press **MENU**.)

5) Press **OK** to see a confirmation screen. Select **YES** and press **OK** to delete the selected image(s); to exit without deleting any images, select **NO**.

› Delete all

1) To delete all images on a card, highlight **Delete** and press ▶.

2) In the menu options screen, choose which card slot's images you wish to delete.

3) Press ▶ or **OK** to see a confirmation screen. Select **YES** and press **OK** to delete all image(s); to exit without deleting any images, select **NO**.

› Playback folder

By default, the D800's playback screen will only display images created on the D800: if a memory card is inserted which contains images captured on a different model of camera (even another Nikon DSLR) they will not be visible. This can be changed using this menu.

› Hide image

Hidden images are protected from deletion and cannot be seen in normal playback; the only way they can be seen is through this menu.

1) In the Playback menu, highlight **Hide image** and press ▶. (The other option is **Deselect all?**)

2) In the menu options screen, choose **Select/set**. Images in the Active playback folder or folders are displayed as thumbnails.

3) Use the Multi-selector to scroll through the displayed images. Press and hold the 🔍 button to view the highlighted image

Note:
The current (or Active) folder is chosen through the Shooting menu *(see page 82).*

full-screen. Press 🔘 to mark the highlighted shot to be hidden. It will be tagged with a 🔲 icon. If you change your mind, highlight a tagged image and press the center of the Multi-selector again to remove the tag.

4) Repeat this procedure to select further images. (To exit without hiding any images, press **MENU**.)

5) Press **OK**.

› Playback display options

This is an important menu as it enables you to choose what information about each image will be displayed on playback, over and above the basic info screen that is always available. *See page 69* for more on image playback. To make checked options in this menu effective, scroll up to **Done** at the top of the screen and then press **OK**.

Playback folder options

ND800 (default)	Displays images in all folders created by the D800.
All	Displays images in all folders on the memory card.
Current	Displays images in the current folder only.

Playback pages	Selection	Details
File information	Always available	Displays large image, basic file info displayed at bottom of screen.
None (image only)	Playback menu> Playback display options> image only	Displays large image with no other data.
Overview data	Always available	Displays small image, simplified histogram, summary information. Focus point used can also be shown: select using **Playback display options >Playback display options>Focus point**.
GPS data	Only appears when a GPS device was attached during shooting. *(see page 238)*.	
Shooting data (3 or 4 pages)	Playback menu> Playback display options> Data	Pages 1–3 are always available. Page 4 only appears when Copyright Information is recorded *(see page 109)*.
RGB histogram	Playback menu> Playback display options> RGB histogram	See opposite.
Highlights	Playback menu> Playback display options> Highlights	See opposite.

2

› Copy image(s)

This menu item allows image(s) recorded on one memory card to be copied to the other card (assuming both card slots are occupied, and there is space on the destination card). **Select source** determines which card images will be copied from: the other card then automatically becomes the destination. **Select image(s)** allows individual images or entire folders to be selected for copying. **Select destination folder** determines which folder on the destination card will be used (you can also create a new folder).

Tip

It's certainly worth backing up precious images, but this is a slow way to do it. If you find yourself using this item repeatedly, consider enabling automatic backup of all images as they are taken (see Secondary slot function in the Shooting menu).

› Image review

If Image review is **ON**, (the default setting), images are automatically displayed on the monitor after shooting. If Image review is **OFF**, they can only be displayed by pressing the ▶ button. This helps economize battery power.

› After delete

This enables you to determine "what happens next" after an image is deleted (in normal playback, not via the Delete menu). **Show next** means that the next image in the order of shooting will be displayed. **Show previous** means that the previous image in the order of shooting will be displayed. **Continue as before** means that the next image to be displayed is determined by the order in which you were viewing images before deleting; so if you were scrolling back through the sequence, the previous image will be displayed, and vice versa.

› Rotate tall

Rotate tall enables you to display portrait format ("tall") images the "right way up" during playback. If set to **OFF**, which is the default, these images will not be rotated, meaning that you need to turn the camera 90° to view them correctly. If set to **ON**, these images will be displayed in correct orientation but they will appear smaller.

› Slide show

This enables you to display images in a slide show on the monitor or an external device such as a TV. All the images in the selected folders (under the Playback Folder menu) will be played in chronological order.

1) In the Playback menu, select **Slide show**.

2) Select **Image type**. Choose between **Still images and movies**, **Still images only, Movies only**. Press **OK**.

3) Select **Frame interval**. Choose between intervals of 2, 3, 5 or 10 seconds. Press **OK**.

4) Select **Start** and press ▶ or **OK**.

5) When the show ends, a dialog screen is displayed. Select **Restart** and press **OK** to play again. Select **Frame interval** and press **OK** to return to the Frame interval dialog. Select **Exit** and press **OK** to exit.

6) If you press **OK** during the slide show, the slide show is paused and the same screen is displayed. The only difference here is that if you select **Restart** and press **OK**, the show will resume where it left off.

› Print set (DPOF)

This allows you to select image(s) to be printed when the camera is connected to, or the memory card is inserted into, a suitable printer, i.e. one that complies with the DPOF (Digital Print Order Format) standard. (For more on printing *see page 226*, Chapter 9 Connection and care.)

1) In the Playback menu, highlight **Print set (DPOF)** and press ▶.

2) In the menu options screen, choose **Select/set**. JPEG and TIFF images in the Active playback folder or folders are displayed as thumbnails.

3) Use the Multi-selector to scroll through the displayed images. Press and hold the ⊕ button to view a highlighted image full-screen.

4) Press the ⊕☒ button and then ▲ to select the image to be printed as a single copy. It will be tagged with a 凸 icon and the number **01**. To print more than one copy, keep pressing the ⊕☒ button and press ▲ as many times as necessary; the number displayed increases accordingly. If you change your mind, highlight a tagged image and press the center of the Multi-selector again to remove the tag.

5) Repeat this procedure to select further images. (To exit without tagging any images, press **MENU**.) When all the desired images have been selected, press **OK**.

6) From the confirmation screen select **Print shooting data** if you wish shutter speed and aperture to be shown on all pictures printed. Select **Print date** if you wish the date of the photo to be shown. When you're ready to confirm the order, select **Done** and press **OK**.

> **Note:**
> NEF (RAW) images cannot be selected for printing by this method.

2 » SHOOTING MENU

SHOOTING MENU

Shooting menu bank	A
Extended menu banks	ON
Storage folder	100
File naming	D8C
Primary slot selection	⬜CF
Secondary slot function	⬜+⬜
Image quality	RAW
Image size	⬜

The Shooting menu contains numerous options, but many of these are also accessible through button and dial and have already been discussed, so can be dealt with briefly here.

› Shooting menu bank

This is a handy way to store particular combinations of Shooting menu settings which you use repeatedly. This saves having to make all those changes individually. For instance, I might create a "Landscape" menu bank which sets **Image Quality** to NEF (RAW), **NEF (RAW) recording** to 14-bit, **White Balance** to Direct Sunlight and **ISO setting** to 100, which are my usual settings for landscape photography. I can then reset the camera to these parameters at any time with a single visit to the Shooting menu. You can create up to four menu banks for different shooting requirements.

Note:
Shutter speed is recorded only for Shutter Priority and Manual modes; aperture is recorded only for Aperture Priority and Manual modes.

Extended menu banks

Normally, your choice of exposure mode, shutter speed and aperture is not included in the settings saved in shooting menu banks. By switching to Extended menu banks you can ensure that these are included. You might not wish to do this for, say, landscape photography, where light levels are highly variable, but it would be handy if you regularly visit certain venues (such as sports halls) where the light levels are consistent. Selecting the appropriate menu bank would then instantly recall settings which you've previously found to work well in that venue.

To create a Shooting menu bank

1) In the Shooting menu, select **Shooting menu bank** and press **OK** or ▶.

2) Select one of the four available banks, by default named **A**, **B**, **C** and **D**, and press **OK** or ▶. The normal Shooting menu screen now appears. If Shooting menu bank A has not been used previously it will show the current settings; the others

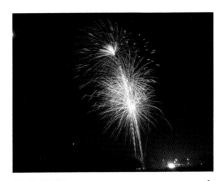

FIREWORKS ⌃
Certain basic settings are nearly always suitable for fireworks displays—or, at least, a good starting point. Extended Menu Banks make it easy to retrieve these (ISO 100, Mode M, shutter speed B, aperture f/16).

remain at default settings until used. Make any desired changes and then exit by pressing **Menu**. If desired, rename the selected bank as follows.

Renaming a Shooting menu bank

1) In the Shooting menu, select **Shooting menu bank** and press **OK** or ▶.

2) Select **Rename** and press ▶.

3) Use the Multi-selector to navigate through the "keyboard" that appears. To use the highlighted character press the center of the Multi-selector. To make corrections, move the cursor by holding ⊖ and then pressing ◄ or ▶ to position the cursor, then press 🗑 to delete a character from the string. Names can be no more than 20 characters long.

Note:
Shooting menu banks are still shown by the letters **A**, **B**, **C** and **D** in the main Shooting menu screen, but new names will be shown in the **Shooting menu bank** menu.

4) To exit and save the new name press **OK**. To exit without saving, press **MENU**.

To use a Shooting menu bank

1) In the Shooting menu, select **Shooting menu bank** and press **OK** or ▶.

2) Select one of the four available banks and press **OK**.

› Storage folder

By default the D800 stores images in a single folder (named "100ND800"). If multiple memory cards are used they will all end up holding folders of the same name. This isn't usually a problem but a few users might wish to avoid it. You might also want to create specific folders for different shoots or different types of image. For instance, you could create a folder linked to a "Landscape" Shooting menu bank.

However, you can't give these folders any name you like: only the first three digits of the name are editable and only numbers can be used.

To create a new folder number

1) In the Shooting menu, select **Active folder** and press **OK** or ▶.

2) Select **Select folder by number** and press **OK** or ▶.

3) Edit the three-digit number: press ◀ or ▶ to highlight a digit, ▲ or ▼ to change it. (If the indicated number is already in use, a "blocked folder" icon appears and a new folder will not be created.)

4) Press **OK** to create the new folder and return to the Shooting menu. It automatically becomes the active folder.

To change the active folder

1) In the Shooting menu, select **Storage folder** and press **OK** or ▶.

2) Select **Select folder** from list and press **OK** or ▶. To exit without making a change, press **MENU**.

File naming

By default image files are named as follows: if Color space is set to sRGB, the name begins DSC_; if Color space is set to AdobeRGB, the name begins _DSC. This is followed by a four-digit number and a three-letter extension (e.g. .JPG for JPEG files, .MOV for movies). You can edit the initial three-letter string if desired, for instance replacing it with your initials, so that instead of files being DSC_4567.JPG they could be CJS_4567.JPG.

To edit the file-naming string

1) In the Shooting menu, select **File naming** and press **OK** or ▶.

2) In the new screen, select **File naming** and press **OK** or ▶.

3) Edit the three-digit string, using the Multi-selector and on-screen "keyboard" as described above under Renaming a Shooting menu bank.

4) Press **OK** to accept the new name, **MENU** to exit without making the change.

› Primary slot selection

Determines which card slot (CF or SD) is designated as the main or primary slot.

› Secondary slot function

When memory cards are present in both slots, the secondary slot can be used in three different ways. **Overflow** (the default setting) means that images will only be recorded to the secondary slot when the card in the primary slot is full. **Backup**

> **Note:**
> If only one card is present, the camera will automatically use it, regardless of whether that slot is designated primary or not.

means that each image is written to both cards simultaneously. **RAW primary, JPEG secondary** is a little more complicated. If Image quality is set to *NEF (RAW)+JPEG*, then the NEF version of each shot is recorded to the primary slot and the JPEG version to the secondary slot. At all other Image quality settings, this option works exactly the same as Backup.

› Image quality

Use this to choose between NEF (RAW), TIFF and JPEG options, as described on *page 51.*

› Image size

Use this to choose between Small, Medium and Large image sizes, as described on *page 56.* (If RAW is selected for **Image quality** this Shooting menu item is grayed out and cannot be accessed.)

› Image area

Use this to choose between **FX**, **DX**, **1.2x** and **5:4** image areas, as described on *page 54.*

› JPEG compression

Use this to choose how JPEG images are compressed. **Size priority** means that all images are compressed down to a set size (dependent on options selected for Image area, Image quality and Image size). **Optimal quality** means that image sizes are allowed to vary, for better file quality.

› NEF (RAW) recording

This menu offers two sets of options for how NEF (RAW) files are recorded *(see page 52).* **Type** gives three options for NEF (RAW) file compression (below). NEF (RAW) bit depth allows you to select 12-bit or 14-bit depth.

Lossless compressed (default)	Files are compressed by about 20–40% with no detectable effect on image quality.
Compressed	Files are compressed by around 40–55%, with a very small effect on image quality.
Uncompressed	Files are not compressed. Uncompressed files take up more memory card space and write times are slightly increased.

› White balance

This menu allows you to set the white balance (see page 58).

› Set Picture Control and Manage Picture Control

These menus govern the use of Nikon Picture Controls, as already discussed on page 73.

› Color space

This menu allows you to choose between sRGB and Adobe RGB color spaces (see page 62 for explanation).

› Active D-Lighting

This menu governs the use of Active D-Lighting, as discussed on page 72.

› Vignette control

Vignetting is a darkening, or fall-off in illumination, towards the corners of the image, which shows up most clearly in even-toned areas like clear skies. Almost all lenses have a slight tendency to vignetting at maximum aperture, but it usually disappears when the lens is stopped down. The D800 has the facility to compensate for vignetting during the in-camera processing of TIFF and JPEG images.

Note:
Vignette control only operates when Type D or Type G lenses are attached. It does not work with DX lenses, or when shooting DX-format images or movies.

Use this menu to choose between **Normal** (the default setting), **High**, **Low** and **Off**.

› Auto distortion control

If **ON**, this automatically corrects for distortion (see page 144) which may arise with certain lenses. It's available only with Type G and D lenses (see page 199), excluding fisheye and perspective control (PC) lenses, and does not apply when shooting movies.

Tip

When using DX lenses, make sure that **Auto DX crop** is **On**, or **Image area** is set to **DX**; otherwise Auto distortion control may produce undesirable results.

› Long exposure NR

Photos taken at long shutter speeds can be subject to increased noise *(see page 145)*. The D800 offers the option of extra image processing to counteract this. If Long exposure noise reduction (NR) is **ON**, it operates when exposure times are 1 second or longer. During the processing, **Job nr** blinks in the viewfinder and control panel displays. The time the process takes is roughly equal to the shutter speed in use, and no further pictures can be taken until the processing is complete. This causes significant delays in shooting and many users prefer to use post-processing to reduce image noise instead, especially when shooting NEF (RAW) files.

› High ISO NR

Photos taken at high ISO settings can also be subject to increased "noise". The default setting of **Normal** applies a moderate amount of noise reduction. This can be changed to **Low** or **High**. High ISO NR can also be set to **OFF**, but even then a modest amount of NR will be applied to images taken at the ISO settings of 1600 or above.

WATER WORKS ⌄⌄
I chose a long exposure rather than High ISO for this image as the water was almost still. There's a tiny amount of movement in the nearest boat, most apparent if you look closely at the TV aerial. *24mm, 1/15th sec., f/11, ISO 200.*

> ## ISO sensitivity settings

This menu governs the ISO setting, as discussed in depth on *page 60*.

> ## Multiple exposure

Given the ease with which you can combine images on the computer, precisely and flexibly, it might seem that digital cameras like the D800 have little need of a multiple exposure facility. However, the Nikon manual states that, because they make use of RAW data from the camera image sensor, in-camera multiple exposures *"produce results with colors noticeably superior to those in software-generated photographic overlays."*

This suggests that results could be at least equally good if you shot individual RAW images for careful post-processing before combining them on the computer, but doing the same with images originally shot as JPEGs might produce disappointing results. The Multiple exposure facility also allows images to be quickly combined for immediate use, e.g. as JPEG files for printing. Multiple exposure can also be combined with the camera's Interval timer facility (see below) to take the exposures at set intervals.

To create a multiple exposure

1) In the Shooting menu, select **Multiple exposure** and press ▶.

2) Select **Multiple exposure mode** and press ▶. Select **On (series)** to keep shooting multiple exposures or **On (single photo)** to shoot just one. Press **OK**.

3) Select **Number of shots** and use the Multi-selector to choose a number (between 2 and 9) then press **OK**.

4) Select **Auto gain** and choose **ON** or **OFF** (see below for explanation) then press **OK**.

5) Select **Done** and press **OK**.

6) Frame the photo and shoot normally. If CL (continuous low speed) or CH (continuous high speed) is selected as release mode, the designated number of images will be exposed in a single burst. In S (single frame) release mode, one

Tip

Multiple exposure can be assigned to the BKT button via Custom setting f8. If this has been done, hold the button and rotate the Main Command Dial to select Multiple exposure mode, and the Sub-command Dial to select the number of shots.

image in the sequence will be exposed each time the shutter-release button is pressed. Normally the maximum interval between shots is 30 seconds. This can be extended by setting a longer monitor-off delay in Custom setting c4.

7) If **On (series)** was selected at step 2, you'll need to return to **Multiple exposure mode**, select **Off** and press **OK** to return to normal shooting.

› Auto gain

Auto gain (ON by default) adjusts the exposure, so that if you are shooting a sequence of three shots, each is exposed at ⅓ the exposure value required for a normal exposure. You might turn Auto gain **Off** where a moving subject is well lit but the background is dark, so that the subject is well-exposed and the background isn't over-lightened.

› Interval timer shooting

The D800 has the facility to take a number of shots at pre-determined intervals. If Multiple exposure is activated first, they will be combined into a single image, otherwise they will be recorded as separate images.

1) In the Shooting menu, highlight **Interval timer shooting** and press ▶ or **OK**.

2) Choose a start time. If **Now** is selected, shooting begins about 3 seconds after you complete the other settings, and you can skip Step 3. If **Start time** is selected, press ▶ to continue to the next step.

3) Use ◀ and ▶ to select hours and minutes. Use ▲ and ▼ to change these to the desired time in the next 24 hours. Press ▶ to continue to the next step.

4) Choose the interval between shots. Use ◀ and ▶ to select hours, minutes or seconds. Use ▲ and ▼ to change these values as desired. Press ▶ to continue to the next step.

5) Choose the number of intervals (up to 999) and the number of shots to be taken at each interval (up to 9). The total number of shots that this amounts to is also displayed. Press ▶ to complete the setup and reach the primary Interval timer shooting screen.

6) Highlight **Start> On** and press **OK**.

> **Note:**
> If a large number of shots, and/or long intervals, are planned, ensure that the battery is fully charged or the camera is connected to a mains adapter, and that there is sufficient space on the memory card—if the card becomes full, no more shots can be taken until the card is replaced.

2

› Time-lapse photography

Time-lapse photography shoots a series of still frames, so in some senses it's similar to Interval timer shooting. However, the interval timer records each shot as a separate image—RAW, JPEG or TIFF, according to current settings. Time-lapse photography combines them into a silent movie. Frame size and other settings are as decided in the **Movie settings** item (see below).

To create a time-lapse movie
Set up the camera—a tripod is recommended, and you may want to take a test shot. Manual mode is not recommended unless the lighting is sure to remain constant.

1) In the Shooting menu, highlight **Time-lapse photography** and press ▶.

2) Select **On** and press ▶.

3) Choose the interval between shots. The default is 5 seconds; if you wish to change this, use ◄ and ▶ to select minutes or seconds, ▲ and ▼ to change these values. Press ▶ to continue to the next step.

4) Choose the shooting time. The default is 25 minutes; if you want to change this, use ◄ and ▶ to select hours or minutes, ▲ and ▼ to change these values. The maximum you can set is 7 hours 59

minutes. Press ▶ to continue to the next step.

5) This returns you to the main **Time-lapse photography** screen. Press **OK** to proceed; shooting begins after approximately 3 seconds.

› Movie settings

Determines key settings for movie shooting; these are described in the Movies chapter on *page 186*.

» CUSTOM SETTING MENU

The Custom Setting menu allows almost every aspect of the camera's operation to be fine-tuned to your personal preferences. The menus are divided into seven main groups, identified by key letters and a color: a: Autofocus (red); b: Metering/Exposure (yellow); c: Timers/AE Lock (green); d: Shooting/display (light blue); e: Bracketing/flash (dark blue); f: Controls (lilac); and g: Movie (purple). In addition there are options to create Custom settings banks.

› To choose Custom Setting

1) Press **MENU**. If another menu appears first, press ◀ to highlight the icons in the left-hand column and scroll up or down to the Custom Setting menu icon (pencil). Press ▶ to enter the Custom settings menu.

2) Use the Multi-selector to scroll up or down to the desired settings group. Press ▶ to display the group.

3) Use the Multi-selector to scroll up or down to the desired settings. Press ▶ to display options for that setting.

4) Highlight the desired option and press **OK** to select it.

› Custom settings bank

In a similar way to the Shooting menu banks discussed on *page 82*, this is a handy way to store particular combinations of Custom settings that you may use repeatedly. This saves having to make all those changes individually. You can create up to four such menu banks for different shooting requirements. The procedure for creating and renaming Custom settings banks is exactly the same as that for Shooting menu banks on *page 82* (except of course that you start from the Custom settings menu).

› Restoring default settings

To restore the current Custom settings bank to standard camera default values, highlight that menu bank then press 🗑. A confirmation dialog appears; select yes and press **OK** to confirm.

a: Autofocus

Custom Setting	a1 AF-C priority selection
Options	Release (default) Release + focus Focus
Notes	Applies when the camera is in AF-C Continuous-servo AF release mode *(see page 47)*.
Custom Setting	a2 AF-S priority selection
Options	Focus (default) Release
Notes	Applies when the camera is in (S) Single-servo AF release mode *(see page 47)*.
Custom Setting	a3 Focus tracking with lock-on
Options	5 (Long) 4 3 Normal (default) 2 1 (Short) Off
Notes	Governs how the camera reacts to sudden large changes in the distance to the subject. Off means the camera reacts instantly to such changes, but can be fooled when other objects pass through the frame.
Custom Setting	a4 AF activation
Options	Shutter/AF-ON (default) AF-ON only
Notes	Governs whether autofocus is activated by half-pressure on the shutter-release button as well as the AF-ON button, or by the AF-ON button only.

Custom Setting	a5 AF Point illumination
Options	Auto (default) On Off
Notes	Governs whether the active focus point is illuminated in red in the viewfinder. If Auto is selected, the focus point is illuminated only when the subject is dark.

Custom Setting	a6 Focus point wrap-around
Options	Wrap No wrap (default)
Notes	Governs whether or not the active focus point wraps to the opposite edge of the available area *(see page 50)*.

Custom Setting	a7 Number of focus points
Options	AF51 (default) AF11
Notes	Governs the number of focus points available for manual selection in Single-area AF. Using 11 points is less precise but makes selection quicker.

Custom Setting	a8 Built-in AF-assist illuminator
Options	On (default) Off
Notes	Governs whether or not the the AF-assist illuminator operates when lighting is poor *(see page 14)*.

b: Metering/Exposure

Custom Setting	b1 ISO sensitivity step value
Options	⅓ step (default) ½ step 1 step
Notes	Governs the increments used when changing ISO sensitivity value *(see page 61)*.

2

Custom Setting	b2 EV steps for exposure cntrl
Options	⅓ step (default) ½ step 1 step
Notes	Governs the increments used by the camera for setting shutter speed and aperture, plus the increments available for bracketing.

Custom Setting	b3 Exp./flash comp. step value
Options	⅓ step (default) ½ step 1 step
Notes	Governs the increments used when applying exposure compensation *(see page 44)* or flash compensation *(see page 163)*.

Custom Setting	b4 Easy exposure compensation
Options	On (Auto reset) On Off (default)
Notes	Governs how exposure compensation operates in P, S and A modes. When Off, the exposure compensation button must be pressed and the Main Command Dial rotated. When On, exposure compensation can be applied simply by rotating the Sub-command Dial (P and S modes) or Main Command Dial (A mode). Auto reset means the setting is not retained when the camera or meter turns off.

Custom Setting	b5 Center-weighted area
Options	8mm 12mm (default) 15mm 20mm Average
Notes	Governs the size of the primary area when Center-weighted metering is in use *(see pages 41, 110)*. With non-CPU lenses only 12mm and Average are available. Average means metering is based equally on the entire frame.

Custom Setting	b6 Fine tune optimal exposure
Options	Yes No (default)

Notes	Allows a sort of permanent exposure compensation to be applied, with separate values for each of the three main metering methods. Usually the normal exposure compensation procedure is to be preferred, but this option could be useful in conjunction with the Custom settings banks. Suppose, for instance, you consistently find that matrix metering gives slightly darker or lighter results than desired when shooting landscapes. Use this setting to apply a consistent correction (+/- 1 Ev in steps of ⅙ Ev) to all shots taken with matrix metering, and save it in a Custom settings bank to use when shooting landscapes. You will need to remember that this compensation is in operation as the normal exposure compensation indicator will not be displayed.

c: Timers/AE Lock

Custom Setting	c1 Shutter-release button AE-L
Options	On Off (default)
Notes	Governs whether exposure is locked by half-pressure on the shutter-release button. If Off, exposure can only be locked using the AE-L/AF-L button *(see page 51)*.
Custom Setting	c2 Auto meter-off delay
Options	4 sec. 6 sec. (default) 10 sec. 30 sec. 1 min. 5 min. 10 min. 30 min. No limit
Notes	Governs how long the exposure meter (and shutter speed/aperture displays in the viewfinder and control panel) remains active if no further operations are carried out. A shorter delay is good for battery economy. No limit applies automatically when the D800 is connected to a mains adapter.

Custom Setting	c3 Self-timer
Self-timer delay	2 sec. 5 sec. 10 sec. (default) 20 sec.
Notes	Governs the delay in self-timer release mode *(see page 32)*. You can also select Number of shots (from 1–9) and Interval between shots (0.5, 1, 2 or 3 sec.), to create sequences from one press of the release button when in self-timer mode.

Custom Setting	c4 Monitor off delay	
Options	4 sec.	Default for Image review
	10 sec.	Default for Playback, Information display
	20 sec.	
	1 min.	Default for Menus
	5 min.	
	10 min.	Default for Live view
Notes	Governs how long the monitor screen remains active if no further operations are carried out. Separate settings can be applied for Playback, Menus, Information display, Image Review and Live view (which also governs movie mode). Shorter delays are good for battery economy. A 10-minute delay applies across the board when the D800 is connected to a mains adapter.	

d: Shooting/display

Custom Setting	d1 Beep
Volume	3 (High) 2 1 Off (default)
Pitch	High Low
Notes	Governs the volume and pitch of the beep which is used when the self-timer operates, and to signify that focus has been acquired when shooting in single-servo AF mode.

Custom Setting	d2 CL mode shooting speed
Options	5fps 4fps 3fps 2fps (default) 1fps
Notes	Governs the maximum frame rate when using CL Continuous low-speed mode. 5fps is only possible under certain conditions *(see page 33)*.

Custom Setting	d3 Max continuous release
Options	Set with Multi-selector (range between 1 and 100)
Notes	Governs the maximum number of shots that can be taken in a single burst when using either of the continuous release modes.

Custom Setting	d4 Exposure delay mode
Options	3 sec. 2 sec. 1 sec. Off (default)
Notes	Can be used to create a shutter delay when the shutter-release button is pressed. A possible alternative to the self-timer or mirror lock-up to reduce vibration when shooting on a tripod.

Custom Setting	d5 File number sequence
Options	On (default) Off Reset
Notes	Controls the way file numbers are set. If On, when a new memory card is inserted, the card is formatted, or a new folder is created, numbering continues from the previous highest number used. If Off, file numbering is reset to 0001 in any of those conditions. Reset means that 1 is added to the largest number used in the current folder.

Custom Setting	d6 Viewfinder grid display
Options	On Off (default)
Notes	Allows on-demand grid lines to be displayed in the viewfinder, which may help when leveling the camera is critical. Not available when Image area is set to DX.

Custom Setting d7 ISO display and adjustment

Options	Show ISO Sensitivity Show ISO/Easy ISO Show frame count (default)
Notes	If Show ISO sensitivity is selected, the figure at bottom right of LCD screen and viewfinder displays shows the selected ISO. If Show frame count is selected, the figure shows the number of exposures remaining *(see page 19)*. For explanation of Easy ISO, *see page 61*.

Custom Setting d8 Screen tips

Options	On (default) Off
Notes	Governs the availability of on-screen tips when items are selected in the shooting info display.

Custom Setting d9 Information display

Options	Auto (default) Manual Dark on light Light on dark
Notes	Governs the way shooting information is displayed on the monitor: display can be switched from light-on-dark to dark-on-light to suit lighting conditions and by default the camera does so automatically.

Custom Setting d10 LCD illumination

Options	On Off (default)
Notes	Governs illumination of the control panel. If On, the control panel will be illuminated when the exposure meter is active. If Off, the control panel is only illuminated when the power switch is moved to the ☀ position.

Custom Setting d11 MB-D12 battery type

Options	LR6 (AA alkaline) HR6 (AA Ni-MH) FR6 (AA lithium)
Notes	When the optional MB-D12 battery pack *(see page 223)* is attached and AA cells are inserted, set this menu to match the type of cells in use.

Custom Setting	d12 Battery order
Options	Use MB-D12 batteries first (default)
	Use camera battery first
Notes	Governs order in which batteries are called on when the optional MB-D12 battery pack *(see page 223)* is attached.

e: Bracketing/flash

Custom Setting	e1 Flash sync speed
Options	1/320 sec. (Auto FP)
	1/250 sec. (Auto FP)
	1/250 sec. (default)
	1/200 sec.
	1/160 sec.
	1/125 sec.
	1/100 sec.
	1/80 sec.
	1/60 sec.
Notes	Governs the flash sync speed *(see page 160)*. The Auto FP settings only apply when certain auxiliary Nikon flash units are attached, in which case flash sync is possible at any speed. If other flash units are attached, sync speed is limited to 1/320th sec. or 1/250th sec.

Custom Setting	e2 Flash shutter speed
Options	From 1/60 sec. (default) to 30 sec. in increments equal to 1 Ev
Notes	Governs the slowest shutter speed which the camera can set when using P or A exposure modes (see page 36). When using M or S exposure modes, any speed down to 30 sec. can be set anyway.

Custom Setting	e3 Flash control for built-in flash
Options	TTL (default) Manual (options from Full down to 1/128th power) Repeating flash (options for power, number of flashes, and frequency) Commander mode
Notes	Governs how the built-in flash is regulated. TTL means flash output is regulated automatically. Manual means it is set manually. Repeating flash fires multiple flashes, giving a strobe-like effect. Commander mode uses the built-in flash as a controller for remote flash unit(s) *(see page 167)*.
Custom Setting	e4 Modeling flash
Options	On (default) Off
Notes	Applies when the built-in flash is active or one of certain optional flash units *(see page 165)* is attached. If On, a modeling flash is emitted when the depth of field preview button is depressed, giving some (limited) indication of the flash effect.
Custom Setting	e5 Auto bracketing set
Options	AE and flash (default) AE only Flash only WB bracketing ADL bracketing
Notes	Determines which settings are bracketed when auto bracketing is activated *(see page 45)*. If flash is not active, AE & flash has the same effect as AE only.
Custom Setting	e6 Auto bracketing (Mode M)
Options	Flash/speed Flash/speed/aperture Flash/aperture Flash only
Notes	Determines which settings are bracketed when using Manual mode, and AE & flash or AE only are selected in Custom setting e5 (above). If AE only is selected, or flash is not active, then the first three settings allow speed only, speed+aperture, or aperture only, to be bracketed.

Custom Setting	e7 Bracketing order
Options	MTR>under>over (Default) Under>MTR>over
Notes	Determines the order in which auto bracketed exposures are taken: by default, the first exposure is taken at the metered exposure, while the alternative places it, perhaps more logically, in the middle of the sequence.

f: Controls

Custom Setting	f1 :☀: switch
Options	LCD backlight (default) Both
Notes	By default, the :☀: switch causes the top-plate LCD display to illuminate. If Both is selected, operating this switch also activates the Shooting info display on the rear monitor.

Custom Setting	f2 Multi-selector Center Button
Options —shooting mode	Select center focus point (default) Highlight active focus point Not used
Options —playback mode	Thumbnail on/off (default) View histograms Zoom on/off *(see page 70)* Choose slot and folder
Options —Live View	Select center focus point (default) Zoom on/off Not used
Notes	Governs which functions are activated, in Shooting mode and in Playback mode, when the center of the Multi-selector is pressed.

Custom Setting	f3 Multi-selector
Options	Reset meter-off delay Do nothing (default)
Notes	Normally, operating the Multi-selector when the camera is inactive has no effect. Reset meter-off delay activates the exposure meters when the Multi-selector is operated.

Custom Setting f4 Assign Fn button

Options Fn button press		
	Preview	Activates depth of field preview.
	FV lock	Locks flash value (compatible flashguns only).
	AE/AF lock	Locks focus and exposure.
	AE lock only	Locks exposure only.
	AE lock (Reset on release)	Locks exposure until shutter is released, exposure meters turn off, or Fn button is pressed again.
	AE lock (Hold)	Locks exposure until exposure meters turn off or Fn button is pressed again.
	AF lock only	Locks focus.
	AF-ON	Initiates autofocus.
	Flash off	Flash will not fire even if built-in flash is raised or accessory flashgun is on.
	Bracketing burst	Activates a bracketing burst at the settings last used.
	Matrix metering	
	Center-weighted metering	
	Spot metering	
	Playback	Initiates playback (duplicates ▶).
	Access top item in My Menu	
	+NEF (RAW)	If Image quality is set to record JPEG images, a NEF (RAW) copy will also be produced when the next shot is taken.
	Viewfinder virtual horizon	Displays pitch and roll indicators in viewfinder.
	None (default)	
Options Fn button + dials	Choose image area	Use Fn button and either command dial to choose image area (see page 54).
	Shutter speed & aperture lock	Locks shutter speed (S and M modes: Main Command Dial) and/or aperture (A and M modes: Sub-command Dial).
	1 step spd/aperture	If Fn button is pressed while command dials are rotated, changes to aperture/shutter speed value will be made in 1 Ev steps.
	Choose non-CPU lens number	Use Fn button and dial to select among lenses specified using Non-CPU lens data (see page 37).
	Active D-Lighting	Use Fn button and either command dial to toggle Active D-Lighting options (see page 72).
	None (default)	

Notes	A wide range of functions can be assigned to the Fn button, both on its own and when used in conjunction with the command dials. Some of these duplicate functions normally assigned to other buttons (e.g. Preview, normally assigned to the depth of field preview button).
	At the time of writing there is a glitch with this Custom setting; if you choose an option for Fn button + dials, Fn button press is reset to None, and vice versa. No doubt this will soon be addressed via a firmware upgrade.

Custom Setting f5 Assign Preview button

Almost exactly the same range of functions can be assigned to the Preview button as to the Fn button (above). The only differences are that the default setting (for Preview button press) is Preview, and AF-ON is not available.

Custom Setting f6 Assign AE-L/AF-L button

Almost exactly the same range of functions can be assigned to the AE-L/AF-L button as to the Fn button (above). The default setting (for AE-L/AF-L button press) is AE/AF Lock, and 1 step spd/aperture and Active D-Lighting are not available.

Custom Setting f7 Shutter spd & aperture lock

Options	Shutter Speed lock	Off (default)
		On
	Aperture lock	Off (default)
		On

Notes	If On, locks the relevant setting at the currently selected value. Shutter Speed lock is only available in S and M exposure modes; Aperture lock is only available in A and M modes. In P mode neither value can be locked.

Custom Setting f8 Assign BKT button

Options	Auto bracketing
	Multiple Exposure
	HDR (high dynamic range)

Notes	Normally, the BKT button is used to enable bracketing (see page 45). It can instead be used to set options and activate Multiple Exposure or HDR photography.

Custom Setting	f9 Customize command dials
Options	Reverse rotation (set separately for Exposure compensation and/or Shutter speed/aperture). Change main/sub Aperture setting Menus and playback
Notes	Normally, Main Command Dial sets shutter speed and Sub-command Dial sets aperture: Change main/sub reverses these roles. Aperture setting governs whether the aperture ring (on lenses which have one) can be used to set apertures, instead of the Sub-command Dial. Note that if this option is On, apertures will change in increments of 1 Ev. Also, Live View cannot be used. Menus and playback, when set to ON, allows the command dials, as well as the Multi-selector, to be used to navigate images during playback.

Custom Setting	f10 Release button to use dial
Options	Yes No (default)
Notes	Normally, buttons such as QUAL, WB and ISO must be kept pressed while the command dial is rotated to make changes. If this option is activated, changes can be made even after the button is released—but only until the button is pressed again or the shutter-release button is pressed.

Custom Setting	f11 Slot empty release lock
Options	Release locked Enable release (default)
Notes	If Enable release is selected, the shutter can be released even if no memory card is present. Images are held in the camera's buffer and can be displayed on the monitor (demo mode), but are not recorded.

Custom Setting	f12 Reverse indicators
Options	− 0 + + 0 − (default)
Notes	Governs how the exposure displays in the viewfinder and control panel are shown, i.e. with overexposure to left or right.

Custom Setting	f13 Assign MB-D12 AF-ON	
Options	AF-ON	Initiates autofocus
	FV lock	Locks flash value (built-in and compatible flashguns only).
	AE/AF lock	Locks focus and exposure
	AE lock only	Locks exposure only
	AE lock (Reset on release)	Locks exposure until shutter is released, exposure meters turn off, or Fn button is pressed again.
	AE lock (Hold)	Locks exposure until exposure meters turn off or Fn button is pressed again.
	AF lock only	Locks focus
	Same as Fn button	Button will perform the same function as selected for camera Fn button in Custom setting f4.
Notes	Choose the function performed by the AF-ON button on the MB-D12 accessory battery pack.	

g: Movie

Custom Setting	g1 Assign Fn Button	
Options	Power aperture (open)	Use in conjunction with Custom setting g2 (see below).
	Index marking	Press to add an index mark at current point.
	View photo shooting info	Press to see info on key photo settings in place of usual movie display; press again to revert.
	None (default)	Button has no effect
Notes	Governs function performed by Fn button when camera is in movie mode.	
Custom Setting	g2 Assign Preview button	
Notes	Governs function performed by Preview button when camera is in movie mode. Options are the same as g1 except that button closes aperture in Power aperture operation (see page 188), and the default is Index marking.	

2

Custom Setting	g3 Assign AE-L/AF-L button	
Options	Index marking	Press to add an index mark at current point.
	View photo shooting info	Press to see info on key photo settings in place of usual movie display; press again to revert.
	AE/AF lock (default)	
	AE lock only	
	AE lock (Hold)	
	AF lock only	
	None	
Notes	Governs function performed by AE-L/AF-L button when camera is in movie mode.	

Custom Setting	g4 Assign shutter button	
Options	Take photos	Fully press shutter-release button to take a still photo (this ends movie recording) *(see page 193).*
	Record movies	*See page 189.*
Notes	Governs the behavior of the shutter-release button when camera is in movie mode.	

» SETUP MENU

The Setup menu controls a number of important camera functions, though many of them are ones you will need to access only occasionally, if at all.

› Format memory card

The one item in this menu that many users will use regularly, though many find the alternative "two-button" method of formatting the memory card more convenient.

To format a memory card
1) In the Setup menu, select **Format memory card** and press **OK**.

2) Select **SD card slot** or **CF card slot** and press **OK**.

3) Select **Yes** and press **OK**.

Note:
This does not apply in Live View/ movie shooting.

› Monitor brightness

The brightness of the LCD automatically adjusts to suit ambient lighting conditions. If you need to adjust it further, select **Manual** then press ▲ or ▼.

› Clean image sensor/Lock mirror up for cleaning

For more details *see page 240.*

› Image Dust Off Ref Photo

Nikon Capture NX2 features automatic removal of dust spots on images by reference to a photo which maps dust on the sensor. If you know there are stubborn dust spots resistant to normal sensor cleaning, this can save a lot of grunt-work on the computer. The option to **Clean sensor and then start** should not be used if the pictures from which spots are to be removed have already been taken.

To take a dust-off reference photo

1) Fit a lens (preferably full-frame of at least 50mm focal length). Use the longest setting on a zoom lens. Find a bright, featureless white object such as a sheet of paper, large enough to fill the frame.

2) In the Setup menu, select **Image Dust Off Ref Photo** and press **OK**. Select **Start** or **Clean sensor and then start** and press **OK**. When the camera is ready to shoot the reference photo, **rEF** appears in the Viewfinder and Control Panel.

3) Frame the white object at a distance of approximately 10cm (4in.). Press the shutter-release button halfway; focus will automatically be set at infinity (if using Manual Focus, set focus to infinity manually). Press the shutter-release button fully to complete the process. If the reference object is too bright or dark, a warning will be displayed; change exposure settings or choose another reference object and reshoot.

› HDMI

You can also connect the camera to HDMI (High Definition Multimedia Interface) TVs and monitors *(see page 239)*. This menu allows you to set the camera's output to match the HDMI device; get this information from the device instructions.

› Flicker reduction

Some light sources can produce visible flicker in the Live View screen image and in movie recording. To minimize this, use this menu to match the frequency of the local mains power supply: **60Hz** is common in North America, **50Hz** in the European Union and UK. The **Auto** setting will normally adjust automatically.

› Time zone and date

Sets date, time and time zone, and specifies the date display format (Y/M/D, M/D/Y or D/M/Y). First set the time zone in which you normally operate, then set the time correctly. If you travel to a different time zone, change this setting and the time correct automatically.

› Language

Sets the language which the camera uses in its menus. The options include most major European languages, Arabic, Indonesian, Chinese, Japanese, Korean and Thai.

› Auto image rotation

If set to **ON** (default), the orientation of the camera is recorded with every photo taken, ensuring that they appear the right way up when viewed with Nikon or most third-party imaging applications.

› Battery info

Displays information about battery status, including percentage of charge remaining and how many shots have been taken since the battery was last charged. The information displayed may change if an optional battery pack is fitted.

› Wireless transmitter

Normally grayed-out and inaccessible, this menu is only used if the camera is connected to a wireless transmitter. *(See under Accessories, page 216.)*

› Image comment

Inputting text

You can append brief comments (36 characters or about a quarter of a "Tweet") to images. Comments appear in the info page of the photo info display and can be viewed in Nikon View NX2 and Nikon

Capture NX2. To attach a comment, select **Input comment** and press ▶. Use the Multi-selector to input text as described on *page 83*. When finished press ⊕. Select **Attach comment**, then select **Done** and press **OK**. The comment will be attached to all new shots until turned off again.

› Copyright Information

Copyright is an important protection against the theft or misappropriation of your creative work. This menu allows copyright information to be embedded into file data, using the standard method of text input, described on *page 83*. There are separate fields for **Artist** (i.e. photographer) and **Copyright holder**; however, under UK law, and in many other countries, they are usually one and the same—copyright automatically belongs to the person creating the image. There is an exception for photographers shooting in the course of their permanent employment (not freelances under contract), when copyright belongs to the employer. To attach this information to all subsequent photos, select **Attach copyright information**, then scroll up to **Done** and press **OK**.

Use this facility with discretion if more than one person may use the camera.

› Save/load settings

This menu allows you to save many camera settings (see table opposite) to a memory card. If the same card (or another to which the settings file has been copied) is inserted later, the saved settings can be quickly restored. This could be useful, for instance, if more than one user share the camera but require different settings, or when the camera is sent away for servicing. It can also be used to transfer settings to another D800, but not to any other model. The settings file is named NCSETUP8 and the procedure will not work if the file name is changed.

› GPS

Used to set up a connection between the D800 and a compatible GPS device (see page 238).

› Virtual horizon

Displays a virtual horizon on the monitor to assist in leveling the camera. Alternatively, the analog displays in the viewfinder and control panel can be used as a tilt-meter, in conjunction with the Fn, PREVIEW or AE-L/AF-L button; this function is enabled using Custom setting f5, f6 or f7 respectively.

› Non-CPU lens data

Many older Nikon lenses, often ruggedly built and optically superb, can be fitted to the D800. When lenses lack a built-in CPU, little information is available to the camera and shooting options are drastically reduced, but important functions can be restored by using this menu to specify the focal length and maximum aperture of a given lens. If several non-CPU lenses are available, this data can be specified for each one and each can be assigned a number, which saves having to input the details manually each time. Data can be stored for up to nine such lenses.

› AF fine tune

With this menu, allowance can be made for slight variations in autofocus performance between different lenses (back-focus or front-focus). Note that this applies to CPU lenses only, but the camera can store details for up to 20 lenses. It will subsequently recognize these lenses automatically. This feature should be used with care and only when you are certain that back-focus or front-focus exists; however it gains extra importance with the critical resolution offered by the D800. It is **OFF** by default.

Detecting back- or front-focus requires careful testing. One method is to compare results using standard AF with those from

Live view. Use a solid tripod to avoid camera movement and make sure the same focus point is being targeted by both AF systems.

› Eye-Fi upload

This menu option will only be visible if an Eye-Fi card is inserted *(see page 231)*. It then allows you to **Enable** (default) or **Disable** automatic upload of photos over a WiFi network.

Menu

Playback
Playback display options
Image review
After delete
Rotate tall

Shooting menu
Shooting menu bank
Extended menu banks
File naming
Primary slot selection
Secondary slot selection
Image quality
Image size
Image area
JPEG compression
NEF (RAW) recording
White balance
Set Picture Control
Color space
Active D-Lighting
Vignette control
Auto distortion control
Long exposure NR
High ISO NR

› Firmware version

Firmware is the onboard software which controls the camera's operation. Nikon issues updates periodically. This menu shows the version presently installed, so you can verify whether it is current.

When new firmware is released, download it from the Nikon website and copy it to a memory card. Insert this card in the camera then use this menu to update the camera's firmware.

Menu

Shooting menu
ISO sensitivity settings
Movie settings
Live view

Custom settings
All custom settings in all banks

Setup menu
Clean image sensor
HDMI
Flicker reduction
Time zone and date (saves preferred format and time zone, not date and time).
Language
Auto image rotation
Image comment
Copyright information
GPS
Non-CPU lens data
Eye-Fi upload

My menu/Recent settings
All My Menu items
All recent settings
Choose tab

RETOUCH MENU

D-Lighting	
Red-eye correction	
Trim	
Monochrome	
Filter effects	
Color balance	
Image overlay	
NEF (RAW) processing	

The Retouch menu is used to make various corrections and enhancements to images, including cropping, color balance and so on. This does not change the original image, but creates a copy with the changes applied. Further retouch options can be applied to the new copy, with some limitations: for example, you can make a monochrome copy and then **Trim** (crop) it, but you can't apply further corrections to an image which has already been trimmed. Copies are always created in JPEG

Format of original photo	Quality and size of copy
NEF (RAW)	Fine, Large
TIFF	Fine, size matches original.
JPEG	Quality and size match original.

format (except in **Image overlay**), but the size and quality of the copy depends on the format of the original.

› To create a retouched image

Retouching can begin either from the Retouch menu, or from normal playback.

1) If starting from the Retouch menu, select the desired retouch option and press ▶. A screen of image thumbnails appears. Select the required image using the Multi-selector, as in normal image playback. Press **OK**. If subsidiary options appear, make a further selection and press ▶ again. A preview of the retouched image appears.

2) If starting from normal playback, select the required image and press **OK**. Now select the desired retouch option and press ▶. If subsidiary options appear, make a further selection and press ▶ again. A preview of the retouched image appears.

3) Depending on the type of retouching to be done (see details below), there may be further options to choose from.

4) Press **OK** to create a retouched copy. ◀ takes you back to the options screen and ▶ lets you exit without creating a copy.

SEEING DOUBLE
The same original image with D-Lighting Off (L) and High (R).

› D-Lighting

D-Lighting should not be confused with
Active D-Lighting, though the final effect is
similar. Active D-Lighting is applied before
shooting; D-Lighting is applied later. In
essence, D-Lighting lightens the shadow
areas of the image. The D-Lighting screen
shows a side-by-side comparison of the
original image and the retouched version;
a press on ⊕ zooms in on the retouched
version. Use ▲/▼ to select the strength of
the effect—**High**, **Medium** or **Low**.

› Red-eye correction

This is aimed at dealing with the notorious
problem of "red-eye", caused by
on-camera flash *(see page 161)*. This
option can only be selected for photos
taken using flash. The camera then
analyzes the photo looking for evidence of
red-eye; if none is found the process ends.

If red-eye is detected a preview image
appears and you can use the Multi-selector
and the zoom controls in the usual way to
view it more closely.

› Trim

This allows you to crop an image to
eliminate unwanted areas or to better fit it
to a print size. When this option is selected,
a preview screen appears, with the crop
area marked by a yellow rectangle. You can
change the aspect ratio of the crop by
rotating the Main Command Dial. Adjust
the size of the cropped area by pressing
⊖ to reduce the size, ⊕ to increase it.
Adjust its position using the Multi-selector.
Press the center of the Multi-selector to
preview the cropped image. Press **OK** to
create a cropped copy.

2

Aspect ratio	Possible sizes for trimmed copy								
3:2	4480 x 2984	3840 x 2560	3200 x 2128	2560 x 1704	1920 x 1280	1280 x 856	960 x 640	640 x 424	
4:3	4256 x 3200	3840 x 2880	3200 x 2400	2560 x 1920	1920 x 1440	1280 x 960	960 x 720	640 x 480	
5:4	4000 x 3200	3600 x 2880	2992 x 2400	2400 x 1920	1808 x 1440	1200 x 960	896 x 720	608 x 480	
1:1	3200 x 3200	2880 x 2880	2400 x 2400	1920 x 1920	1440 x 1440	960 x 960	720 x 720	480 x 480	
16:9	4800 x 2704	4480 x 2520	3840 x 2160	3200 x 1800	2560 x 1440	1920 x 1080	1280 x 720	960 x 536	640 x 360

› Monochrome

Unsurprisingly, this creates a monochrome copy of the original image. You can choose from straight **Black-and-white**, **Sepia** (a brownish-toned effect similar to many antique photos) and **Cyanotype** (a bluish-toned effect). If you select Sepia or Cyanotype, a preview screen appears and you can make the toning effect stronger or weaker using ▼ and ▲.

› Filter effect

This mimics several common photographic filters. **Skylight** reduces the blue cast which can affect photos taken on clear days with a lot of blue sky. Applied to other images its effect is very subtle, even undetectable. **Warm filter** has a stronger warming effect, akin to an 81B or 81C filter. **Red/green/blue intensifier** and **Soft** are all fairly self-explanatory, but **Cross screen** is not. This creates a "starburst" effect around light sources and other bright points (like sparkling highlights on water). There are multiple options within this item.

MONO MAGIC **«**
The in-camera black-and-white conversion can be very effective.

Filter option heading	Options available
Number of points	Create four-, six-, or eight-pointed star.
Filter amount	Choose brightness of light sources that are affected.
Filter angle	Choose angle of the star points.
Length of points	Choose length of the star points.
Confirm	See a preview of the effect; press ⊕ to see it full-screen.
Save	Create a copy incorporating the effect.

› Color balance

Creates a copy with adjusted color balance. When this option is selected a preview screen appears and the Multi-selector can be used to move around a color grid. The effect is shown both in the preview and in the histograms alongside; use ⊖⊞ to zoom in on the preview.

› Image overlay

This allows you to create a new combined image from two existing photos. Image overlay can only be applied to originals in NEF (RAW) format, but Nikon claim that the results are better than combining the images in an application like Photoshop because Image overlay makes direct use of the raw data from the camera's sensor.

To create an overlaid image

1) In the Retouch menu, select Image overlay and press ▶. A dialog screen

SUBTLE STAR ⌃
The starburst effect is relatively subtle here.

> ### Tip
>
> *Although Image overlay works from NEF (RAW) images, the size and quality of the new image are not automatically set to Fine, Large as they would be with other retouch options when starting from NEF (RAW) images. Before using Image overlay check that Image quality and Image size options match your requirements for the finished image.*

appears with sections labeled Image 1, Image 2 and Preview. Initially, Image 1 is highlighted. Press **OK**.

2) The camera displays thumbnails of NEF (RAW) images on the memory card. Select the first image you want to use for the overlay and press **OK**. It now appears as Image 1.

3) Select **Gain**: this determines how much "weight" this image has in the final overlay. Use ▲ and ▼ to adjust gain from a default value of 1.0.

4) Press ▶ to move to Image 2. Repeat steps 2 and 3 for the second image.

5) If necessary, press ◀ to return to Image 1. You can make further adjustments to gain, or even press **OK** to change the selected image.

6) Finally, press ▶ to highlight **Overlay**. Press **OK** to preview the overlay. If not satisfied you can return to the previous stage by pressing ⊖✷. If you are satisfied, press **OK** again and the overlay will be saved. You can also skip the preview stage by highlighting **Save** and pressing **OK**.

› **NEF (RAW) Processing**

This menu creates JPEG copies from images originally shot as RAW files. While no substitute for full RAW processing on computer *(see page 232)* it allows the creation of quick copies for immediate sharing or printing. Options available for the processing of RAW images are displayed in a column to the right of the preview image (see table) and these do allow considerable control over output.

Option	Description
Image quality	Choose Fine, Normal, or Basic *(see pages 51, 85)*.
Image size	Choose Large, Medium, or Small *(see pages 56, 85)*.
White balance	Choose a white balance setting; options are similar to those described on *pages 59, 86*.
Exposure comp.	Adjust exposure (brightness) levels from +2 to -2.
Set Picture Control	Choose any of the range of Nikon Picture Controls *(see pages 73, 86)* to be applied to the image. Fine-tuning options can be applied.
High ISO NR	Choose level of noise reduction as appropriate *(see pages 61, 87)*.
Color space	Choose color space *(see pages 62, 86)*.
Vignette control	Apply vignette control *(see page 86)*.
D-Lighting	Choose D-Lighting level—High, Normal, Low, Off *(see page 113)*.

Option	Size (pixels)	Possible uses
2.5M	1920 x 1280	Display on HD TV and larger computer monitor, new iPad.
1.1M	1280 x 856	Display on typical computer monitor or iPad 1 or 2.
0.6M	960 x 640	Display on standard (non-HD) television, iPhone 4.
0.3M	640 x 424	Display on majority of mobile devices.

When satisfied with the previewed image, select **EXE** and press **OK** to create the JPEG copy. Pressing ▶ exits without creating a copy.

› Resize

This option creates a small copy of the selected picture(s), suitable for immediate use with various external devices. Four possible sizes are available.

Resize can be accessed from the Retouch menu or from Image playback, but there are slight differences in the procedure. From the Retouch menu, you select a picture size first and then select the picture(s) to be copied at that size. From Image Playback, you select a picture first and then choose the copy size; this way you can only copy one picture at a time.

› Quick retouch

Provides basic one-step retouching for a quick fix, boosting saturation and contrast. D-Lighting is applied automatically to retain shadow detail. Use **OK** and ▼ to increase or reduce the strength of the effect, then press **OK** to create the retouched copy.

› Straighten

It is best to get horizons level at the time of shooting, but it doesn't always happen. This option allows correction by up to 5° in steps of 0.25°. Use ▶ to rotate clockwise, ◀ to rotate anticlockwise. Inevitably, this crops the image slightly. As usual, press **OK** to create the retouched copy, or ▶ to exit.

› Distortion control

Some lenses create noticeable curvature of straight lines *(see page 144)*; this menu allows you to correct this in-camera. This inevitably crops the image slightly. **Auto** allows automatic compensation for the known characteristics of Type G and D Nikkor lenses, but not with other lenses.

Manual can be applied whatever lens was used: use ▶ to reduce barrel distortion, ◀ to reduce pincushion distortion. The Multi-selector can also be used for fine-tuning after **Auto** control is applied.

› Fisheye

Instead of correcting distortion, this menu exaggerates it to give a fisheye lens effect. Use ▶ to strengthen the effect, ◀ to reduce it.

› Color outline

This detects edges in the photograph and uses them to create a "line-drawing" effect.

› Color sketch

Turns a photo into something resembling a colored pencil drawing. Controls for Vividness and Outlines adjust the effect.

› Perspective control

Corrects the convergence of vertical lines in photos taken looking up, for example, at tall buildings. Grid lines aid in assessing the effect, and the strength of the effect is controlled with the Multi-selector. The process inevitably crops the original image, so it's vital to leave room around the subject. For alternative approaches to perspective control, and an example, *see page 144, 208.*

› Miniature effect

This option mimics the in-vogue technique of shooting images with extremely small and localized depth of field *(see page 125)*, making real landscapes or city views look like miniature models. It usually works best with photos taken from a high viewpoint, which typically have clearer separation of foreground and background. A yellow rectangle shows the area which will remain in sharp focus; you can reposition this using ▲/▼. Use ◀/▶ to make the "in-focus" zone appear wider or narrower.

Press ⊕ to preview the results and press **OK** to save a retouched copy.

› Selective color

Select particular color(s) (up to three); other hues are rendered in monochrome.

1) Choose Selective color in the Retouch menu. Press ▶.

2) Select an image from the thumbnail screen and press **OK**.

3) Use the Multi-selector to place the cursor over an area of the desired color. Press ⊙ to choose that color.

4) Turn the command dial and then use ▲/▼ to alter the color range.

5) To select another color, turn the command dial again to highlight another "swatch" and repeat steps 3 and 4.

6) To save the image, press **OK**.

› Edit movie

This allows you to trim the start and/or end of movie clips. It's far short of proper editing *(see page 194)*, but has its uses.

To trim a movie clip

1) Select a movie clip in full-frame playback.

2) Press ⊙ to start playing the movie. Press ▼ to pause, ▶/◀ to advance or rewind.

3) Pause on the frame you want to use as the start/end point. Press **OK**.

4) In the dialog which appears, select **Choose start/end point** and press **OK**. You can also opt to save the current frame as a still image.

5) Select **Start point** or **End point** and press **OK**.

6) Press ▲; select **Save as new file** or **Overwrite existing file** and press **OK**.

7) Repeat if necessary to trim the other end of the clip.

› Side-by-side comparison

This option is not strictly part of the Retouch menu; it is only available in full-frame playback, when a retouched copy, or its source image, is selected. It displays the copy alongside the original source image. Highlight either image with ◀ or ▶ and press 🔍 to view it full frame. Press ▶ to return to normal playback. To return to the playback screen with the highlighted image selected, press **OK**.

2 » MY MENU/RECENT SETTINGS

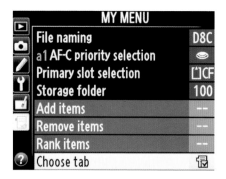

> My Menu

My Menu is a convenient way to speed up access to menu items and settings that you use frequently. Items from any other menu can be added to My Menu to create a handy shortlist, up to a maximum of 20 items.

To add items to My Menu

1) In My Menu, highlight **Add items** and press ▶.

2) A list of the other menus now appears. Select the appropriate menu and press ▶.

3) Select the desired menu item and press **OK**.

4) The My Menu screen reappears with the newly added item at the top. Use ▼ to move it lower down the list if desired. Press **OK** to confirm the new ordering of the list.

To remove items from My Menu

1) In My Menu, highlight **Remove items** and press ▶.

2) Highlight any item in the list and press ⊙ or ▶ to select it for deletion. A check mark appears beside the item.

3) If more than one item is to be deleted, use ▲/ ▼ to select additional items as above.

4) Highlight **Done** and press **OK**. A confirmation dialog appears. To confirm the deletion(s) press **OK** again. To exit without deleting anything, press **MENU**.

To rearrange items in My Menu

1) In My Menu, highlight **Rank items** and press ▶.

2) Highlight any item and press **OK**.

3) Use ▲ or ▼ to move the item up or down: a yellow line shows where its new

> *Tip*
>
> *To delete the item currently highlighted in My Menu, press the 🗑 button. A confirmation dialog appears. To confirm the deletion press the 🗑 button again.*

position will be. Press **OK** to confirm the new position.

4) Repeat steps 2 and 3 to move further items. When finished, press **MENU** to exit.

› Recent settings

Alternatively, you can activate the Recent Settings menu, which stores the 20 most recent settings made using the other menus. Note that these are not recorded automatically: you must first activate Recent Settings.

To activate Recent Settings

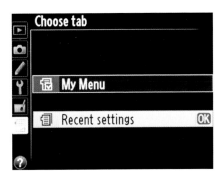

Choose tab switches between My Menu and Recent Settings.

1) In My Menu, select **Choose tab** and press **OK**.

2) Select **Recent Settings** and press **OK**.

The name of the menu changes to Recent Settings. Once activated, Recent Settings begins to record any changes to settings made using the other menus. Select any item from the list and press ▶ to access the range of options for that setting. To revert to My Menu you must use the **Choose tab** procedure again.

To remove items from the Recent Settings menu

It is possible to delete items from the list; this may be useful, for example, if you've recently made extensive use of the Retouch menu. By deleting the Retouch options from the Recent settings list you bring shooting settings—which are usually the ones to which quick access is most helpful—back to the top of the list.

1) Highlight any item in the list and press 🗑 to select it for deletion. A confirmation dialog appears.

2) To go ahead with the deletion(s) press 🗑 again. To exit without deleting anything, press **MENU**.

> **Note:**
> Even if you start with a "full" Recent settings menu (20 items), deleting the items simply makes the list shorter. The camera does not "recall" older items.

Chapter 3
IN THE FIELD

3 IN THE FIELD

Cameras like the D800 are so capable that getting focusing and exposure right is now rarely a major worry. However, there's a big difference between photos that "come out" and those that turn out exactly the way you want them. Possessing a great camera like the D800 does not guarantee stunning shots every time. Photography still—thank goodness—offers ample scope for individual expression, vision, and skill.

Although in-depth technical knowledge may no longer be essential to get correctly exposed, in-focus images, understanding essential photographic principles still helps you make the most of a powerful tool like the D800, and to make it do exactly what you want.

In any case, technical mastery is wasted without vision. With any camera, knowing what you want to say with your photo is vital. The clearer your ideas on what you want the photo to show and how you want it to look, the better. If you know why you're taking the shot and what you want it to show (and, equally important, what you want to leave out), then the how part should flow much more naturally.

Of course, the how part is the main concern of this book. Vision is a personal thing, but it's more easily realized if you understand how light works and how lenses and digital images behave.

RIGHT PLACE, RIGHT TIME «
Exposure, framing, and light all play their part, but there's no substitute for being in the right place at the right time—in this case, Tampere in Finland on a gorgeous summer evening. *128mm, 1/400th sec., f/13, ISO 400, bean bag.*

» DEPTH OF FIELD

No camera, however sophisticated, always sees what the eye sees. Nothing illustrates this better than depth of field. The eye scans the world dynamically, and whatever we're looking at, near or far, appears in focus (assuming you have good eyesight, or you're wearing glasses or contact lenses, that is). This gives us a sense that everything is in focus, which photographs frequently fail to match.

In simple terms, depth of field means what's in focus and what isn't. A more precise definition is as follows:

The depth of field is the zone, extending both before and behind the point of focus, in which objects appear to be sharp in the final image.

Depth of field can make a big difference between what the eye sees and what the camera captures. In landscape photography, for example, tradition suggests that pictures should appear sharp throughout. This matches our normal view of the world and so looks natural. At other times, however, creative intent or simple necessity may lead us to take photos with much narrower depth of field.

Three main factors determine depth of field: the focal length of the lens, the aperture, and the distance to the subject. As focal length and subject distance are often pre-determined (at least partly) by framing and other factors, aperture is key. The simple rule is: small aperture = big

STRENGTH IN DEPTH

The same setup, focused on the same plant, taken at f/4, f/8 and f/16, shows the effect on depth of field. Which shot you prefer is, of course, subjective.

depth of field, and vice versa. (Remember that aperture numbers are really fractions, so f/16 is small and f/4 is large.)

Long lenses (telephotos) produce less depth of field than wide-angle lenses. To increase depth of field, then, you would naturally think of fitting a wide-angle lens. However, real shooting situations are more complex. For example, suppose your main subject is a tree. To ensure that every branch and twig is sharp you need good depth of field, so you might fit a wide-angle lens. However, you then have to move in closer to keep the tree the same size in the frame—and moving closer reduces depth of field, losing at least some of the benefits of changing the lens. Moving closer also changes perspective and the apparent shape of the tree.

For many shots, changing the lens may not be an option anyway. When photographing a broad landscape, for instance, you may be limited to a single viewpoint.

Depth of field preview

When you look through the D800's viewfinder, the lens is at its widest aperture; if a smaller aperture is selected, it will stop down at the moment the picture is actually taken. This means that the viewfinder image frequently has less depth of field than the final picture. Like all good SLRs, the D800 has a depth of field preview button *(see page 14)*; this stops the lens down to the selected aperture, giving a sense of the depth of field in the final image. Unfortunately this also darkens the viewfinder image but it's usually still possible to assess the sharpness of defined edges (e.g. trees against the sky). If time allows, check images on the monitor after shooting, perhaps using the zoom function for a better look.

Hyperfocal distance

When you really need an image to be sharp from front to back, remember that depth of field extends both in front of and behind the point of exact focus. If you focus at infinity, there's nothing beyond that, so you are in effect wasting half your depth of field. In fact, depth of field extends further behind the point of focus than in front of it. In order to exploit this, you'll frequently see advice to "focus one third of the way into the picture", though this doesn't really make sense: after all, what's one third of the way from here to infinity?

What this advice is hinting at is focusing at the hyperfocal distance. This is the point—for any given aperture—at which depth of field extends to infinity. A rough way to find the hyperfocal point for any combination of lens and aperture begins by focusing on infinity. Use the depth of field preview and find the nearest objects which appear sharp: they are at the hyperfocal point. Refocus at this distance for maximum depth of field.

Apparent sharpness

Objects may appear sharp in a small print or a web image, but begin to look fuzzy when the image is enlarged. This can be obvious when zooming in to 100% on the D800's huge images; images, or parts of images, may often appear soft, yet everything appears pin-sharp in a medium-size print or on the page. Depth of field is relative, not absolute. It's easy to forget this and become obsessed with using the smallest apertures and determining the hyperfocal distance. All this may be overkill unless you are planning to make big prints or submit your images for magazine reproduction. The depth of field preview is a fair guide for images which will be printed small or only viewed on screen, but big enlargements are more critical. And there's another complication: using very small apertures promotes diffraction, an optical phenomenon which softens fine detail. With most lenses, the sharpest rendering at the focused distance will be at f/8 or f/11; stopping down further may reduce sharpness on the main subject even as it increases apparent sharpness on nearer and more distant objects.

HYPER SPACE

The near end of the tree branch is only a few inches from the lens. Focusing at the hyperfocal distance ensured the depth of field covered the entire field of view. *14mm, 1/500th sec., f/11, ISO 200.*

Capturing motion in a still image *(movies are another story—see page 182)* is a prime example of the camera not seeing what the eye sees. After all, we see movement, but the camera produces still images. However, there are very effective ways to convey movement in a still photograph, often revealing drama and grace that may be missed with the naked eye or in a movie.

Freezing the action

Dynamic posture and straining muscles shout "movement", even in a figure frozen by a fast shutter speed. Pin-sharp definition of muscles or facial expression can enhance the feeling of dynamism. But what is a "fast" shutter speed? Do you need to use the D800's maximum 1/8000th-second shutter speed every time?

The answer to the second question is definitely "No", but the answer to the first is harder to determine. The exact shutter

CREST OF A WAVE ⌄

A fast shutter speed freezes the action effectively, but we need other clues, such as body language and angle and, in this case, the wave, to give a sense of speed. *300mm, 1/1600th sec., f/10, ISO 100.*

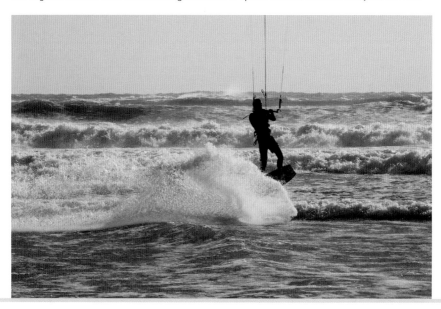

speed needed to capture a sharp, frozen image depends on various factors: not just the speed of the subject, but also its size and distance, which determine the scale of movement in relation to the image frame. It can be easier to get a sharp image of a train traveling at 200mph than of a mountain biker doing 30, because you need to be much closer to the biker. The direction of movement is another factor: subjects traveling across the frame need faster shutter speeds than those moving towards or away from the camera.

There's no "right" shutter speed, but you can play safe by setting the fastest shutter speed that's feasible under prevailing light conditions; this makes Shutter priority or Manual the obvious shooting modes—but see the Tip below. Check images on the monitor if you have time, and if a faster shutter speed appears to be necessary, be prepared to up the ISO setting *(see page 60)*. If you regularly shoot a particular activity, you'll soon discover what works.

ON THE TURN ⪢
An ideal situation for a panning shot: regular movement across the field of view. Using a 14mm lens meant I was very close to the riders and the blur at the edges of the frame was more pronounced. *14mm, 1/100th sec., f/9, ISO 200.*

Tip

Here's a simple "back-door" method to ensure you're always using the fastest possible shutter speed for the conditions: use Aperture priority mode and select the widest available aperture. If the speed still doesn't seem fast enough, increase the ISO setting.

Panning

With subjects moving across the field of view, panning is an excellent way to convey a sense of movement. By following the subject with the camera, it is recorded crisply while the background becomes blurred. The exact effect varies, so experimentation is advisable, preferably well before a critical shoot. Relatively slow shutter speeds are usually employed: anything from 1/8th—1/125th second can work and you may even go outside this range. Sports mode can't accommodate this and Shutter Priority or Manual are the only logical choices.

Panning is usually easiest with a standard or short telephoto lens, but the decision is often out of your hands

because shooting distance is fixed (e.g. behind barriers at sports events). To maintain a smooth panning movement during the exposure, keep following through even after pressing the shutter.

Blur

Blurred images can also give a strong sense of movement. It may be a necessity, because you just can't set a fast enough shutter speed, or it may be a creative choice, like the silky effect achieved by shooting waterfalls at exposures measured in seconds rather than fractions.

To ensure that only the moving elements are blurred, secure the camera on a tripod or other solid support, but you can also try for a more impressionistic effect by handholding. You need direct control of shutter speed, so Shutter priority or Manual mode are obvious choices.

DANCE TROPE ⌄
A slow shutter speed can create blur to convey movement. *55mm, 1/25th sec., f/5.6, ISO 6400.*

Tip

When you want to embrace creative blur, turn Vibration Reduction OFF on VR-equipped lenses.

Camera shake

Moving the camera unintentionally is another story. Serious shake would be obvious on any camera, but the exceptional resolution of the D800 means that even the most marginal softening is likely to be all too evident when images are viewed at 100%. Such images may be perfectly usable at normal sizes, of course, but when you want to exploit the full resolution offered by the D800, there's a self-evident need for ultra-careful handling and, very often, the use of camera support *(see page 224)*. Many Nikon lenses have a Vibration Reduction (VR) function *(see page 200)*.

The old rule of thumb, to avoid camera-shake in handheld shooting, was that the minimum shutter speed should be the nearest equivalent to the reciprocal of the focal length in use; e.g. with a 50mm lens, use nothing slower than 1/60th second, and so on. However, for the really critical user of the high-resolution D800, this is no longer good enough and the minimum shutter speed needs to be a stop or two faster; i.e., with a 50mm lens, 1/200 or 1/250 is a more appropriate minimum.

»COMPOSITION

Composition is an innocuous word for something that causes endless frustration and confusion. Composition, in its widest sense, is why some photos can be perfectly exposed and focused but have no emotional or aesthetic impact, while others may be technically flawed yet heart-stopping. Every time you take a picture you make many decisions (consciously or unconsciously): where to shoot from, where to aim the camera, how wide a view you want, what to include and what to leave out. These are the essence of composition.

Personally, I distrust the "C word"— "framing" relates much better to what photographers actually do. Discarding the "C word" also helps us jettison associated baggage, like "rules of composition", above all the stultifying "Rule of Thirds". The great Ansel Adams said many wise things about photography, and none was wiser than this: "There are no rules for good photographs, there are only good photographs."

Rules are made to be broken. It's principles that really help. And two basic principles underpin effective framing: know where the edges are, and see what the camera sees.

The edges define the picture, and the picture is everything within them. Our eyes and brains can "zoom in" selectively on the interesting bits of a scene, but the camera

WINDOW FRAME ⌃
Framing is about seeing a picture as a complete entity. Every element is important in this shot.
85mm, 1/100th sec., f/13, ISO 1600.

will happily and indiscriminately record all the bits we didn't even notice. This, all too often, produces pictures that seem cluttered or confusing. Hence the importance of seeing what the camera sees, not just what we want to see.

Looking through a traditional viewfinder is rather like looking through a

window. In Live View mode, on the other hand, you're very obviously looking at a screen. One immediate difference is that the screen image is more obviously two-dimensional—like a picture. Perhaps there are subtler differences too; intuition suggests that using the screen to frame a shot might make it easier to see the whole image—the bits you're interested in and the bits you aren't interested in.

Using the screen continuously isn't recommended as it makes handling awkward and wobbly, drains batteries, and the screen becomes unclear in bright sunlight. The viewfinder is superior for most shooting, but the "Live View—Picture" approach is a worthwhile exercise.

When you revert to the viewfinder, make a conscious effort to see it as a picture. Look at the whole image, take note of the edges and what's included, and consciously seek out distracting and irrelevant elements.

It may be worth recalling that even when you use the viewfinder, you are actually looking at a screen—what you see is the image projected by the lens onto the focusing screen inside the camera. Though the illusion of depth can be convincing, it is in fact a two-dimensional image.

ON REFLECTION ⌄⌄
This is certainly not a "Rule of Thirds" image, but placing the waterline centrally across the image emphasizes the symmetry of this sunset scene. *24mm, 1/20th sec., f/11, ISO 200, tripod.*

Framing the landscape

Landscape photography poses special challenges for framing, because—unlike, say, portraits—there's rarely a single subject. This, of course, makes "rules" even less useful.

Landscape is boundless. The first challenge is simply choosing which segment of it you want to photograph. Be selective, look for the essence of a place, and try and catch what makes it appeal to you. Remember the old saying, "seeing the wood for the trees".

"Views" are fine, but landscape is an all-round sensory experience. Many "view" photos end up looking small, or flat, or otherwise disappointing. Very often there's a simple reason: no foreground.

Foregrounds do many things. They show texture and detail, evoking sounds and smells and the rest of the sensory totality. Foregrounds can bring life and crispness where the distant scene is hazy or flatly-lit. Above all, using foregrounds connects you to the place, distinguishing your shots from the detached views that anyone might get from a bus or train. However, dull or ill-chosen foregrounds can be worse than useless.

Foregrounds can also help to convey depth and distance, and strengthen a sense of scale. If you want a photo of a mountain that conveys a sense of its awesome size, zoning in on it may not be the best way.

FREEZE-FRAME ⇡
A wide-angle lens, angled sharply downward, gives prominence to the patterns of ice by the river. *24mm, 1/30th sec., f/13, ISO 200.*

For many people, a shot of a peak in isolation is hard to "read". Including relatively familiar objects—walls, trees, houses—helps us make sense of the unfamiliar. Human figures are ideal, because we all know how small we are. Even really tiny figures are often very effective, provided they're still recognizably human.

To strengthen foregrounds, the first principle is to get close. The second is

to get closer. Use the third dimension: sit, kneel, crawl, climb.

Wide-angle lenses excel at encompassing both foregrounds and distant vistas, and as a "full-frame" (FX-format) DSLR, the D800 gives full value from these lenses. Using a longer lens helps pick out details or small sections of the larger landscape.

Small details can also convey the essence of a place. And if the light isn't magical, or if distant prospects look flat or hazy, details and textures and the miniature landscapes of a rockpool or forest clearing can save the day. Variations in scale and focus also help liven up sequences of pictures. Even if individually excellent, an unrelieved sequence of big landscape images will eventually become oppressive.

BRANCHING OUT ≽
Smaller details can say as much about a landscape as a wide view (cropped to the 4:5 aspect ratio). *56mm, 1/60th sec., f/11, ISO 400.*

»LIGHT

What makes a good photograph? For that matter, what makes any photograph? The answer is light. You can take photographs without a lens, even without a camera, but not without light. Because it's universal, it's easy to take it for granted, to think "the camera will take care of it". And there is some truth in this: cameras like the D800 are very good at dealing with varying amounts of light. However, there's much more to light than whether it's bright or dim. It really is worth tuning in to the endless variety of light. It generally leads to better pictures, and it certainly makes photography even more rewarding.

Light sources

Natural light essentially means sunlight— direct or indirect. Even moonlight is reflected sunlight. The sun itself varies little, but before it reaches the camera its light can be modified in many ways by Earth's atmosphere and by reflection. As a direct light source, the sun is very small, giving strongly directional light and hard-edged shadows, yet on an overcast day the same light can be spread across the entire sky, giving soft, even illumination. Studio photographers use massive "softboxes" to replicate this effect and, on a small scale, we can approach it with bounce flash *(see page 165).*

PAINTING WITH LIGHT ⌃
Soft, and yet highly directional, echoing the North light often favored for artists' studios, the window light seemed exactly right for this shot. *85mm, 1/50th sec., f/16, ISO 1600.*

Beyond sun and flash are many other artificial light sources: their color can vary enormously—making the D800's White Balance controls a godsend—but their other qualities, like direction and contrast, can usually be understood by comparison with more familiar sunlight and flash.

3 » CONTRAST AND DYNAMIC RANGE

Large-sensor cameras like the D800 and D4 typically have better dynamic range performance than comparable cameras with smaller sensors. In fact, according to independent tests, the D800 is currently the best performer on the market in terms of dynamic range, at least at lower ISO ratings.

In overcast, "soft" lighting conditions, contrast is much lower. Though rarely ideal for wide landscapes, this can be excellent for portraits and details. For some subjects soft light is highly desirable—photographers who specialize in shooting wild flowers often carry diffusers to create it.

The D800 offers several options for tackling high contrast, notably Active D-Lighting or D-Lighting *(see page 72)*. Shooting RAW files also gives a chance of recovering highlight and/or shadow detail in post-processing. However, all these have their limits. Sometimes it's simply impossible to capture the entire brightness range of a scene in a single exposure. The histogram display *(see page 71)* and the highlights display *(see page 78)* help to identify such cases. One option is to reframe your shot to exclude large areas of extreme brightness/darkness. Small patches of dead black or white often go unnoticed, but big featureless blobs will be all too conspicuous.

TOWERING CONTRAST ⟩⟩
From white, backlit steam to strong shadows, this image of a power station has very high contrast but—apart from the sun itself—the camera has managed to capture detail across the range. *24mm, 1/500th sec., f/16, ISO 200.*

Tip

For any camera, dynamic range steadily declines as ISO setting increases, and the D800 is no exception. If you're shooting in high-contrast conditions, use the lowest possible ISO setting for best results. This may of course require slow shutter speeds, which can be tricky with moving subjects. For static subjects, this is yet another reason why the D800 is often best used on a tripod.

Tip

For nearby subjects, like portraits, you can compensate for high contrast by throwing some light back into the shadows. You can use the D800's built-in flash (or an accessory flashgun) for fill-in light, or you may prefer a reflector, which has the advantage that you can easily preview the effect. Dedicated photographic reflectors are available, but you can often improvise with objects to hand, from a map to a white wall.

SEEING DOUBLE ⌃
This isn't one photo, it's two: one exposure for the shady foreground and one for the brighter background, merged using the LR/Enfuse plugin for Adobe Lightroom. *24mm, ⅓rd and ⅛th sec., f/11, ISO 100.*

Apart from Active D-Lighting and D-Lighting, or when they are stretched beyond their limits, digital imaging offers another solution. This involves making multiple exposures—typically one optimized for the bright areas, one for the mid-tones and another for the shadows—which can then be combined. The D800's HDR (high dynamic range) feature applies a similar approach in-camera *(see page 75)* but is limited to two source images.

For greater flexibility you can shoot several JPEG or RAW images and combine them in post-processing. HDR software can automate the merging of images, but I've always found it unpredictable and now

I habitually process manually, using Layer Masks in Adobe Photoshop. For any merging of images, a solid tripod is essential to keep source images aligned, and there can be additional problems when there's movement in the scene.

3 » DIRECTION OF LIGHT

With direct sunlight or a single flashgun, the direction of the light source is obvious. The same subject, seen from different angles, can appear totally different. At the other extreme, under an overcast sky, light comes from a wide area and its quality varies much less with the viewing angle. Completely even lighting is quite rare and there's usually at least a vague sense of direction to it. Still, the effects of the direction of light are much easier to appreciate with a single distinct source like direct sunlight. In simple terms, we refer to frontal lighting, oblique lighting and backlighting.

Frontal lighting strikes head-on, flooding everything with light—it's what you get with on-camera flash, or with the sun behind you. The resultant lack of shadows can make everything look flat and uniform, but may work well with subjects that derive impact from pure color, shape, or pattern. True frontal lighting doesn't lead to extremes of contrast, so exposure is usually straightforward.

PETAL POWER ⌄
Frontal lighting can work well for landscapes as well as other subjects with strong shapes and colors. *105mm, 1/250th sec., f/11, ISO 200.*

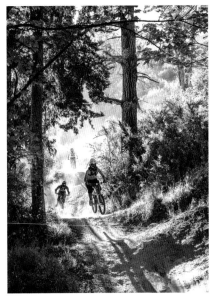

INSPIRING ⌃
Oblique lighting emphasizes the details and textures of the magnificent Orthodox Cathedral in Helsinki. *26mm, 1/400th sec., f/11, ISO 200.*

OUT OF THE WOODS ⌃
Back-lighting gave a special quality to this shot, especially when a group of riders raised some dust. *70mm, 1/800th sec., f/8, ISO 1600.*

Oblique lighting (or "side-lighting") is more complex and usually more interesting. Shadows emphasize form and texture, outlining hills and valleys. At really acute angles, the light accentuates fine details, from crystals in rock to individual blades of grass. This is one reason why dedicated landscape photographers love the beginning and end of the day. However, in hillier terrain, even a high sun may still cast useful shadows. In some places, such as deep gorges, direct light

only penetrates when the sun is high. What's really key is the angle at which light strikes the subject. Oblique lighting is terrific for landscapes, and many other subjects, but is often accompanied by high contrast, making exposure more tricky.

Backlighting can give striking and beautiful results, in almost any sphere of photography—nature, portrait, landscape—but needs careful handling. By definition, backlit subjects are in shadow and can easily appear as mere

silhouettes. Sometimes this is exactly what you want: bare trees can look fantastic against a colorful sky. If so, meter for the bright areas to maximize color saturation there, perhaps using exposure lock *(see page 51)*.

If you don't want a total silhouette effect, a reflector or fill-in flash can help, but don't overdo it or you risk negating the backlit effect. Backlighting combined with a reflector is a simple way to get great portraits. Translucent materials like foliage and fabric can glow beautifully when backlit, without turning into silhouettes.

LILY LIGHT ⌄⌄

Soft light was ideal here as strong shapes and shadows would have been distracting. It also avoided highlight clipping in the white petals. *300mm, 1/160th sec., f/7.1, ISO 100, bean bag.*

» COLOR

A prism in a sunbeam reveals all the colors of the rainbow. "White" light is a misnomer at any time, and natural light varies enormously in color. Generally our eyes adjust automatically, so that we go on seeing green leaves as green, oranges as orange, and so on. Only at their most extreme, as in the intense red of the setting sun, do the changing hues become really obvious.

Natural light changes color because the sun's light is filtered by the atmosphere. When the sun is high in a clear sky the light is affected least; when the sun is low its path through the atmosphere is much longer and the light is shifted towards yellow and ultimately red, while the "lost", or scattered, light turns the sky blue.

The warmer light of a low sun is another reason why landscape

DUSK DRAMA ⌄
The warm light of the evening sun contrasts with much cooler tones in areas illuminated only by the sky. It was almost dark by the time I got back to the road. *24mm, 1/40th sec., f/13, ISO 400, tripod.*

photographers traditionally favor mornings and evenings. It's not just that that we tend to find warm colors more pleasing—if that was all, the effect could be easily replicated with a Photoshop adjustment. In the real world, however, sunlit surfaces pick up a warm hue, while shadows receive light from the sky, tinting them blue. It's most obvious in snow scenes, but it's always true to some degree. This color difference between sunlit and shadow areas intensifies as the direct sunlight becomes redder, adding vibrancy to morning and evening shots. Filters can't duplicate this effect.

When shifting colors are part of the attraction, you don't want to "correct" them back to neutral. However, if White Balance is set to **Auto**, the D800 may attempt to do exactly this. Try changing White Balance to **Direct sunlight** instead.

It's the same with artificial light; sometimes you'll want to correct its color, sometimes it's better left alone. Portraits shot under fluorescent lamps often acquire a ghastly greenish hue, which you will surely want to avoid. Auto White Balance often improves matters, but it's less reliable with artificial light than natural light. Another option, if you are shooting JPEGs, is white balance bracketing *(see page 46)*.

Conversely, when shooting floodlit buildings, the variations in color may be part of the appeal. Results with Auto White

Tip

The D800 has a very good LCD screen, with a wider color gamut than previous cameras, but using it to judge the color accuracy of an image is still fraught, especially when the ambient lighting is strongly colored. Shooting RAW gives much greater scope for later correction.

Balance can be somewhat unpredictable and may not match what you see or what you want.

›› IMAGE PROPERTIES

Cameras and lenses, full as they are of amazing technology, still handle light and images differently from the human eye, and sometimes produce results which don't match what you see, expect or want. Some of these properties are related to the way lenses work and are common to both film and digital cameras, while other issues are specifically digital.

Optical Issues
Flare

Lens flare results from stray light bouncing around within the lens. It's most prevalent when shooting towards the sun, whether the sun is actually in frame or just outside. It may produce a string of colored blobs, apparently radiating from the sun, or a more general veiling effect.

Advanced lens coatings, like those in Nikkor lenses, greatly reduce the incidence of flare. Keeping lenses and filters scrupulously clean is also vital. Even so, if the sun's actually in the frame, some flare may be inescapable. It may diminish when the lens is stopped down. Otherwise, look for ways to reframe the shot or to mask the sun, for instance behind a tree.

If the sun isn't actually in frame, you can try to shield the lens. A good lens hood is essential, but further shading may be needed, especially with zoom lenses. You can provide this with a piece of card, a map, or even your hand. This is easiest with the camera on a tripod; otherwise it requires one-handed shooting (or a friend!). Check the viewfinder and/or playback carefully to see if the flare has gone away—and make sure the shading object hasn't crept into shot!

FLARE DEALING

Flare is all too evident in the first shot on the left, but by changing position slightly and shading the lens I was able to eliminate the flare altogether. *14mm, 1/200th sec., f/11, ISO 400.*

Distortion

Distortion means that lines that are actually straight appear curved in the image. As lens design continually improves it's far less of an issue than it once was. The worst offenders are likely to be zoom lenses that are old, cheap, or both, and distortion is often worst at the extremes of the zoom range.

When straight lines bow outwards, it's called barrel distortion; when they bend inwards it's pincushion distortion. Both can be forestalled using **Auto Distortion Control** (Shooting menu) or subsequently corrected using **Distortion Control** in the Retouch menu, or by using software like Nikon Capture NX or Adobe Lightroom. However, all these methods crop the image, so it's preferable to avoid the issue as far as possible by using good lenses.

DISTORTION ⨯
You'd never spot barrel distortion in the curved steps, but it's obvious in the building, especially top left. It has been slightly exaggerated in post-processing to make the point more clearly.
18mm, 1/160th sec., f/14, ISO 250.

Distortion may go unnoticed when shooting natural subjects with no straight lines, but it can still rear its ugly head when a level horizon appears in a landscape or a seascape, especially near the top or bottom of the frame.

Aberration

Chromatic aberration occurs when light of different colors is focused in slightly different planes, appearing as colored fringing when images are examined closely. The D800 has built-in correction for chromatic aberration during processing, but this applies only to JPEG images. Aberration can also be corrected in post-processing—with RAW images this is the only option.

Although it's a lens property, chromatic aberration can be exaggerated by the way light strikes a digital sensor. These effects are exaggerated by smaller sensors and therefore lenses such as Nikon's DX series are specifically designed for DX-format cameras. With the D800's larger sensor, older lenses designed for 35mm SLRs will probably give good results, but it's always a good idea to take some test shots and examine them closely before engaging in any critical work. The latest Nikkor lenses are optimized for cameras like the D800.

Vignetting

Vignetting is a darkening, or fall-off in illumination, towards the corners of the

image, most conspicuous in even-toned areas like clear skies. Most lenses display some vignetting at maximum aperture, but it should quickly disappear on stopping down. It can be tackled in post-processing but as usual this is a last resort.

Vignetting can be caused, or exaggerated, by unsuitable lens hoods or filter holders, or by the "stacking" of multiple filters on the lens.

Digital Issues
Noise
Image noise is created by random variations in the amount of light recorded by each pixel, and appears as speckles of varying brightness or color. It's most conspicuous in areas that should have an even tone, and normally most severe in darker areas. Unfortunately, cramming more megapixels onto a sensor creates a greater tendency to noise, but there have (so far) been compensating improvements in other aspects of sensor technology and in processing software which reduces image noise.

The D800's 36-megapixel sensor certainly created challenges for the designers, but its level of noise control is undeniably impressive. It's worth reflecting

NOISES OFF «
Compare the result at maximum ISO before (left) and after noise reduction is applied (below). *14mm, 1/100th sec., f/11, ISO 25,600.*

that its individual photosites are similar in size to those of the well-liked D7000 (DX-format, 16-megapixels). However, for the ultimate in low-noise/high-ISO photography the D800 cannot match the D4, and in some circumstances (typically ISO 6400 and above) it can also fall slightly behind the D700.

In general, though, noise levels are very good, but noise can still obscure the very fine detail which the 36-megapixel D800 is capable of capturing. Therefore, especially when images may be highly enlarged, it is more than usually important to shoot at the lowest ISO rating possible and expose carefully—underexposure increases the incidence of noise. The on-board High ISO Noise Reduction function *(see page 87)* is applied automatically to shots taken at ISO 1600 and above.

Clipping

Clipping occurs when highlights and/or shadows are recorded without detail, turning highlights a blank white and shadows an empty black. Clipping is indicated by a "spike" at either extreme of the histogram display, and you can also set the D800 to show highlight clipping during playback by flashing affected parts of the image (Playback display options, see page 78).

The D800 performs extremely well, but no camera is totally immune to clipping. As it's directly related to contrast and dynamic range, possible approaches to this issue have already been suggested *(see pages 43, 71)*.

Artefacts, aliasing and moiré

Normally when viewing a digital image it's not apparent that it is made up from individual pixels, but these can sometimes become apparent as "artefacts" of various kinds. They are usually more evident in low-resolution images, simply because of the smaller number (or coarser mapping) of pixels. Aliasing is most evident on sharp diagonal or curved lines, giving them a jagged or stepped appearance.

Moiré can occur when there's interference between areas of fine pattern in the subject and the grid pattern of the sensor itself. This often takes the form of aurora-like swirls or fringes of color. To

Tip

Even when present, moiré is normally not detectable on the camera's monitor, which can lead to the occasional unpleasant surprise when reviewing images on a computer later. In critical shooting it is advisable to have instant review on a larger screen, probably using a laptop or iPad. Of course many professional studio photographers routinely do this already.

compensate for such issues, most digital cameras employ a low-pass filter directly in front of the sensor itself, which actually works by blurring the image slightly. This is very effective in removing artefacts but means that images then need to be re-sharpened either in-camera or in post-processing (see below).

The essential difference between the D800 and D800E is that the D800 has a conventional low-pass filter whereas the D800E does not *(see page 11)*. On the face of it this means that the D800E poses a greater risk of moiré. This is most likely to manifest when shooting subjects with fine, repeating patterns, such as fabrics and some architectural surfaces (e.g. tiles). It is much less likely to arise when shooting landscapes.

The latest version of Nikon Capture NX2 includes tools for removing moiré effects.

Moiré can diminish or disappear when the lens is stopped down to a small aperture, but this is not always the answer. It results from the softening due to

Tip

Repeatedly opening and re-saving JPEG images on the computer multiplies the effect of JPEG artefacts. If repeated edits of the image are anticipated it's advisable to save the image as a TIFF first.

diffraction, which also blunts fine detail more generally. Small apertures are also not an option when you want to limit depth of field.

JPEG artefacts look much like aliasing, but are created when JPEG images are compressed, either in-camera or on the computer. Avoid them by limiting JPEG compression: use the **Fine** setting for images that may be printed or viewed at large sizes.

Sharpening images

Because of the low-pass filter, some degree of sharpening is required to make digital camera images look acceptable. However, too much sharpening can produce artefacts, including white fringes or halos along defined edges. JPEG images will be sharpened in-camera, and it's normally best to leave the D800's sharpening at its default setting. It's relatively easy to do a bit more sharpening later, but it's virtually impossible to get rid of artefacts once they've been created by over-sharpening. If time allows, sharpening may be best left until post-processing, when you can assess the effect at suitable magnification on the computer screen.

As the D800E does not have a "softening" filter, images may be expected to be sharper from the start and therefore sharpening settings, whether for in-camera processing or post-processing, will be more conservative.

3 » VISUALIZATION

I've photographed Helsinki's glorious Lutheran Cathedral numerous times; this time I wanted to catch one of the city's trams too. In fact I had a clear image in my mind before I started. This is often referred to as "visualization", a concept explored in depth by the late, great Ansel Adams.

This corner of the square gave a good perspective and the light was good on the Cathedral. Fortunately, there's another range of light-colored buildings just out of shot on the right, and these acted as a

giant reflector so the near side of the tram wasn't too dark. It was then just a matter of waiting. I didn't use a tripod because my camera position was on another tram-track and I might have needed to be able to get out of the way in a hurry!

Settings
> Focal length: 45mm
> Sensitivity: ISO 200
> Shutter speed: 1/400 sec.
> Aperture: f/11

SENATE SQUARE, HELSINKI, FINLAND

» SERENDIPITY

I was surprised to be able to get this close to a heron merely by walking slowly. The bird even gave me enough time to attach a 300mm lens and set up my tripod, though I took a couple of quick handheld shots first as "insurance". Using a 300mm lens handheld encouraged me to set a fast shutter speed. The DX crop helped to ensure the bird was large in the frame, while still yielding a 15-megapixel image.

Settings
> Focal length: 300mm (DX crop on: 450mm equivalent)
> Sensitivity: ISO 400
> Shutter speed: 1/1600 sec.
> Aperture: f/5.6

GRAY HERON

After riding the hill several times, stopping often to take photographs, I returned my hired bike then took one more ride up on the gondola and walked down. Fairly late in the day, the light was at its best, especially for this section of track.

Obviously, this shot is very similar to the one on page 139, but overall I prefer the "roomier" landscape composition in this image. It seems that *Privateer* magazine preferred this one too, as they published it across a double-page spread.

Settings
> Focal length: 24mm
> Sensitivity: ISO 400
> Shutter speed: 1/60 sec.
> Aperture: f/11
> Support: tripod

QUEENSTOWN MOUNTAIN BIKE PARK, NEW ZEALAND

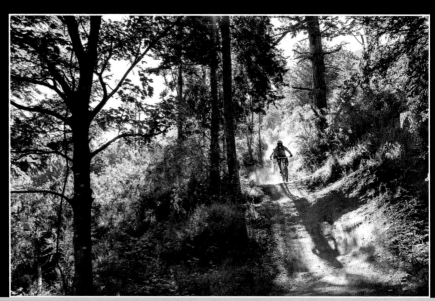

» CRITICAL FRAMING

This is one of those shots which may look simple but took some time to get right—even tiny movements of the tripod made a big difference to the result. This is a favorite location that I've visited many times; it's close enough to home that I sometimes go for a walk there. Still, this perfect spring afternoon, with light shining through the trees, gave me some of the best shooting opportunities I've ever had there—it was a fitting place and time for my very first outing with the D800.

Settings
> Focal length: 38mm
> Sensitivity: ISO 1600
> Shutter speed: 1/800 sec.
> Aperture: f/8
> Support: tripod

GRIZEDALE, LANCASHIRE

Chapter 4
FLASH

4 FLASH

The D800 has great flash capabilities, whether using its own built-in flash or more powerful accessory units but, even so, flash photography causes frequent confusion and frustration. The full benefits are only seen if the basic principles are grasped. What's fundamental is that all flashguns are small light sources and that they are all relatively weak.

This is especially true for built-in units like that on the D800 and most other DSLRs (those on compact cameras are typically even smaller and weaker). The small size of a flashgun gives its light a hard, one-dimensional quality. It's somewhat similar to direct sunlight, but even the strongest sunlight is slightly softened by scattering and reflection. There are various ways to soften and redirect the light (*see page 135* for more).

The weakness of flash is an even more fundamental property. Essentially, all flashguns have a limited range. If the subject is too far away the flash simply

TUNNEL VISION

The limited range of the built-in flash is obvious here. *28mm, 1/15th sec., f/5.6, ISO 800.*

Guide Numbers

In the past, determining flash exposures and working range required calculation based on the Guide Number (GN) of each unit, which relates subject distance to the f-stop (aperture setting) in use. It's really not necessary to memorize the formula; after all the D800 has very advanced flash metering which will usually ensure correct illumination. The GN does, however, help us compare the power and range of different flash units.

GNs are specified in feet and/or metres and usually for an ISO rating of 100. When comparing different units, be sure that the GNs for both are given in the same terms. Nikon quote the GN for the D800's built-in flash as 12 (metres) or 39 (feet).

Comparing GNs indicates, for instance, that Nikon's SB-910 offers around triple the power of the built-in unit, allowing shooting at three times the distance, at a lower ISO, or with a smaller aperture.

can't deliver enough light. The upshot is that flash—especially built-in flash—is not the answer to every low-light shot. Understanding its limitations helps us to decide when not to use flash, as well as when and how we can use it effectively.

› Fill-in flash

A key application for flash is for "fill-in" light, giving a lift to dark shadows like those cast by direct sunlight. This is why pros regularly use flash in bright sunlight (exactly when most people wouldn't think to use it).

Fill-in flash doesn't need to illuminate the shadows fully, only to lighten them a little. This means the flash can be used at a smaller aperture, or greater distance, than when it's the main light (averaging around two stops smaller, or four times the distance).

As part of its Creative Lighting System (CLS), Nikon has developed i-TTL balanced fill-flash, to help achieve natural-looking results when using fill-in flash,

i-TTL balanced fill-flash for DSLR

i-TTL balanced fill-flash automatically comes into play provided (a) matrix or center-weighted metering is selected and (b) a CPU lens is attached or lens data has been specified *(see page 110)*. If using an external flash, this must be CLS-compatible. The flash emits a series of virtually invisible pre-flashes immediately before exposure. Light reflected from these is detected by the metering sensor and analyzed together with information on ambient light. If type D or G lenses are used, distance information is also incorporated.

Standard i-TTL flash for DSLR

If spot metering is selected, this mode is activated instead. Flash output is controlled to provide correct illumination of the

ON THE BEACH ⌄
The background exposure is the same for both shots, retaining detail in the sky, but the foreground in the shot without flash (right) is too dark. *35mm, 1/250th sec., f/16, ISO 200.*

WHEEL BALANCE ☆
The flash was off-camera, to the right, but controlled wirelessly by the camera. i-TTL balanced fill-flash for DSLR gives a subtle result; the flash lifts the foreground but remains in balance with the general light levels. *24mm, 1/8th sec., f/11, ISO 200.*

subject but background illumination is not taken into consideration. This mode is more appropriate when flash is being used as the main light source rather than for fill-in flash.

Flash pop-up button

› Operating built-in flash

The built-in flash of the D800, like all such units, is small, low-powered and fixed in position close to the lens axis. Low power limits working range, while its size and position produce a rather harsh frontal light which is—to say the least—unflattering for portraits, though occasionally better than nothing. The built-in flash really blossoms when used for fill-in light, and can also be used to trigger remote flashguns.

1) Select a metering method: matrix or center-weighted metering is appropriate for fill-in flash. Spot metering is appropriate when flash is the main or only light.

2) Press ⚡ and the flash will pop up and begin charging. When it is charged the

Flash control button

ready indicator ⚡ is displayed in the viewfinder.

3) Choose a flash mode by pressing ⚡ and rotating the Main Command Dial until the appropriate icon appears in the Control Panel. *See page 160* for an explanation of the different flash modes.

4) Half-press the shutter-release button to meter and focus. Fully depress the shutter-release button to take the photo.

5) When finished, lower the flash by pressing it gently down until it clicks into place.

See page 160

Tip

The built-in flash covers the field of lenses up to 24mm (16mm if using DX crop). With wider lenses, the corners of the frame will not be covered by the flash. Some lenses may block part of the flash output at close range; removing the lens hood often helps.

HOODED FLAW ⌄
The built-in flash can cast a very obvious shadow from the lens and lens-hood, especially over close-up subjects.

 » FLASH EXPOSURE

The combinations of shutter speed and aperture that are available when using flash depend on the exposure mode in use. The following table applies when the built-in flash is used. With the optional SB-910/700 units it is possible to use faster shutter speeds *(see page 167)*.

Exposure mode	Shutter speed	Aperture
P	Set automatically by the camera. The normal range is between 1/250th and 1/60th sec., but in certain flash modes all settings between 1/250th and 30 sec. are available.	Set automatically by the camera.
S	Selected by user. All settings between 1/250th and 30 sec. are available.	Set automatically by the camera.
A	Set automatically by the camera. The normal range is between 1/250th and 1/60th sec., but in certain flash modes all settings between 1/250th and 30 sec. are available.	Selected by user.
M	Selected by user. All settings between 1/250th and 30 sec. are available. If user sets a faster shutter speed, the D800 will fire at 1/250th sec. when the flash is active.	Selected by user.

» FLASH RANGE

The usable range of any flash depends on its power, and on the ISO sensitivity setting and the aperture selected. If the flash does not reach as far as you want, you can increase its effective range, within limits, by using a higher ISO rating and/or a wider aperture—but check first that flash compensation *(see page 163)* is not in effect.

The following table shows the approximate range of the built-in flash for selected distances, apertures, and ISO settings. These figures are based on Nikon's published figures, verified by practical tests. It's not necessary to memorize all these figures but it is helpful to have a general sense of the range limitations that apply when using flash. In any given situation, a few quick test shots will soon establish a workable shooting range.

| | ISO equivalent setting | | | | | | Range | |
	100	200	400	800	1600	3200	meters	feet
	1.4	2	2.8	4	5.6	8	0.7–8.5	2′ 4″–28′
	2	2.8	4	5.6	8	11	0.6–6.1	2′–20′
	2.8	4	5.6	8	11	16	0.6–4.2	2′–13′ 9″
Aperture	4	5.6	8	11	16	22	0.6–3.0	2′–9′ 10″
	5.6	8	11	16	22	32	0.6–2.1	2′–6′ 11″
	8	11	16	22	32		0.6–1.5	2′–4′ 11″
	11	16	22	32			0.6–1.1	2′–3′ 7″

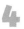 **» FLASH SYNCHRONIZATION AND FLASH MODES**

Flash, as the name implies, is virtually instantaneous: a burst of flash lasts just a few milliseconds. If the flash is to cover the whole image frame it must be fired when the shutter is fully open. However, at faster shutter speeds, DSLRs like the D800 do not in fact expose the whole frame at once. In the case of the D800, the fastest shutter speed which can normally be used with flash is 1/250th second. This is therefore known as the sync (for synchronization) speed.

The D800 has a number of flash modes and the differences between them are largely to do with options relating to synchronization and shutter speed. Choose a flash mode by pressing the ⚡ button and rotating the Main Command Dial.

› Front-curtain sync

Front-curtain sync (the default mode) fires the flash as soon as the shutter is fully open, i.e. at the first possible instant after

FLASH PAST ⌄
Front-curtain sync creates blur trailing ahead of the sharp image (look at the lead rider's helmet).

the shutter-release button is pressed. This is generally appropriate for fast response. In P and A exposure modes, the camera will set a shutter speed in the range 1/60th–1/250th second.

The "opposite" of front-curtain sync is, naturally enough, rear-curtain sync—see next page.

› Red-eye reduction

On-camera flash, especially built-in units, is very prone to "red-eye", where light reflects off the subject's retina. In animals you may see other colors.

Red-eye reduction works by shining a light (the AF-assist illuminator) at the subject just before the exposure, causing the subject's pupils to contract. This delay makes it inappropriate with moving subjects, and kills spontaneity. Most of the time, it's far better to remove red-eye using the red-eye correction facility in the Retouch menu (see page 113), or on the computer. Better still, use a separate flash, away from the lens axis, or no flash at all, perhaps shooting at a high ISO rating.

› Slow sync

This mode allows longer shutter speeds (up to 30 seconds) to be used in P and A exposure modes, so that backgrounds can be captured even in low ambient light. Movement of the subject or camera (or even both) can result in a partly blurred image combined with a sharp image where the subject is lit by the flash. This may be unwanted, but is often used for specific creative effect. This mode is unavailable when shooting in S and M exposure modes, because longer shutter speeds can then be set directly.

› Red-eye reduction with slow sync

Self-evidently, this combines the two modes named, allowing backgrounds to register. This may give a more natural look to portraits than red-eye reduction mode on its own, but is still subject to the same limitations owing to the delay. Like slow-sync, this mode is only available when using P and A exposure modes.

› Rear-curtain sync

Rear-curtain sync triggers the flash not at the first available moment (as per front-curtain sync) but at the last possible instant. This can be advantageous when photographing moving subjects because any image of the subject created by the ambient light then appears behind the subject, which looks more natural than having it appear to extend ahead of it. Rear-curtain sync can be used in any exposure mode: in P and A modes it also allows slow shutter speeds (below 1/60th second) to be used, and can therefore be called slow rear-curtain sync.

Shooting with rear-curtain sync can be tricky at longer exposure times as you need to predict where your subject will be at the end of the exposure, rather than immediately after pressing the shutter-release button. It is often best suited to working with co-operative subjects so that the timing can be fine-tuned after reviewing the images on the monitor.

TRUCK TRAILS
Front-curtain sync (left) makes the light-trails run ahead of the flash image, rear-curtain sync (right) lets them trail behind it. *28mm, ⅓rd sec., f/8, ISO 200.*

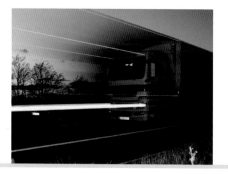
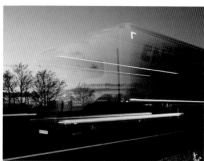

» FLASH COMPENSATION

Although the D800's flash metering is extremely sophisticated, you may still want to adjust flash output, perhaps for creative effect. Playing back images on the monitor makes it easy to assess the effect of the flash level, allowing compensation to be applied with confidence to further shots.

To use flash compensation, hold down ⚡ and rotate the Sub-command Dial. Flash compensation can be set from −3 to +1 Ev in ⅓ Ev steps. Positive compensation brightens areas lit by the flash, while leaving other areas of the image unaffected. Negative compensation darkens flash-lit areas, again leaving other areas unaffected. After use, reset the flash compensation level to zero.

> ### Tip
>
> *If the flash is already at the limit of its range, positive compensation can't make it any brighter. To brighten the flash image, use a wider aperture or move closer to the subject.*

Note:
Flash compensation and FV Lock work similarly when a compatible Speedlight is attached.

These shots show flash compensation in action, in 1 Ev steps. *85mm, 1/250th sec., f/13, ISO 320.*

-1

0

+1

› FV lock

FV lock is analogous to exposure lock *(see page 51)*, allowing flash output to be locked and the image to be reframed. It's most useful when you want to use flash with an off-center subject, especially one outside the area covered by the focusing sensors (and spot metering).

Using FV lock is somewhat involved: it requires assigning the Fn button to FV lock. It is more convenient to use flash compensation (see above), fine-tuning the compensation level using the screen.

1) To assign the Fn button to the FV lock function, navigate to Custom setting f4 Assign Fn button and select **Fn button press**. Select **FV lock** and press **OK**. The function can also be assigned to the Preview button (f5) or to the AE-L/AF-L button (f6).

2) Raise the built-in flash, and wait for it to charge.

3) Position the subject in the center of the frame and use half-pressure on the shutter to activate focus and metering.

4) Check that the flash-ready indicator ⚡ is shown in the viewfinder. Press the Fn button. A pre-flash is fired to set the flash level, after which FV lock icons appear in the viewfinder and control panel.

5) Recompose the image and shoot by pressing the shutter fully. The flash level remains locked if you take further shots.

6) Press the Fn button to release FV lock.

› Flash exposure bracketing

Flash exposure bracketing is another way to achieve the required level of flash illumination. It works just like exposure bracketing *(see page 45)*, and it's possible to bracket both flash and main exposure simultaneously. Flash bracketing requires Custom setting e5 **Auto bracketing set** to be set to **Flash only** (to bracket flash values only) or **AE & flash** (to vary the main exposure as well).

1) While pressing **BKT**, rotate the Main Command Dial to select the number of shots (2 or 3) for the bracketing burst.

2) While pressing **BKT**, rotate the Sub-command Dial to select the flash output increment between shots. Possible values run from 0.3 Ev to 2 Ev.

3) Frame, focus and shoot normally. The camera will vary the flash output (and exposure if AE & flash was selected) with each frame until the sequence is completed. A progress indicator appears in the Control Panel.

4) To return to normal shooting, press **BKT** and rotate the Main Command Dial until 0F appears in the Control Panel.

» USING OPTIONAL SPEEDLIGHTS

If you're serious about portrait or close-up photography, in particular, you'll soon find the built-in flash inadequate. Accessory flashguns, which Nikon calls Speedlights, enormously extend the power and flexibility of flash with the D800.

For really outstanding results using flash, Nikon's Creative Lighting System is hard to beat, and to take full advantage really requires a Nikon Speedlight. The current range offers six models, all highly sophisticated units mainly aimed at professional and advanced users, and priced accordingly.

Independent makers such as Sigma offer alternatives, many of which are also compatible with Nikon's i-TTL flash control. However such dedicated units are also rarely cheap. Many possibilities can be explored with much cheaper units. For instance, any flashgun, however basic, that has a "test" button allowing it to be fired manually, can be used for the "painting with light" technique. You may have an old flashgun at the back of a cupboard somewhere, and it's also worth looking in the bargain bin at the local camera shop.

There is only space in this book to cover Nikon's own units.

› Mounting an external Speedlight

1) Check that the camera and the Speedlight are both switched OFF, and that the pop-up flash is down. Slide the foot of the Speedlight into the camera's hot-shoe. If it does not slide easily, check whether the mounting lock on the Speedlight is in the locked position.

2) Rotate the lock lever at the base of the Speedlight to secure it in position.

3) Switch ON the camera and the Speedlight.

› Bounce flash and off-camera flash

The fixed position of the built-in flash throws shadows on close subjects and gives portraits a "police mugshot" look. A separate Speedlight mounted in the hotshoe improves things slightly, but you can make a much bigger difference by either:

1) bouncing the flash light off a ceiling, wall or reflector

2) taking the Speedlight off the camera.

Bounce flash

Bouncing the flash light off a suitable surface both spreads the light, softening hard-edged shadows, and changes its direction, producing better modeling on the subject.

Nikon's SB-910, SB-800, SB-700 and SB-600 Speedlights have heads which can be tilted and swiveled through a wide range, allowing light to be bounced off walls, ceilings and other surfaces. The SB-400 has a basic tilt capability, allowing light to be bounced off the ceiling or a reflector.

Off-camera flash

Taking the flash off the camera gives complete control over the direction of its light. The flash can be fired wirelessly (see

STILL LIFE ⌃
The same subject photographed using (from top) the built-in flash, off-camera flash, and bounce flash.

below) or using a remote cord; Nikon's dedicated cords *(see page 223)* preserve i-TTL flash control.

› Wireless flash

Many external flash units can be fired wirelessly using a "slave" attachment, but this gives no control over flash output. However, using Nikon Speedlights like the SB-910 and SB-700 allows full flash control, integrated by the camera's powerful metering system. The D800's built-in flash can act as the "commander" unit, controlling multiple Speedlights in one or two separate groups. This ability elevates the built-in flash from an "amateur" add-on to a powerful professional feature. To enable Commander mode, and tune the output of one or more remote Speedlights, use Custom setting e3 **Flash cntrl for built-in flash**. To allow the camera to regulate flash output set Mode to **TTL** for each unit or group. Comp settings are exactly like Flash Compensation *(see page 163)*.

› High speed flash sync

Nikon's SB-910, SB-700 and SB-R200 Speedlights all offer Auto FP High Speed sync. This enables the flash output to be phased or pulsed, allowing flash to be used at all shutter speeds. Combining flash with fast shutter speeds is useful, for instance, when ambient light levels are high or you wish to use a wide aperture.

Enable Auto FP High Speed sync using Custom setting e1: set either **1/320s (Auto FP)** or **1/250s (Auto FP)**. If a suitable Speedlight is attached, flash can then be used at any shutter speed from 30 seconds to 1/8000th second. Note, however, that the effective power (and therefore working range) of the Speedlight will reduce as the shutter speed gets faster.

See the manual for the individual Speedlight for more details, and take test shots and review them on the monitor if at all possible.

WIRELESS FLASH »
Off-camera flash, from the right, was used to balance up the lighting with the very bright welding torch. The flash was triggered wirelessly using the built-in flash as commander.

› Nikon Speedlight SB-910

Introduced in 2011, the SB-910 is the new flagship of Nikon's Speedlight range, replacing the SB-900. The most obvious change over the earlier model is a more intuitive control interface, in line with the SB-700. It offers multiple illumination patterns, an impressive 17–200mm zoom range (extendable to 14mm with the built-in diffuser) and automatic detection of sensor format: in other words, it knows whether it's attached to an FX-format or DX-format camera. The firmware is upgradeable when the flash is attached to a camera such as the D800. The Guide Number is quoted as 34 (ISO 100/meters), but the effective GN varies according to

the zoom setting. The SB-910 can also be employed as the "commander" unit giving integrated, fully auto flash control with multiple Speedlights.

Guide Number
GN 34 (meters) (ISO 100, set at 35mm zoom).

Flash coverage (lens focal length range)
17–200mm with Nikon D800; can be widened to 14mm with built-in adapter or separate diffusion dome.

Tilt/swivel
Yes

Recycling time
2.3 sec. with Ni-MH batteries; 4 sec. with alkaline batteries

Approximate number of flashes per set of batteries
190 with Ni-MH batteries; 110 with alkaline batteries

Dimensions (width x height x depth)
78.5 x 145 x 113 mm

Weight
420g (without batteries)

Included accessories
Diffusion Dome SW-13H, Speedlight Stand AS-21, Fluorescent Filter SZ-2FL, Incandescent Filter SZ-2TN, Soft Case SS-910

› Nikon Speedlight SB-700

The SB-700 is a highly featured unit with several innovative aspects including intuitive operation and a choice of illumination patterns. Though lacking a few of the high-end features of the SB-910, and being slightly less powerful, it still has everything most users will ever need. It's also smaller, lighter and significantly cheaper.

Guide Number
GN 28 (meters) (ISO 100, set at 35mm zoom)

**Flash coverage
(lens focal length range)**
Equivalent to 24–120mm on D800

Tilt/swivel
Yes

Recycling time
2.5 sec.

Approximate number of flashes per set of batteries
200

Dimensions (width x height x depth)
71 x 126 x 104.5

Weight
360g (without batteries)

Included accessories
Speedlight Stand AS-22, Nikon Diffusion Dome SW-14H, Incandescent Filter SZ-3TN, Fluorescent Filter SZ-3FL, Soft Case SS-700

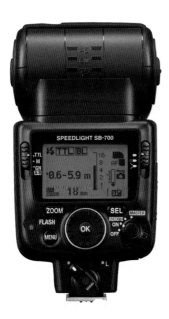

› Nikon Speedlight SB-400

A compact, light and simple flash.

Guide Number
GN 21 (meters) (ISO 100, set at 35mm zoom)

Tilt/swivel
Tilt only

Dimensions (width x height x depth)
66 x 56.5 x 80mm

Weight
127g (without batteries)

Included accessories
SS-400 soft case

› Nikon Speedlight SB-R200

Designed principally to work as part of a close-up lighting system *(see page 179)*. The SB-R200 can't be used as a stand-alone flash or attached to the camera's hot-shoe. It can be triggered using the D800's built-in flash as a commander, or an SU-800 Commander or SB-910/SB-700 Speedlight.

› Nikon Wireless Speedlight Commander SU-800

The Wireless Speedlight Commander SU-800 allows complete control over a complex setup of up to three groups of Speedlights.

› Nikon Speedlight Commander Kit R1C1 and nikon Speedlight Remote Kit R1

Dedicated kits for close-up photography. *See page 179* for more details.

» FLASH ACCESSORIES

Flash accessories such as diffusers, reflectors and remote leads allow yet more flexibility and greater control of the lighting effects achievable. Nikon has an extensive range, but when time is short or money is tight substitutes can often be improvized. Further accessories for the SB-910 may appear in the near future.

Nikon Speedlight Stand AS-19
Allows compatible Speedlights in a wireless setup to stand on any flat surface. Also includes a tripod socket.

Nikon TTL Sync Cord SC-28
Extending to 5ft (1.5 meters), this cord allows a compatible Nikon Speedlight to be positioned well away from the camera.

Flash diffusers
Flash diffusers are a simple, economical way to spread and soften the hard light from a flash head. Both the SB-910 and SB-700 include a diffuser. For other flashguns, Jessops Universal Flash Diffuser is an ultra-cheap option while Sto-Fen make a range of Omni-Bounce diffusers to fit most flash units.

Diffusers inevitably reduce the light reaching the subject; the D800's metering system will compensate for this, but the effective range of the flash will be reduced.

Flash extenders
A flash extender is another simple accessory which slips over the flash head, using mirrors or a lens to create a tighter beam and therefore extend the effective range of the flash. Again, the D800's metering system will automatically adapt. Nikon do not make flash extenders so a third-party option will be required. The 200mm zoom of the SB-910 means an extender will rarely, if ever, be needed.

Flash brackets
The ability to mount the flash off-camera, and therefore change the angle at which the light hits the subject, is invaluable in controlling the quality of light. Nikon's Speedlights can be mounted on a tripod or stand on any flat surface using the supplied stand, but for a more portable solution many photographers prefer an arm or bracket which attaches to the camera and supports the Speedlight. Nikon's SB-7 is a simple example. Novoflex and other manufacturers produce a wider range. All such brackets normally attach to the camera via a standard tripod screw, and a suitable bracket might easily be found in the bargain bin at a good camera shop.

Chapter 5
CLOSE-UP

5 CLOSE-UP

Most photography is about capturing what you can see with the naked eye. Close-up photography goes beyond this into a whole new world, or at least a new way of seeing the world. For many its fascination can last a lifetime.

For close-up photography, DSLRs like the D800 now reign supreme—the choice of reflex viewing and Live View gives the best of both worlds. Also, the D800 is part of the legendary Nikon system of lenses and accessories, which offers many additional options for close-up photography.

A key issue in close-up and macro photography is depth of field *(see page 125)*. As you move closer to the subject, depth of field becomes narrower. This has several consequences. First, it's often necessary to stop down to small apertures, which can make long exposures essential.

SMALL WORLD ❯❯
Close-up photography really opens our eyes to a different world. *62mm, 1/320th sec., f/7.1, ISO 200.*

Second, the slightest movement of either subject or camera can ruin the focus. For both reasons, a tripod or other solid camera support is often required. It may also be necessary to prevent the subject from moving (within ethical limits, of course!).

Because depth of field is so slim, focusing becomes critical. Merely focusing on "the subject" is no longer adequate and it is necessary to decide which part of the subject—an insect's eye, the stamen of a flower—should be the point of sharp focus. With its 51 AF points, the D800 can focus accurately within much of the frame, but this is also where Live View mode comes into its own. Live View AF *(see page 66)* allows the focus point to be set anywhere in the frame. If you prefer to use manual focus, Live View, with its zoomable view, also makes this ultra-precise.

BIRCH BARK ⌃
Close-up and macro photography encourages you to look at the world more closely. *135mm, 1/160th sec., f/5.6, ISO 160.*

Tip

To ensure that you're as close to the subject as you can possibly get, use manual focus and set the lens to its minimum focusing distance. Don't touch the focus control again; instead move either camera or subject until the image is sharp. This may seem slow, but does guarantee that you're as close as the lens will allow.

5 » MACRO PHOTOGRAPHY

There's no exact definition of "close-up" but the term "macro" really should be used more precisely. Macro photography strictly means photography of objects at life-size or larger, implying that a true macro lens should allow a reproduction ratio of at least 1:1. Many zoom lenses are badged "macro" when their reproduction ratio is around 1:4, or 1:2 at best. This still allows a great deal of fascinating close-up photography, but it isn't macro as classically defined. If you want to explore real macro photography without going to the expense of a dedicated macro lens, there are several possibilities—see opposite.

Reproduction ratio

The reproduction ratio (or image magnification) is the ratio between the actual size of the subject and the size of its image on the D800's imaging sensor. This measures 35.9 x 24mm and therefore an object of these dimensions captured at 1:1 would exactly fill the image frame. At 1:1, an SD memory (32 x 24mm) card will not completely span the long side of the frame but will overflow the short side. Of course, when the image is printed or displayed on a computer screen, it may appear many times larger than "life".

Working distance

The working distance is the distance required to obtain the desired reproduction ratio with any given lens. It is obviously related to the focal length of the lens: with a 200mm macro lens the working distance for 1:1 reproduction is double that of a 100mm lens. This can be a

PICK A CARD ❧

The first shot shows the closest view achieved with a "normal" 24–85mm zoom lens (approximately 1:2). The second, taken with a 50mm macro lens at the closest possible distance, gives approximately life size (1:1) reproduction. *85mm and 50mm macro, 1/15th sec., f/5.6, ISO 200.*

big help when photographing live subjects. For any given lens, working distance will be shorter with an FX-format camera like the D800 than with a DX-format camera such as the D7000. If a greater working distance is needed, and no alternative lens is available, switching Image area to DX is a real possibility; in fact it delivers images very comparable to those from a D7000.

› Close-up attachment lenses

Close-up attachment lenses are simple magnifying lenses that screw into the filter thread of the lens. They are light, easy to carry and attach, and relatively inexpensive. They are also easy to use as they are fully compatible with the camera's exposure and focusing systems. For best results, it's traditionally advised to use them with prime (fixed focal length) lenses.
Nikon produces six close-up attachment lenses: see the table below.

› Extension tubes

Extension tubes (also known as extension rings) are another simple, relatively

PINK ON BLACK ⌃
This shows the minimal depth of field typical in close-ups. *150mm, 1/800th sec., f/7.1, ISO 500.*

inexpensive, way of extending the close-focusing capabilities of an existing lens. An extension tube is just that: a tube which fits between the lens and the camera. This decreases the minimum focusing distance and thereby increases the magnification factor. Again they are light, compact and easy to carry and attach. Unlike close-up

Product number	Attaches to filter thread	Recommended for use with
0, 1, 2	52mm	Standard lenses
3T, 4T	52mm	Short telephoto lenses
5T, 6T	62mm	Telephoto lenses

attachment lenses they contain no glass elements and should not compromise the optical quality of the lens. They can also be used with almost any lens.

The Nikon system includes four Extension tubes—PK-11A, PK-12, PK-13 and PN-11—which extend the lens by 8mm, 14mm, 27.5mm and 52.5mm respectively. The PN-11 incorporates a tripod mount. These extension tubes do not support many of the camera's functions. There's no autofocus, although this is arguably less of a drawback in macro photography than in most other areas, no autoexposure modes (manual only) and no matrix metering.

But if you are prepared to use the D800 in the good old-fashioned way, it offers a great low-cost route into true macro photography.

› Bellows

Like extension tubes, bellows extend the spacing between the lens and the camera body. However, they are not restricted to a few set lengths. Again, there's no extra glass to impair optical quality. However, bellows are expensive, heavy and cumbersome, and take time to set up. They are usually employed in controlled shooting situations, such as a studio. Nikon's PB-6 bellows unit offers extensions from 48mm to 208mm, giving a maximum reproduction ratio of about 11:1. Focusing and exposure are manual only.

Warning!

Nikon state that some recent lenses are not compatible with accessories such as extension rings, bellows (see below) and teleconverters *(see page 209)*. Check the manual for each lens before using any of these accessories.

› Reversing rings

Known as reverse adapters or inversion rings, these allow lenses to be mounted in reverse: the adapter screws into the filter thread. This allows closer focusing with the lens than normal. They are ideally used with a prime lens, such as an old manual-focus 50mm f/1.8; Nikon's Inversion Ring BR-2A fits a 52mm filter thread.

Note:
Because accessories like extension tubes and bellows increase the effective physical length of the lens, they also increase the effective focal length. However, the physical size of the aperture does not change. The result is to make the lens "slower"; that is, a lens with a maximum aperture of f/2.8 starts to behave like an f/4 or f/5.6 lens. This makes the viewfinder image dimmer than normal, and affects the exposure required (though the camera's metering will compensate). Reversing rings do not have this effect.

» MACRO LIGHTING

We've already observed that macro photography often requires small apertures. This may lead to long exposure times, creating particular problems with mobile subjects. Additional lighting is often required, which usually means flash. However, regular Speedlights are not designed for such close-range use. If mounted on the hotshoe, the short working distance means that the lens may throw a shadow onto the subject. All these limitations are even more acute with the built-in flash.

Specialist macro flash units usually take the form of either ring-flash or twin flash. Because of the close operating distances they do not need high power and can be relatively light and compact.

Ring-flash units encircle the lens, giving an even spread of light even on ultra-close subjects (they're also favored by some portrait photographers). Nikon's discontinued SB-29s may still be found at some dealers, while alternatives come from Sigma and Marumi.

Nikon now favours the twin-flash approach with its Speedlight Commander Kit R1C1 and Speedlight Remote Kit R1. Both utilize two Speedlight SB-R200 flashguns mounted either side of the lens; the difference is in how these are controlled. The R1C1 uses a Wireless Speedlight Commander SU-800, which

The Sunpak LED Macro Ring Light

mounts on the hotshoe, while the R1 requires a separate Speedlight as Commander. These kits are quite expensive but they do give very flexible and controllable light on macro subjects.

An alternative is to use LED lights, like the Sunpak LED Macro Ring Light. Its continuous output allows you to preview the image in a way not possible with flash. However, its low power limits it to close, and usually static, subjects. But then again, it is very cheap.

› Improvization

Dedicated macro flash units aren't cheap, and may be unaffordable or unjustifiable when you just want a taste of macro work.

Fortunately, you can do lots with a standard flashgun, plus a flash cord. With more basic units, you'll lose the D800's advanced flash control, but it only takes a few test shots to establish settings that you can use repeatedly (make sure you keep notes). The other essential is a small reflector, perhaps just a piece of white card. Position the card as close as possible to the subject for maximum benefit.

This setup can even be more flexible than twin flash or ring-flash, allowing the light to be directed wherever you choose. On static subjects, "painting with light" *(see page 165)* is also an interesting option.

PENCIL PARADE

This shot was taken with the Sunpak Macro Ring Light. It gives good illumination on the subject but the background is dark even though it's actually a white wall and only about 20in. away. *50mm macro, 1/250th sec., f/5.6, ISO 800, tripod.*

» MACRO LENSES

True macro lenses achieve reproduction ratios of 1:1 or better and are optically optimized for close-up work, though they are normally very capable for general photography too. This is certainly true of Nikon's widely admired Micro Nikkor lenses, of which there are currently five.

The 60mm f/2.8G ED AF-S Micro Nikkor is an upgrade to the previous 60mm f/2.8D. Advances include ED glass for superior optical quality and Silent Wave Motor for ultra-quiet autofocus.

The 105mm f/2.8G AF-S VR Micro Nikkor also features internal focusing, ED glass and Silent Wave Motor, but its main claim to fame is as the world's first macro lens with VR (Vibration Reduction). As the slightest camera shake is magnified at high reproduction ratios, technology designed to combat its effects is extremely welcome, allowing you to employ shutter speeds up to four stops slower than otherwise possible. However, though it may neutralize camera shake, it has no effect on subject movement.

The 200mm f/4D ED-IF AF Micro Nikkor is an older design, but is particularly suited to photographing the animal kingdom, as

105mm f/2.8G AF-S VR Micro Nikkor

its longer working distance means there is much less chance of frightening your subject away.

If you're happy using DX crop mode, there are also two Micro Nikkor lenses specifically engineered for the DX format. If you're just dipping your toe in the waters, the 40mm f/2.8G AF-S DX Micro Nikkor has the attraction of being Nikon's least expensive macro lens. The 85mm f/3.5G ED VR AF-S DX Micro Nikkor is a versatile focal length and has internal focusing, ED glass and Silent Wave Motor.

MAGNIFIED MONGOOSE »
Long lenses are very useful for some subjects that can run away (note that focus is on the eye). *100mm, 1/250th sec., f/5.6, ISO 320.*

Chapter 6
MOVIES

6 MOVIES

Nikon pioneered movies on DSLRs, launching the D90 with movie capability in August 2008. For many, the true purpose of the DSLR is just to shoot stills and its ergonomics are still best for this, but it has become ever clearer that the addition of video is no mere sideshow.

Dedicated movie makers have embraced DSLRs because their large sensors deliver image quality that's superior—and just plain different—to standard camcorders, while photojournalists welcome the ability to shoot high-quality stills and video on the same camera. However, still photography and movies are very different media, requiring distinctly different approaches for the best results.

Movie quality

The D800 can shoot movies in full HD (high definition) quality with a frame size

WATCH THE BIRDIE ⌄
It's easier to get really shallow depth of field—or "the DSLR look"—than with most video cameras.

LOW-LIGHT SHOW ⤊
The D800 also scores top marks when it comes to shooting in low light.

WIDE AND HANDSOME ⤊
Here the focal length was 15mm: on a full-frame camera like the D800 that's a seriously wide view.

of 1920 x 1080 pixels. It does not follow, however, that shooting at the maximum frame size is always a good idea. For example, Vimeo.com, widely recognized as a key outlet for quality movie-making online, is standardized on the 1280 x 720 frame size. On the other hand, the latest iPads have a a 2048 x 1536 display, boasting more pixels than full HD.

The D800's frame size options are 1920 x 1080, 1280 x 720, and 640 x 424 pixels. Even the smallest size has wide applications online and on mobile devices. The lower settings also allow you to record more video on the same memory card—but, it must be said, footage shot in full HD may be more "future-proof".

Advantages
DSLRs in general, and the D800 in particular, have several real advantages over standard camcorders. One is their

ability to achieve very shallow depth of field *(see page 125)*—movie-makers have particularly embraced this "DSLR look". This is a direct consequence of the large sensor, which also brings greater dynamic range *(see page 136)* and better quality at high ISO ratings, extending the possibilities for shooting in low light.

Another plus is the D800's ability to use the entire array of Nikon-fit lenses (see chapter 7, *page 210*). In particular, it can use wide-angle lenses which go well beyond the range of most camcorders.

Limitations
The D800 is one of the best DSLRs yet for shooting movies, but some limitations remain. SLR ergonomics make handheld shooting awkward. Movie autofocus is similar to Live View—which, we've already noted, often struggles to keep up with mobile subjects.

6 » SHOOTING MOVIES

› Preparation

Before shooting, select key settings in the **Movie settings** section of the Shooting menu (see below). Other settings such as Picture Controls should also be set in advance. A good way to check the general look of a shot is by using Live View Exposure Preview *(see page 64).*

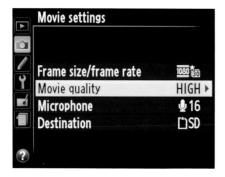

Movie settings has four sub-menus:

Frame size/frame rate sets the movie image size and frame rate. The size options are: 1920 x 1080 pixels; 1280 x 720 pixels; 640 x 424 pixels. The frame rate options vary according to the size chosen and whether PAL or NTSC *(see pages 108, 239)* is selected for video mode. *(See also Image area, below.)*

Movie quality sets the compression level (see Note): options are **High** or **Normal**.

Note:
Footage recorded to a card is always compressed to some degree, though High quality is fine for most purposes (akin to JPEG Fine for stills). For professional broadcasters and filmmakers, however, the D800 can also export uncompressed movie footage when a compatible recorder is connected to the camera via the HDMI port.

Microphone determines the sensitivity of the built-in microphone (or an external microphone if attached). The options are: **Auto**, **Manual Sensitivity** (in steps from 1–20) and **Off**.

Destination determines which card slot is used for recording movies. Often it makes sense to use one card for stills and one for movies. The settings screen shows available recording time for each card at current settings.

Image area

The D800 records movies with a "widescreen" aspect ratio of 16:9; normally these use almost the full width of the sensor *(see diagram on page 54).* However, if **Image area** *(see page 55)* is set to DX, or **Auto DX Crop** is On and a DX lens attached, the camera will employ a smaller area. This does not affect the output size of

the footage; you can still record full HD as well as smaller frame sizes. This not only allows the use of DX lenses (which can be light, inexpensive and have very wide zoom ranges) but also gives a "teleconverter" effect *(see page 55)*.

Focusing

Movie focusing options are the same as Live View *(see page 66)*, including manual focus. While the quality of the Live View display makes manual focusing fairly easy, it is hard to operate the controls smoothly, especially when handholding the camera. Yet again, this supports using a tripod, especially with longer lenses. Older lenses, with large and well-placed focus rings, can be easier to focus manually.

> ### *Tip*
>
> *Movie and TV credits often include a "focus puller". This is an assistant camera operator, whose sole task is to adjust the focus, normally between predetermined points (e.g. from one character's face to another). This frees the lead camera operator to concentrate on framing, panning and zooming. Frequently, the focus puller uses the distance scale on the lens barrel, relying on previously measured distances.*

Without doubt, Live View/movie autofocus is the D800's "Achilles heel"— albeit one shared by most DSLRs. Live View AF is slow and often lags behind moving subjects. The lens can sometimes "hunt" for several seconds. AF operation can also be obtrusively noisy, especially when using the built-in microphone.

This becomes a particular issue with subjects moving towards or away from the camera—implying that it is easier to shoot action when subject distance is relatively constant (e.g. panning shots from the inside of a curve). Using a fixed focus for each shot is often perfectly viable, especially when depth of field is good (e.g using wide-angle lenses). To use a fixed focus for a shot, set focus in Live View before starting to shoot and avoid pressing the shutter-release button or **AF-ON** while shooting. By all means experiment with AF for movies, but this will bring home its limitations.

Exposure

Exposure control depends on the exposure mode selected before shooting begins.

In Program or Shutter-priority mode, exposure levels can be adjusted by ±3 Ev using 🔳 and the Main Command Dial. Shutter speed, aperture and ISO are set automatically. In fact, for movies there is no functional difference between P and S modes.

In Aperture-priority mode, aperture can be manually adjusted during shooting.

Shutter speed and ISO are set automatically. Aperture control is obviously vital if you're seeking to create "DSLR-look" footage with slender depth of field.

Manual mode gives you direct control over aperture, shutter speed and ISO sensitivity. The shutter speed does affect how moving subjects are recorded, so this can be very important. However, the available shutter-speed range is limited; you can't use ½ second exposures and still shoot 24 frames per second! The normal limit is 1/30th second.

While all these adjustment options are welcome, making them while shooting is fiddly. It's difficult to avoid jogging the camera unless it's on a solid tripod, and the built-in microphone may also capture the sounds of these operations. Another consequence can be obtrusive changes in brightness level in the resulting footage. Getting these things right takes practice.

Power aperture

You can use the Fn and Preview buttons to govern aperture. Use Custom setting g1 and select **Power aperture (open)**. This also automatically sets g2 to **Power aperture (close)**. Once these are enabled, each press on the Fn button widens the aperture, while the Preview button makes it smaller. This is quieter and smoother than using the Sub-command Dial, but it only works in Live View, not while actually shooting.

Sound

The D800 has a built-in microphone, giving reasonable quality mono output. Though front-aiming, it readily picks up any sounds you make operating the camera (focusing, zooming, even breathing). If you want to include dialog or "talking heads", keep subjects close to the camera and ensure that background noise is minimized.

Fortunately the D800 also allows you to attach an external microphone. External microphones connect to a standard 3.5mm socket under the cover on the camera's left side. This automatically overrides the internal microphone.

The D800 allows you to monitor sound during shooting by plugging headphones into the appropriate socket. However, you can't adjust recording level while shooting, so check and set sound levels beforehand in Live View.

› Shooting

1) Choose exposure mode, AF mode and AF-area mode as for Live View shooting.

2) Rotate **Lv** to the 🎥 position and activate Live View by pressing its center button.

3) Check framing and exposure. In A mode, set the aperture; in M mode set shutter speed and ISO also. Initialize focus by half-pressure on the shutter-release button (or focus manually).

4) Check sound levels: press and hold 🔍⊠ to reveal the levels indicator. Use ◀/▶ to highlight the microphone icon then ▲/▼ to adjust level. If headphones are attached you can adjust headphone volume in a similar manner.

5) Press **O** to start recording the movie. **REC** flashes red at the top of the screen while recording, and an indicator shows the maximum remaining shooting time.

6) To stop recording, press **O** again.

7) Exit Live View by pressing **Lv** again.

Tip

*You can also use the shutter-release button to start and end movie recording: see Custom Setting g4 **Assign shutter button**. This removes the option to shoot a still frame directly during movie recording.*

› Index marking

Adding index marks at key points during a take can facilitate editing. Use Custom Setting g2 **Assign preview button** and select **Index marking**. Now, pressing the preview button during recording adds an index mark—a maximum of 20 for each movie clip.

The golden rule is: think ahead. If a still frame isn't quite right, you can review it, change position or settings, and be ready to reshoot within seconds. To shoot and review even a short movie clip eats up much more time, and you may not get a second chance anyway. It's doubly important to get shooting position, framing, and camera settings right before you start. It's easy to check the general look of the shot by shooting a still frame beforehand, but this does not allow for movement of subject, the camera, or both; you can also do a "dry run" in Live View before shooting for real.

If you're new to the complexities of movies, start with simple shots. Don't try zooming, panning and focusing simultaneously: do one thing at a time. Many subjects can be filmed with a fixed camera: waterfalls, birds at a feeder, musicians playing, and loads more. Equally, you can become familiar with camera movements shooting static subjects: try panning across a wide landscape or zooming in from a broad cityscape to a detail of a single building.

› Handheld or tripod shooting

It's impossible to overemphasize the importance of a tripod for shooting good movies. Shooting handheld is a good way to reveal just how wobbly you really are—especially since you can't use the viewfinder. Of course, even professional movie directors sometimes use handheld cameras to create a specific feel, but there's a big difference between controlled wobble for deliberate effect and unwanted, uncontrolled, and unending shakiness. Using a tripod or other suitable camera support is the best and easiest way to give movie clips a polished, professional look.

If you choose to handhold, or need to shoot a clip when no tripod is available, it really pays to approach the task carefully. Adopt a comfortable stance where you won't be jostled, and look for something solid on which you can rest your elbows. Sometimes you can get better results by sitting with elbows braced on your knees. Whatever you do, think "steady".

> ### *Tip*
>
> *A standard tripod with a pan-and-tilt head is a good start. If you're serious about movies, consider a dedicated video tripod, or tripod-head. This isn't necessarily heftier than its standard counterpart, but the tripod head is specifically designed to move smoothly.*

ON THE LEVEL ⌃
Panning with the boat is an obvious shot, but the tripod needs to be leveled correctly, or the water could appear to be on a steep slope!

› Panning

The panning shot is a movie-maker's staple. Often essential for following moving subjects, it can also be used with static subjects, for instance, sweeping across a vast panorama. Of course, landscapes aren't always static, and a panning shot combined with breaking waves, running water or grass blowing in the breeze can produce beautiful results.

Handheld panning is very problematic. It may be acceptable when following a moving subject, but a wobbly pan across a grand landscape will definitely grate. You really, really need a tripod for this—and it needs to be properly leveled, or you may start panning with the camera aimed at the horizon but finish seeing nothing but ground or sky. Do a "dry run" before shooting.

Keep panning movements slow and steady. Panning too rapidly can make the shot hard to "read" and even nauseate the viewer. Smooth panning is easiest with video tripods, but perfectly possible with a standard model; leave the pan adjustment slightly slack. Hold the tripod head, not the camera, and use the front of the lens as a reference to track steadily across the scene.

6

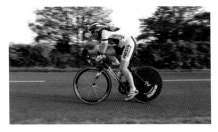

PANNING FOR GOLD ⌃
A classic panning shot but still tricky to follow neatly when hand-holding.

With moving subjects, the speed and direction of panning is dictated by the need to keep the subject in frame. Accurate tracking of fast-moving subjects is very challenging and takes a lot of practice.

› Zooming

The zoom is another fundamental technique. Moving from a wide view to a tighter one is called zooming in, the converse zooming out. Again, a little forethought makes all the difference to using the zoom effectively; consider the framing of the shot at both start and finish. If you're zooming in to a specific subject, double-check it's central in the frame.

No current lenses for the D800 are designed specifically for shooting movies; this is most obvious in relation to zooming. Firstly, none of them have such a wide zoom range as video camera lenses. More seriously, it's hard to achieve a really

STILL WATERS ⌄
The camera can "explore" a scene like this bay in Helsinki, either by panning across it or by zooming in on specific features, such as buildings.

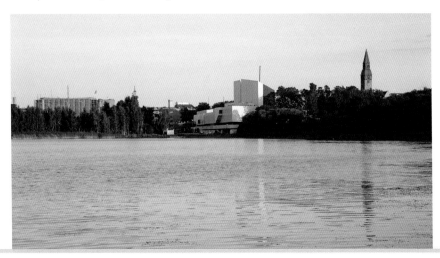

smooth, even-paced zoom action. Practice does help, and mounting the camera firmly on a solid tripod helps even more. Zooming while handholding virtually guarantees jerky zoom and overall wobbliness. It's also worth experimenting to see which lens has the smoothest zoom action. There's definitely a gap in the market for a lens with wide focal length range and powered zoom.

When zooming, remember that depth of field *(see page 125)* decreases at the telephoto end of the range. Your subject may appear perfectly sharp in a wide-angle view but end up looking soft when you zoom in. Set focus at the telephoto end, whether your planned shot involves zooming out or zooming in.

› Still frame capture

To capture a still frame during movie shooting, simply press the shutter-release button. This will end movie recording, take the shot and return you to Live View. The resulting image will use the 16:9 aspect ratio; quality and size are determined by your still image settings *(see pages 51, 55)*. For image sizes see the table below.

› Lighting

For obvious reasons, you can't use flash. LED light units specifically designed for DSLR-movie shooting are readily available, and the D800's ability to shoot at high ISO ratings is invaluable.

› Importing movies to the computer

The basic procedure for importing movies is much the same as for stills *(see page 230)*. Nikon Transfer will recognize and import them, but you will probably want to store movies in a different folder than still images. Often it's better to import movies through your editing software (see below). This ensures that all your movie clips are stored in the same place and that the software can immediately locate them for editing purposes.

Image area	Image size setting	Size (pixels)
FX movie	Large (or RAW)	6720 x 3776
	Medium	5040 x 2832
	Small	3360 x 1888
DX Movie	Large (or RAW)	4800 x 2704
	Medium	3600 x 2024
	Small	2400 x 1352

6 » EDITING

The D800 doesn't shoot movies. Like all movie cameras, it shoots movie clips. A single clip straight from the camera may occasionally serve—if you capture a bank raid in progress it could even earn you a reward!—but in general, turning a collection of clips into a movie that people actually want to see requires editing, and specifically Non-Linear Editing (NLE). This simply means that clips in the final movie don't have to appear in the same order in which they were shot. For example, you might shoot a stunning tropical sunset on the first night of your holiday, but use it as the closing shot in your movie.

With today's software, editing digital camera movies is almost easier to do than it is to describe. The D800's .MOV movie format is accepted by most editing programs—and any recent computer will probably have some such software pre-installed.

For Mac users there's Apple's iMovie, part of the iLife suite, included with all new Macs. The Windows equivalent is Windows Movie Maker, pre-installed with Windows Vista; for Windows 7 it's a free download from windowslive.com. A slightly more advanced option (for either platform) is Adobe Premiere Elements.

All offer NLE, and it's also non-destructive. This means that editing does not affect your original clips (unlike cutting and splicing bits of film in the "old days"). During editing, you work with preview versions of these clips and the software merely keeps "notes" on the edit; this is

iMOVIE ⌃
The iMovie editing program comes with all new Apple Macs.

WINDOWS MOVIE MAKER »
The Windows Movie Maker software is bundled with many Windows PCs.

analogous to the way programs like Lightroom work with still photographs. At the end, you export the result as a new movie; this can take a long time to "render".

All these programs make it easy to trim and reorder your original clips. Instead of simply cutting instantaneously between shots, you can apply various transitions such as dissolves, wipes and fades. You can also adjust the look of any clip or segment of the movie; as well as basic controls for brightness, color and so on, a range of special effects can be added: you can, for instance, make your movie look scratched and faded, as if it was shot on film 50 years ago rather than yesterday with a DSLR.

You can also add other media, like still photos and sound. You can insert stills individually at appropriate points or create slideshows within the main movie. Again

Tip

It's fun to play with special effects, transitions, and so forth—and non-destructive editing means you can do so to your heart's content—but, for the sake of the audience, it's best to use them sparingly in the final version.

Tip

Remember that, if you haven't created them yourself, still photos, music, and other media are someone else's copyright. Look for open-source material or make sure you get the copyright owner's permission to use their work.

various effects and transitions can be applied to give slideshows a much more dynamic feel.

It's equally easy to add a new soundtrack, like a voiceover or music, to part or all of the movie.

Last but not least, you can also add titles and captions—perhaps even crediting yourself as producer, director, camera operator, sound recordist, editor, Best Boy and Key Grip.

› Taking it further

The D800's advanced movie capabilities mean that it will appeal to many experienced video-makers as well as newcomers who want to explore this field. There's far more to it than we can cover in a book of this scale. A useful next step would be *Understanding HD Video* by Chiz Dakin, from this publisher.

Chapter 7
LENSES

7 LENSES

There are many reasons for preferring a DSLR like the D800 over a compact. One of the most important is the ability to use a vast range of lenses, including Nikon's own legendary system as well as lenses from other makers.

Nikon's F-mount for lenses is now—in its basic form—50 years old. A philosophy of continuity of design means that most Nikkor lenses will work on the D800 (though sometimes with major limitations).

However, there are still sound reasons why the best lenses for the camera are among the more recent range. One obvious one is that many older lenses lack a CPU and therefore many automatic functions are unavailable.

Another reason for preferring lenses designed specifically for digital cameras relates to the way light reaches the minute individual photodiodes or "photosites" on the camera's sensor. Because these are slightly recessed, there can be some cut-off if light hits them at an angle. This is less critical with 35mm film, for which older lenses were designed. Newer lenses are specifically designed to ensure that light hits the sensor as nearly perpendicular as possible, maintaining illumination and image quality right across the frame.

Many older lenses can still be used, and will often give very good results, but they may show some loss of brightness towards the edges of the frame, and perhaps a hint of chromatic aberration (color fringing).

Wide-angle lenses are most susceptible, telephotos less so. Much depends on the size of print or reproduction you require, and these shortcomings can to some extent be corrected in post-processing (especially if you shoot RAW files).

The exceptional resolution of the D800 naturally exposes any shortcomings in lenses, which may become all too obvious if you make huge prints or simply "pixel-peep" at 100% screen magnification. Limitations are usually most obvious at the edges of the frame, and many will be mitigated when shooting at apertures two to three stops smaller than the maximum. The "sweet spot" for most lenses is usually between f/5.6 and f/11, before diffraction (see page 127) kicks in, but if you are a really critical user you may want to conduct your own tests.

The D800E is able to resolve even finer detail than the D800 and consequently Nikon has taken the unusual step of producing a list of suggested lenses which are most suitable for its ultimate demands. These are highlighted in **bold** in the table at the end of this chapter. It will be interesting to see how independent lens makers like Sigma respond to this initiative.

» NIKON LENS TECHNOLOGY

Nikon's lens range has long been renowned for technical and optical excellence, and many lenses incorporate special features or innovations. These are referred to extensively in the table on *pages 210–215*, and brief explanations of the main terms and abbreviations are given below.

Abbreviation	Term	Explanation
AF	Autofocus	Lens focuses automatically. The majority of current Nikkor lenses are AF but a substantial manual focus range remains.
ASP	Aspherical lens elements	Precisely configured lens elements that reduce the incidence of certain aberrations. Especially useful in reducing distortion with wide-angle lenses.
CRC	Close-range Correction	Advanced lens design that improves picture quality at close focusing distances.
D	Distance information	D-type and G-type lenses communicate information to the camera about the distance at which they are focusing, supporting functions like 3D Matrix Metering.
DC	Defocus-image Control	Found in a few lenses aimed mostly at portrait photographers; allows control of aberrations and thereby the appearance of out-of-focus areas in the image.
DX	DX lens	Lenses specifically designed for DX-format digital cameras; they will not give full-frame coverage on 35mm cameras or FX-format DSLRs like the D800.
G	G-type lens	Modern Nikkor lenses with no aperture ring; aperture must be set by the camera.
ED	Extra-low Dispersion	ED glass minimizes chromatic aberration (the tendency for light of different colors to be focused at slightly different points).
IF	Internal Focusing	Only internal elements of the lens move during focusing. The front element does not extend or rotate.

Abbreviation	Term	Explanation
M/A	Manual/Auto	Most Nikkor AF lenses offer M/A mode, which allows seamless transition from automatic to manual focusing if required.
N	Nano Crystal Coat	Said to virtually eliminate internal reflections within lenses, guaranteeing minimal flare.
PC	Perspective Control	*See page 208.*
RF	Rear Focusing	Lens design where only the rearmost elements move during focusing: makes AF operation faster.
SIC	Super Integrated Coating	Nikon-developed lens coating that minimizes flare and "ghosting".
SWM	Silent Wave Motor	Special in-lens motors which deliver very fast and very quiet autofocus operation.
VR	Vibration Reduction	System which compensates for camera shake. VR is said to allow handheld shooting up to three stops slower than would otherwise be possible (i.e. 1/15th instead of 1/125th sec.). New lenses now feature VRII, said to offer gain of an extra stop over VR (1/8th instead of 1/125th sec.).

» FOCAL LENGTH

Though familiar, the term "focal length" is often misapplied. The focal length of any lens is a fundamental optical property, and is not changed by fitting the lens to a different camera. Unfortunately, as if to promote confusion, the lenses on most digital compact cameras are described not by their actual focal length but by their "35mm equivalent"; i.e. the focal length that would give the same angle of view on a 35mm or full-frame camera.

Of course zoom lenses do have variable focal length—that's what zoom means—but an 18–55mm zoom is an 18–55 whether it's fitted on an FX format camera like the D800 or a DX camera like the D7000. However, because the D7000 has a smaller sensor, the actual image shows a smaller angle of view.

The same applies to using the DX-crop function of the D800, which normally applies automatically when a DX lens is

14mm

24mm

50mm

100mm

200mm

300mm

300mm lens with DX crop ON, equivalent to 450mm

IN THE DOCK ≪

This page shows a series of images taken on a Nikon D800, from a fixed position, with lenses from 12mm to 300mm.

fitted but can also be activated manually. This can yield 15-megapixel images (quite comparable to the 16-megapixel D7000) with a crop factor, also referred to as focal length magnification factor, of 1.5. If you use DX-crop with a 200mm lens, the field of view is equivalent to what you'd get with a 300mm lens on a full-frame camera.

Field of view

The field of view, or angle of view, is the area covered by the image frame. While the focal length of a lens remains the same on any camera, the angle of view seen in the image changes with the sensor format. The angle of view is usually measured diagonally (as in the table on *page 54*).

Tip

DX-crop is handy for sports and wildlife, allowing long-range shooting with relatively light and inexpensive lenses, as well as reducing file sizes. Of course, you can also crop full-frame images later, with greater flexibility, but the DX-crop method is handy if you want to use the images right away.

ATMOSPHERIC PERSPECTIVE »
The apparent fading of more distant elements in this shot is a good example of atmospheric perspective. *250mm, 1/640th sec., f/6.3, ISO 250.*

» PERSPECTIVE

Perspective concerns the visual relationship between objects at different distances. The apparent fading of distant objects due to haze or scattering of light is known as atmospheric perspective, while optical perspective refers to changes in apparent size of objects at different distances.

It's commonly asserted that different lenses give different perspectives. This is wrong: perspective is determined solely by distance. However, different lenses do lend themselves to different working distances and therefore are often associated with different perspectives.

A powerful emphasis on the foreground may be loosely called "wide-angle perspective" because a wide-angle lens allows you to move closer to foreground objects. Similarly, the apparent compression of perspective in telephoto shots is a result of the greater working distance associated with the long lens. In the series of shots on the right, the sculpture remains the same apparent size even though it's viewed from different distances, but both its apparent shape and its relationship to the background are altered in each shot.

CHANGING VIEW　　　　　　　　»
In this series of shots, the "trig" point remains approximately the same apparent size, but both its apparent shape and the relationship to the background change.

200mm lens, approximate distance 65ft (20m)

70mm lens, approximate distance 20ft (6m)

12mm lens, approximate distance under 7ft (2m)

» STANDARD LENSES

Traditionally, a 50mm lens was called standard, as its field of view was held to approximate that of the human eye. Standard lenses are typically light, simple and have wide maximum apertures. Zoom lenses with ranges which include the 50mm focal length are often referred to as "standard zooms".

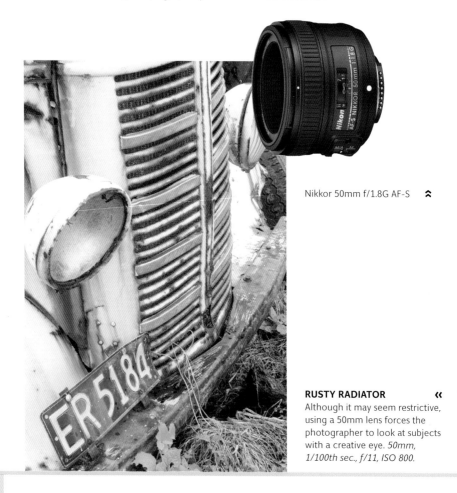

Nikkor 50mm f/1.8G AF-S ⌃

RUSTY RADIATOR «
Although it may seem restrictive, using a 50mm lens forces the photographer to look at subjects with a creative eye. *50mm, 1/100th sec., f/11, ISO 800.*

» WIDE-ANGLE LENSES

A wide-angle lens is really any lens wider than a standard lens; for the D800, this means any lens with a focal length shorter than 50mm. Wide-angle lenses are valuable for working close to subjects or bringing foregrounds into greater prominence. They lend themselves both to photographing expansive scenic views and to working in cramped spaces where it simply isn't possible to step back to "get more in".

In the 35mm film era, anything wider than about 24mm was regarded as "super-wide". The advent of DX-format cameras has spurred the development of a new breed of lenses like Nikon's 14–24mm f/2.8G ED AF–S, yet these come into their own even more with "full-frame" cameras like the D800.

Nikkor 16–35mm f/4G ED AF–S ⟰

TRUNK CALL »
Wide-angle lenses are not just useful for expansive landscape shots—they can be used to create close-ups of features in a landscape, revealing interesting forms and textures. *21mm, 1/80th sec., f/8, ISO 800.*

7 » TELEPHOTO LENSES

Telephoto lenses, often simply called long lenses, give a narrow angle of view. They are mostly employed where working distances need to be longer, as in wildlife and sports photography, but have many other uses, such as singling out small and/ or distant elements in a landscape. Moderate telephoto lenses are favored for portrait photography, because the greater working distance gives a natural-looking result and is more comfortable for nervous subjects. The traditional "portrait" range is 85–135mm, equivalent to 60–90mm with the cropped-sensor D7000.

The laws of optics, plus greater working distance, mean telephoto lenses produce limited depth of field. This is often beneficial in portraiture, wildlife and sport, as it concentrates attention on the subject by throwing backgrounds out of focus. It can be less welcome in landscape shooting.

The size and weight of longer lenses

Nikkor 300mm f/2.8G ED VR II AF-S ⌃

make them harder to handhold comfortably, and their narrow angle of view also magnifies any movement. High shutter speeds and/or the use of a tripod or other camera support are therefore the order of the day. Nikon's Vibration Reduction technology also mitigates the effects of camera shake.

Tip

Switch VR OFF when using the camera on a tripod. (A few of the latest VR lenses have a "Tripod" setting.)

SMOKE STACKS «

Lenses have uses other than the obvious. For instance, telephoto lenses are useful for picking out distant features in landscape photography as well as rendering close-ups in wildlife or sport photography. *300mm, 1/640th sec., f/11, ISO 200.*

» ZOOM LENSES

The term "zoom" applies to lenses with
variable focal length, like the AF-S Nikkor
24-70mm f/2.8G ED. A zoom lens can
replace a bagful of prime lenses and cover
the gaps in between—great for weight,
convenience and economy. Flexible focal
length also allows very precise framing of
images. While they were once considered
inferior in terms of optical quality, there is
now little to choose between a good zoom
and a good prime lens. Cheaper zooms,
and those with a very wide range (e.g.
18-200mm or 28-300mm) may still be
optically compromised, and usually have
a relatively small ("slow") maximum
aperture; they seem a little out of place
on a camera like the D800.

Nikkor 70-300mm ⌃
f/4.5-5.6G AF-S VR

TRAVELING LIGHT ⌃
Zoom lenses are good choices for travel
photography, providing more focal length
options in one compact, lightweight package.
75mm, 1/200th sec., f/4, ISO 200.

» MACRO LENSES

For specialist close-up work there is little
to beat a true macro lens. For more on
these *see page 181.*

CATKIN CLOSE-UP «
Close-up work, such as this image of a willow
tree in spring, is best tackled with a true macro
lens. *105mm macro, 1/320th sec., f/11, ISO 200.*

7 » PERSPECTIVE-CONTROL LENSES

Perspective-control ("tilt and shift") lenses give unique flexibility in viewing and controlling the image. Their most obvious, but by no means only, value is in photographing architecture. Using a "normal" lens in these situations often requires the photograher to tilt the camera upwards, resulting in "converging verticals" (buildings appear to lean back or even to one side). The shift function of the PC lens allows the camera-back to be kept vertical, which in turn means that vertical lines in the subject remain vertical in the image.

The current Nikon range features three PC lenses, with focal lengths of 24mm, 45mm and 85mm. They retain automatic aperture control, but require manual focusing. The 45mm and 85mm are

Nikkor 24mm f/3.5D ED PC-E ⌃

badged "Micro-Nikkor" though their maximum reproduction ratio is 1:2, disqualifying them as true macro lenses *(see page 181).*

LEANING TOWER
A perspective-control lens is able to correct so-called "converging verticals" (above) so that vertical lines on the outer edges of an image appear more natural. *24mm, 1/1600th sec., f/10, ISO 640.*

» TELECONVERTERS

Teleconverters are supplementary optics which fit between the main lens and the camera body, and magnify the focal length of the main lens. Nikon's three examples, the TC-14E II, TC-17E II and TC-20E III, give magnification of 1.4x, 1.7x and 2x respectively. The advantages are obvious, extending the available focal length range relatively cheaply and with minimal additional weight (the TC-14E II, for example, weighs just 7oz or 200 grams).

However, teleconverters can slightly degrade image quality and also cause a loss of light. Fitting a 2x converter to a 300mm f/4 lens turns it into a 600mm f/8. With the D800, this means that autofocus will only work with the central 15 focus points.

Warning!

Nikon state that some recent lenses are incompatible with teleconverters. Check carefully before using any lens with a teleconverter. With a few lenses, AF is not supported and in other cases only a restricted set of focus points can be used.

Nikkor TELECONVERTER TC-20E III ☆

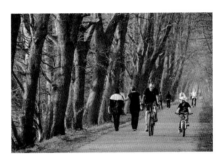

SMALL, FAR AWAY ☆
Teleconverters help to extend your lens' magnification but they reduce the light reaching the sensor and the maximum available aperture.
300mm, 1/125th sec., f/7.1, ISO 800.

› Lens hoods

A lens hood serves at least two functions: it helps to protect the lens against knocks and rain, for instance, and also helps to exclude stray light which, rather than helping to form the image, may degrade it by causing flare. Most Nikkor lenses come with a dedicated lens hood.

7 » NIKKOR LENS CHART

This table lists currently available Nikkor autofocus lenses. DX-series lenses, which do not cover the full sensor area of the D800, are listed last. The angle of view quoted for these lenses is the effective angle of view on the DX frame area.

	Optical features/notes
AF Prime lenses	
14mm f/2.8D ED AF	ED, RF
16mm f/2.8D AF Fisheye	IF
20mm f/2.8D AF	CRC
24mm f/1.4G ED	**ED, SWM, NC**
24mm f/2.8D AF	
28mm f/1.8G AF-S	NC, SWM
28mm f/2.8D AF	
35mm f/2D AF	
35mm f/1.4G AF-S	**NC, SWM**
50mm f/1.8G AF-S	SWM
50mm f/1.8D AF	
50mm f/1.4D AF	
50mm f/1.4G AF-S	IF, SWM
85mm f/1.4G AF	**IF, SWM, NC**
85mm f/1.8D AF	RF
85mm AF-S f/1.8G	IF, SWM
105mm f/2D AF DC	DC
135mm f/2D AF DC	DC
180mm f/2.8D ED-IF AF	ED, IF
200mm f/2G ED-IF AF-S VRII	**ED, VRII, SWM**
300mm f/4D ED-IF AF-S	ED, IF
300mm f/2.8G ED VR II AF-S	ED, VRII, NC, SWM

For an explanation of abbreviations see the table on *page 199*. Lenses specifically recommended by Nikon for optimal quality with the D800E in particular are highlighted in **bold**.

Angle of view on FX format (°)	Min. focus distance (m)	Filter size (mm)	Dimensions diameter x length (mm)	Weight (g)
114	0.2	Rear	87 x 86.5	670
180	0.25	Rear	63 x 57	290
94	0.25	62	69 x 42.5	270
84	**0.25**	**77mm**	**83 x 88.5**	**620**
84	0.3	52	64.5 x 46	270
74	0.25	67	73 x 80.5	330
74	0.25	52	65 x 44.5	205
63	0.25	52	64.5 x 43.5	205
63	**0.3**	**67**	**83 x 89.5**	**600**
46	0.45	58	72 x 52.5	185
46	0.45	52	63 x 39	160
46	0.45	52	64.5 x 42.5	230
46	0.45	58	73.5 x 54	280
28.5	**0.85**	**77**	**86.5 x 84**	**595**
28.5	0.85	62	71.5 x 58.5	380
28.5	0.8	67	80 x 73	350
23.3	0.9	72	79 x 111	640
18	1.1	72	79 x 120	815
13.6	1.5	72	78.5 x 144	760
12.3	**1.9**	**52**	**124 x 203**	**2900**
8.1	1.45	77	90 x 222.5	1440
8.1	2.2	52	124 x 267.5	2900

7

Optical features/notes

400mm f/2.8G ED VR AF-S	**ED, IF, VRII, NC**
400mm f/2.8D ED-IF AF-S II	ED, SWM
500mm f/4G ED VR AF-S	**IF, ED, VRII, NC**
600mm f/4G ED VR AF-S	**ED, IF, VRII, NC**

AF Zoom lenses

14-24mm f/2.8G ED AF-S	**IF, ED, SWM, NC**
16-35mm f/4G ED VR	**NC, ED, VR**
17-35mm f/2.8D ED-IF AF-S	IF, ED, SWM
24-70mm f/2.8G ED AF-S	**IF, ED, SWM, NC**
24-85mm f/2.8-4D IF AF	IF
24-120mm f/4G ED-IF AF-S VR	**ED, SWM, NC, VRII**
28-300mm f/3.5-5.6G ED VR	ED, SWM
70-200mm f/2.8G ED-IF AF-S VRII	**ED, SWM, VRII**
70-300mm f/4.5-5.6G AF-S VR	ED, IF, SWM, VRII
80-400mm f/4.5-5.6D ED VR AF	ED, VR
200-400mm f/4G ED-IF AF-S VRII	**ED, NC,VRII, SWM**

Macro lenses

60mm f/2.8G ED AF-S Micro	**ED, SWM, NC**
105mm f/2.8G AF-S VR Micro	**ED, IF, VRII, NC, SWM**
200mm f/4D ED-IF AF Micro	ED. CRC

Perspective control

24mm f/3.5D ED PC-E (manual focus)	ED, NC
45mm f/2.8D ED PC-E (manual focus)	ED, NC
85mm f/2.8D ED PC-E (manual focus)	ED, NC

Angle of view on FX format (°)	Min. focus distance (m)	Filter size (mm)	Dimensions diameter x length (mm)	Weight (g)
6.1	2.9	52	159.5 x 368	4620
6.1	3.8	52	160 x 352	4800
5	4	52	139.5 x 391	3880
4.1	5	52	166 x 445	5060
114–84	0.28	None	98 x 131.5	970
107–63	0.29	77	82.5 x 125	680
104–62	0.28	77	82.5 x 106	745
84–34.3	0.38	77	83 x 133	900
84–28.5	0.5	72	78.5 x 82.5	545
84–20.5	0.45	77	84 x 103.5	710
75–8.1	0.5	77		800
34.3–12.3	1.4	77	87 x 209	1540
34.3–8.1		67	80 x 143.5	745
30.1–6.1	2.3	77	91 x 171	1340
12.3–6.1	2	52	124 x 365.5	3360
39.6	0.185	62	73 x 89	425
23.5	0.31	62	83 x 116	720
12.3	0.5	62	76 x 104.5	1190
84	0.21	77	82.5 x 108	730
51	0.25	77 x 94	83.5 x 112	780
28.4	0.39	77	82.7 x 107	650

7

DX Lenses (Angle of view assumes DX-crop in effect)

Lens	Optical features/notes
10.5mm f/2.8G DX Fisheye	CRC
10-24mm f/3.5-4.5G ED AF-S DX	ED, IF, SWM
12-24mm f/4G ED-IF AF-S DX	SWM
16-85mm f/3.5-5.6G ED VR AF-S DX	VRII, SWM
17-55mm f/2.8G ED-IF AF-S DX	ED, IF, SWM
18-55mm f/3.5-5.6G AF-S VR DX	VR, SWM
18-55 f/3.5-5.6GII AF-S DX	ED, SWM
18-70mm f3.5-4.5G ED-IF AF-S DX	ED, SWM
18-105mm F/3.5-5.6G ED VR AF-S DX	ED, IF, VRII, NC, SWM
18-200mm f/3.5-5.6G ED AF-S VRII DX	ED, SWM, VRII
35mm f/1.8G AF-S	SWM
40mm f/2.8G AF-S DX Micro NIKKOR	SWM
55-200mm f/4-5.6 AF-S VR DX	ED, SWM, VR
55-200mm f/4-5.6G ED AF-S DX	ED, SWM
55-300mm f/4.5-5.6G ED VR	ED, SWM
85mm f/3.5G ED VR AF-S DX Micro Nikkor	ED, IF, SWM, VRII

Angle of view on FX format (°)	Min. focus distance (m)	Filter size (mm)	Dimensions diameter x length (mm)	Weight (g)
180	0.14	Rear	63 x 62.5	300
109–61	0.24	77	82.5 x 87	460
99–61	0.3	77	82.5 x 90	485
83–18.5	0.38	67	72 x 85	485
79–28.50	0.36	77	85.5 x 11.5	755
76–28.50	0.28	52	73 x 79.5	265
76–28.50	0.28	52	70.5 x 74	205
76–22.50	0.38	67	73 x 75.5	420
76–15.3	0.45	67	76 x 89	420
76–8	0.5	72	77 x 96.5	560
44	0.3	52	70 x 52.5	210
38.5	0.163	52	68.5 x 64.5	235
28.5–8	1.1	52	73 x 99.5	335
28.5–8	0.95	52	68 x 79	255
28.5–5.2	1.4	58	76.5 x 123	530
18.5	0.28	52	73 x 98.5	355

Chapter 8
ACCESSORIES

8 ACCESSORIES

As part of the vast Nikon system, a wide range of accessories is available for the D800. In addition to Nikon's own products, there are many third-party items which further extend the options available to the D800 user. Accessories can be grouped under four main headings: image modification (e.g. filters and flash); camera performance; camera support; and storage.

» FILTERS

Flash and close-up accessories have been covered already, leaving filters as the other main category for image modification. Some types of filter are almost redundant with digital cameras; variable white balance, for instance *(see page 56)*, has virtually eliminated the need for color-correction filters, which were essential for accurate color on film.

As a general principle, avoid using filters unnecessarily. Adding extra layers of glass in front of the lens can increase flare or otherwise degrade the image. "Stacking" of multiple filters increases this risk, and that of vignetting *(see page 144)*.

There is one exception to this rule; it's prudent to keep a UV or skylight filter (see below) attached to each lens as a first line of defence against knocks and scratches. Filters are much cheaper to replace than lenses!

› Types of filter

There are three main classes of filter, defined by the way in which they attach to the lens: round filters; slot-in filters; rear or drop-in filters.

POLAR EXPLORATION »
A polarizing filter (bottom) can intensify colors.

Round filters screw to the front of the lens and are normally made of high-quality optical glass. The filter-thread diameter (in mm) of most Nikon lenses is specified in the table on *page 210*, and usually marked around the front of the lens by the Ø symbol. Nikon produces screw-in filters in sizes matching the range of Nikkor lenses and to the same high optical standards. Larger ranges come from Hoya and B+W.

If you use filters extensively, slot-in filters are more economical and convenient. The filters—normally square or rectangular and made of optical resin or gelatin—fit into a slotted holder. One holder and one set of filters can serve any number of lenses, requiring a simple adaptor ring for each lens. The best-known maker is Cokin, while the Lee Filters range is highly respected.

A few specialist lenses, such as super-telephotos or extreme wide-angle and fish-eye lenses, require equally specialist filters, either fitting to the rear of the lens or into a slot in the lens barrel. A few lenses, like the 14–24mm f/2.8G ED AF-S Nikkor, make no provision for attaching filters.

SHORImg_1E THING ❯❯
A UV or skylight filter helps to protect the lens from spray, dust, dirt and other hazards. *26mm, 1/320th sec., f/11, ISO 400.*

UV and skylight filters

Both these filters cut out excess ultraviolet light which can cause a blue cast in images. The skylight filter also has a slight warming effect. As already suggested, a major benefit is in protecting the front element of the lens.

Polarizing filters

The polarizing filter, beloved of landscape photographers, cuts down reflections from most surfaces, intensifying colors in rocks and vegetation, for instance. It can make reflections on water and glass virtually disappear. Rotating the filter in its mount strengthens or weakens its effect. The polarizer can also cut through atmospheric haze (though not mist or fog) like nothing else, and can make blue skies appear more intense. The effect is strongest when shooting at right angles to the direction of the sunlight, vanishing when the sun is directly behind or in front. Results can sometimes appear exaggerated, and with wide-angle lenses the effect can vary conspicuously across the field of view.

The polarizer should be used with discrimination, and certainly should not be permanently attached. However, many of its effects cannot be fully replicated in any

FREEZING WATER ❯❯

A plain neutral density filter may be useful when you want to use really low shutter speeds. *100mm, 4 sec., f/22, ISO 100, tripod.*

other way, even in digital post-processing. You may only use it occasionally, but then it can be priceless.

Neutral density filters

Neutral density (ND) filters reduce the amount of light reaching the lens. "Neutral" simply means that they don't shift the color of the light. ND filters can be either plain or graduated.

A plain ND filter is useful when you want to set a slower shutter speed and/or wider aperture, and can't reduce the ISO setting any further. A classic example is

Tip

By investing in a little computer time you can replicate, and even improve on, the effect of a graduated ND filter. The best way to selectively darken or lighten parts of an image in Photoshop, for instance, is using Layer Masks, which provide complete control over the boundary between affected areas. This may appear an advanced technique, but soon becomes quick and intuitive. However, it can't work unless the original image captures detail in both highlights and shadows, so keep those ND grads on standby.

LAYER UPON LAYER **«**
A graduated filter wasn't a good solution for the different brightness levels here (inset) as it could only benefit the bow of the ship, not the foreground water or the mooring ropes. For a more natural result two separate RAW conversions were combined using Photoshop Layer Masks. *34mm, 1/125th sec., f/13, ISO 320.*

8

when shooting waterfalls, where you may want a long shutter speed to create a silky blur. The strength of ND filters is specified on a scale where 0.3 represents a reduction of one full stop (1 Ev) of light, 0.6 is two stops and so on.

Graduated ND filters have neutral density over half their area, with the other half being clear, and a gradual transition in the center. They are widely used in landscape photography to compensate for wide differences in brightness between sky and land, though an irregular skyline can make the straight transition of the filter unpleasantly obvious.

Special effects filters
Special effects filters come in many forms. Two of the most common are soft-focus filters and starburst filters. The soft-focus filter is still sometimes used in portrait photography to soften skin blemishes, but its effects can be replicated and extended, through the Retouch Menu or at the computer.

Much the same is true of the starburst and most other special-effects filters. There was an explosion of such images in the 1970s, when the Cokin system first became available, but most people soon tired of their "Top of the Pops" effects, and such images now look dated. In the digital age you can always capture the original image "straight", without such filters, and apply effects later—or not, if good taste intrudes!

» ESSENTIAL ACCESSORIES

Numerous add-ons are available to improve or modify the performance of the D800. Nikon includes several items in the box with the camera, but these are really essentials, not extras.

› EN-EL15 battery

Without a battery, your fabulous D800 is a useless dead-weight. While the camera's battery life is good, it never hurts to have a fully-charged spare on hand. This is especially true in cold conditions, when using the monitor extensively, or when shooting movies.

› MH-25 charger

A charger is vital for keeping the EN-EL15 battery charged and ready.

› BM-11 LCD monitor cover

It's wise to keep the monitor cover permanently attached. If it becomes scratched, it's easily and inexpensively replaced, whereas replacing the monitor is a complex and very expensive business.

› BF-1A/1B body cap

Keeps the interior of the camera free of dust and dirt when no lens is attached.

» OPTIONAL ACCESSORIES

A selection from Nikon's extensive range is listed here.

› Multi-power battery pack MB-D12

The MB-D12 has two main functions, providing extra power and improving the camera's handling in portrait orientation. It provides an extra shutter-release button, command dials and AE-L/AF-L button. It can be loaded with a second EN-EL15 battery or with AA cells.

› AC adapter EH-5/EH-5a/EH-5b

The adapter is used to power the camera directly from the AC mains, allowing uninterrupted shooting in, for example, long studio sessions (a power connector is also required).

› Wireless transmitter WT-4

This enables the camera to connect to WiFi and Ethernet networks. Photographs can be viewed on any computer on the network (e.g. using Nikon View NX2) and also saved immediately to a computer (e.g. using Nikon Transfer). Nikon Camera Control Pro 2 software (available separately) allows camera functions to be controlled directly from any Mac or PC.

Tip

For simple transfer of images over a WiFi network, an EyeFi card is an inexpensive alternative (see page 231).

› Diopter adjustment

The D800's viewfinder has built in dioptric adjustment, between −3 and +1m$^{-1}$. If your eyesight is outside this range, Nikon produces a series of viewfinder lenses between −3 and +2m$^{-1}$, with the designation DK-17C.

Tip

If your eyesight needs correction, it's usually easier to wear contact lenses or glasses to use the viewfinder. Set the built-in dioptric adjustment (page 27) while wearing your usual glasses or lenses.

› Remote cords

To release the shutter from a distance, a variety of cords can be attached to the D800's 10-pin terminal, from simple triggers like the basic MC-30 to sophisticated cords which link to remote triggering devices.

8 » CAMERA SUPPORT

There's much more to camera support than tripods, although these remain a staple—perhaps even more so with the D800 than with most cameras.

› Tripods

The D800 creates something of a paradox. On the one hand, its fine image quality at high ISO settings does make handholding easier. On the other, if you are really trying to make the best use of its amazing resolution, then there's no point in cutting corners and you really should use a tripod for most shots. This is even more true if, as already noted, you also want to exploit its

excellent dynamic range, which is best at low ISO ratings.

A good tripod is also an investment, and should last for many years. Tripods come in all manner of sizes, weights, and materials. Titanium and carbon fiber give the best combination of low weight and good rigidity—but at a price. Carbon fiber tripods are made by Manfrotto and Gitzo, among others. The distinctive design of Benbo tripods gives exceptional flexibility, which is prized by nature photographers who need to shoot in awkward positions. When shooting movies, a tripod is essential, and many tripods are designed specifically for this purpose (see page 190).

READY AND STABLE «
Tripods are ideal for a wide variety of subjects; in this case it's the Old Town in Gdansk, Poland.

» STORAGE

› Monopods

Monopods can't offer the ultimate stability of a tripod, but are light, portable and quick to set up. They are particularly favored by sports photographers, who often have to react quickly while using hefty telephoto lenses.

› Other camera support

There are many other solutions for camera support, both proprietary products and improvized alternatives. It's still hard to beat the humble bean-bag, which can easily be home-made.

BAG OF BEANS ⌄
This simple homemade beanbag has served me well for many years.

› Memory cards

The D800 stores images on Type I Compact Flash cards and Secure Digital (SD), SDHC or SDXC cards. Type II CF cards and Microdrives (now rare) cannot be used. In view of the huge file sizes generated by the D800, large-capacity cards with fast write speeds are recommended. Even these are now remarkably cheap, so it's advisable to carry a spare or two.

› Portable storage devices

Memory cards rarely fail but it's always worth backing up valuable images as soon as possible. The D800's second card slot, of course, allows instant in-camera backup *(see page 84)*. On longer trips, with no regular access to a computer, many photographers use some sort of mobile device for backup. There are various dedicated photo storage devices, usually with a compact hard drive and a small screen, such as the Vosonic VP5500 and Epson P-5000. Some iPods are suitable, but check well in advance. The iPad (but not the iPhone) also works well for this: you'll need an Apple iPad Camera Connector. Transfer speeds can be quite slow, so you might want to back up overnight. The limited capacity of the iPad (max 64GB) may not cope with the D800's huge files.

ACCESSORIES » CAMERA SUPPORT / STORAGE

Chapter 9
CONNECTION AND CARE

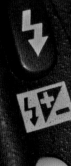

9 CONNECTION

Connecting to external devices is an essential element of digital photography, enabling you to store, organize, view and print your images. The D800 is designed to facilitate these operations, and the main cables required are included with the camera.

» CONNECTING TO A COMPUTER

Connecting to a Mac or PC allows you to store and backup your images. It also helps you exploit the full power of the D800, including the ability to optimize image quality from RAW files. Some software packages allow "tethered" shooting, where images appear on the computer straight after capture. Nikon Camera Control Pro 2 (optional) goes further, allowing the camera to be controlled directly from the Mac or PC.

PORT SIDE ⚹
Connection ports on the left side of the D800.

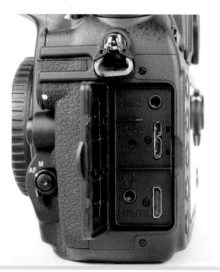

› Computer requirements

The massive file sizes produced by the D800 place extra demands on computer systems, stressing processor speed, hard disk capacity, and—above all—memory (RAM). Systems with less than 4GB of RAM may run slowly when dealing with RAW, TIFF and even full-size JPEG images from the camera. Fortunately, for most systems adding extra RAM is relatively easy and inexpensive. Extra hard disk space can also be helpful, as the system will slow significantly when the hard disk comes close to capacity.

The D800 supports USB3 for connecting the camera; this is backwards-compatible with USB2 but transfer speeds over USB2 will be slower. A CD drive is useful but not essential for installing the supplied software—it can also be

downloaded from the Nikon website.
Nikon Transfer 2 and Nikon View NX2
require one of the following operating
systems: Windows 7; Windows Vista
(Service Pack 2); Windows XP (Service Pack
3); Mac OS X (Version 10.4.11 or later).

› Backing up

Until they are backed up, your precious
images exist only as data on the camera's
memory card (or cards, if using the Backup
option for the D800's second card slot).
Memory cards are robust but they are not
indestructible, and in any case you will
surely wish to format and reuse them.
However, when images are transferred to
the computer and the card is formatted,
those images again exist in just one
location, the computer's hard drive.
If anything happens to that hard drive,

TIME MACHINE ≽
Apple's Time Machine backs up automatically.

TRANSFER WINDOW ≫
A D800 connected to a computer.

whether fire, theft or hardware failure, you
could lose thousands of irreplaceable
images. The simplest form of backup is to
a second hard drive.

› Color calibration

A major headache for digital camera users
is that images look one way on the camera
monitor, different on the computer screen,
different when you email them to your
friends, and different again when printed.
To achieve consistency across different
devices, ensure above all that your main

CALIBRATING COLOR ⏣
This is the Display Calibrator Assistant included in Mac OS X. Windows finally gained an equivalent with the Color Calibration Wizard in Windows 7. Vista and XP users still need a third-party solution.

computer screen is correctly set up and calibrated. This may seem complex and time-consuming but ultimately saves much time and frustration. Detailed advice is beyond the scope of this book but try searching your computer's Help system for "monitor calibration". There's more detail in the *Digital SLR Handbook* (by this author and publisher) and there's useful advice at www.cambridgeincolor.com/tutorials.htm.

Tip

It's often more convenient to transfer photos using a card-reader. Many PCs have built-in card slots but separate card-readers are cheap and widely available. Older readers may not support SDHC or SDXC cards. The procedure is broadly similar.

› Connecting the camera

The supplied USB cable allows direct connection to a computer. This description is based on Nikon Transfer, part of the supplied View NX2 package. The procedure with other software will be similar in outline but different in detail.

1) Start the computer and let it boot up. Open the cover on the camera's right side and insert the smaller end of the supplied USB cable into the USB slot; insert the other end into a USB port on the computer.

2) Switch the camera ON. Nikon Transfer starts automatically (unless you have configured its Preferences not to do so).

3) The Nikon Transfer window offers various options. The following are particularly important.

CARD CHOICE ⏴⏴
Some card-readers can take a range of cards.

4) To transfer selected images only, use the check box below each thumbnail to select/deselect as required.

5) Click the Primary Destination tab to choose where photos will be stored. You can create a new subfolder for each transfer, rename images as they are transferred, and so on.

6) Click the Backup Destination tab if you want Nikon Transfer to create backup copies automatically during transfer.

7) When transfer is complete, switch OFF the camera and disconnect the cable.

Nikon Transfer 2

› Wireless connection (Eye-Fi)

Eye-Fi looks and operates like a conventional SD memory card, but includes an antenna which enables it to connect to WiFi networks, allowing speedy transfer of images without cables.

Eye-Fi cards are supplied with a card-reader: when the card and reader are plugged into any WiFi-enabled Mac or PC the supplied software should install automatically. There's then an automatic registration process which makes that computer the default destination for Eye-Fi upload. Some Eye-Fi cards also support ad-hoc networks, allowing images to be transferred to a laptop or iPad even when out of the range of regular WiFi.

Once configuration is complete, insert the card in the camera. Use the Eye-Fi Upload item in the Setup menu and then the camera will automatically upload images as they are taken, as long as you remain within signal range of the network. The camera displays a notification when images are being uploaded.

Note:
Eye-Fi transfer speeds are not spectacular and ad-hoc networks can be distinctly slow. One option is to use the RAW + JPEG option, setting JPEG size to Small. Use the CF card slot for RAW images and the SD slot for JPEG so the EyeFi card only has to transfer small JPEGs. These offer an instant preview on the iPad or laptop while the large RAW files are saved for later processing. *See page 84* on setting up dual-card slot options.

9 » SOFTWARE AND IMAGE PROCESSING

Most of us want to do more with our images than simply store them. Backing up, printing, organizing, and making them look their best all require the right software.

Software choice depends partly on how you shoot. If you always shoot JPEG images, you may feel little need to tinker with them later, and organizing and cataloging will be your main priorities. If you shoot RAW files, on the other hand, some image processing is essential—and the images themselves give you much more freedom to adjust tone, color and so on to your liking.

› Nikon Software

The D800 is bundled with Nikon View NX2 software. This includes Nikon Transfer, a simple application that does a simple job competently. Nikon View NX2 itself covers most of the main processes in digital photography: you can view and browse images, save them in other formats, and print. View NX2 has a good range of tools for enhancing images (including RAW files), but is weak when it comes to organizing and cataloging.

Nikon Capture NX2 has much wider functionality but feels awkward beside mainstream applications like Adobe Photoshop. Capture NX2 is not included with the camera and you will have to pay to download it or obtain it on CD.

Nikon View NX2

› Using Nikon View NX2

1) From a browser view such as the thumbnail grid, click on an image to highlight it. Image Viewer shows the image in more detail, with a histogram, and Full Screen allows you to see the image full size.

2) On the right of the screen are Metadata (detailed info about the image), and the Adjustment palette, which allows adjustments such as exposure and white balance.

3) Click away from the image and you will be asked if you want to save any adjustments. You do not need to export or convert the file immediately.

4) To export the file as a TIFF or JPEG that can be viewed, edited and printed by most other applications, choose Convert

Nikon View NX2 file format options

JPEG	Choose compression ratio: Excellent Quality; Good Quality; Good Balance: Good Compression Ratio; Highest Compression Ratio.	Suitable for immediate use. Choose Excellent Quality unless storage space is tight, or when images will only be used online.
TIFF (8-bit)		Creates larger files than JPEG, but they stand up better to further editing; 16-bit is better still.
TIFF (16-bit)		The best choice when further editing is anticipated. Images can be converted to 8-bit after editing, halving file size.

Files from the File menu. You can resize and rename the image if required.

5) The File Format menu in the Convert Files dialog offers three options.

› Nikon Capture NX2

Nikon Capture NX2 is a far more complete editing package than Nikon View. For access to a full range of editing options, especially in relation to RAW files, Nikon Capture NX2 or one of its third-party rivals is essential. One point to consider is that, unlike rivals such as Adobe Photoshop, Capture NX2 cannot open RAW files from non-Nikon cameras. Photoshop has a much wider feature set, but is typically around four times dearer. (If you already own an older version of Photoshop, upgrades may be much cheaper.)

Nikon Capture NX2

› Camera Control Pro 2

In the studio, and other controlled settings, Camera Control Pro 2 allows almost all functions and settings of the D800 to be operated directly from a Mac or PC. As soon as images are captured they can be checked in detail on the large, color-corrected computer screen; Live View integration allows real-time viewing. Of course, it's a professional product at a professional price.

› Third-party software

The undisputed monarch of image-editing software is Adobe Photoshop, the current version being Photoshop CS6. Its power is enormous and it's the subject of many dedicated books and websites. It is far more than most users need, and many will prefer the much more affordable Photoshop Elements, which still has

sophisticated editing features, including the ability to open RAW files from the D800.

Photoshop Elements also includes an Organizer module, which allows photos to be sorted into "Albums" and also "tagged" in different ways. Some sort of organizer or cataloging software soon becomes essential as you amass thousands of images.

Mac users have another excellent choice in the form of iPhoto (latest version iPhoto 11), which is pre-loaded on new Macs. Like Photoshop Elements, it combines organizing and editing abilities. With an elegant and intuitive interface, there's no easier imaging software to grasp, and the Adjust palette provides quick and flexible image editing too. iPhoto can open RAW files from the D800, but—unlike Photoshop Elements—cannot edit in 16-bit depth, which is recommended for best results.

Raw file conversion in Adobe Photoshop Elements

iPhoto in Library mode

Finally, if you regularly shoot RAW, there are two one-stop solutions in the shape of Apple's Aperture (Mac only) and Adobe Lightroom (Mac and PC). Both applications combine powerful organizing and cataloging with sophisticated and non-destructive image editing. Essentially this means that edit settings (any changes you make to your image, including color, density, cropping and so on) are recorded alongside the original RAW (or DNG) file without any need to create a new TIFF or JPEG file. TIFF or JPEG versions, incorporating all the edits, can be exported as and when needed.

Recent versions of Aperture and Lightroom both support tethered shooting, as do several other apps. Sofortbild is a free tethered shooting app for Mac OS X.

Note:
Older versions of Adobe Photoshop, Elements and Lightroom will not recognize RAW files created by the D800. These require the Camera Raw plug-in, version 6.6, which is incompatible with versions before Photoshop CS5. To work around this without a costly upgrade, use the free Adobe DNG Converter to convert D800 files to the standard DNG format. These can then be opened with older builds of Photoshop, and many other apps. However, this does add an extra step, possibly a time-consuming one, to your workflow. Upgrading Lightroom or Photoshop Elements is an easier, and reasonably affordable, solution.

Adobe Lightroom's Library module

Adobe Lightroom's Develop module offers a very wide spectrum of RAW adjustments

9 » CONNECTING TO A PRINTER

Photographs from the D800 can be printed in numerous ways. The most flexible and powerful is to transfer pictures to a computer, and this is the only option where NEF (RAW) files are concerned. The memory card can also be inserted into a compatible printer or taken to a photo printing outlet. Finally, the camera can be connected to any printer that supports the PictBridge standard, allowing JPEG (not NEF or TIFF) images to be printed directly. The description below outlines the procedure

for doing this. None of the usual options do full justice to the unprecedented scale of the D800's images; much of the point of its 36-megapixel resolution is the ability to print at huge sizes. The benefits will simply not be apparent in A4 prints from a home inkjet or photo printing kiosk. Even A3 or 16 x 12-inch prints don't really show the difference between the D800 and predecessors such as the D700.

Large-format printers are, of course, expensive and really the province of the

Printing options

Option name	Options available	Notes
Page size	Printer default 3.5 x 5in 5 x 7in A4	Options will be limited by the maximum size the printer can print.
No of copies	1–99	Use ▲ / ▼> to choose number, then press **OK** to select.
Border	Printer default Print with border No border	If **Print with border** is selected, borders will be white.
Time stamp	Printer default Print time stamp No time stamp	Prints time and date when image was taken.
Crop	Crop No cropping	Prints selected area only to size selected under **Page size** (see above).

professional studio and imaging lab. In preparing images to be printed in large formats, follow the lab's guidance carefully to ensure optimum results.

To connect to a printer

1) Make sure the camera is switched OFF.

2) Turn the printer ON and connect the supplied USB cable. Open the cover on the left side of the camera and insert the smaller end of the cable into the USB slot there.

3) Turn the camera ON. You should now see a welcome screen, followed by a PictBridge playback display. There's now a choice between **Printing pictures one at a time** or **Printing multiple pictures**.

Printing pictures one at a time

This process is very straightforward, particularly if you are already familiar with navigating the D800's playback screens.

1) If the photo displayed is the one you wish to print, press **OK**. This brings up a menu of printing options; see the table opposite for details. Use the Multi-selector to navigate through the menu and highlight specific options; press **OK** to select the highlighted option.

2) When the required options have been set, select **Start printing** and press **OK**. To cancel at any time, press **OK** again.

› Image cropping

If **Crop** is selected, the image is displayed again with a border delineating the crop area. Use ⊖▣ and ⊕ to change the size of the crop area and use the Multi-selector to reposition it if you don't want it centered. When satisfied, press **OK**.

› Printing multiple pictures

You can print multiple pictures, and also create an index print of all JPEG images (up to a maximum of 256) currently stored on the memory card.

With the PictBridge menu displayed, press **MENU**. The following options are displayed.

Print Select	Use the Multi-selector to scroll through pictures on the memory card. To view a single image, press ⊕⊠. To choose the currently selected image for printing, hold 〇━ and press ▲. The picture is marked 凸 and the number of prints set to 1. Keep pressing 〇━ and use ▲ to change the number of prints. Repeat to select further images and choose the number of prints from each. Finally, press **OK** to display the PictBridge menu and select printing options, as in the table on *page 236*. Select **Start printing** and press **OK**.
Print (DPOF)	Prints images already selected using the **Print set (DPOF)** option in the Playback menu *(see page 81)*.
Index Print	Prints all JPEG images (up to a maximum of 256) on the memory card. If more images exist, only the first 256 will be printed. If the selected page size is too small for the number of images, a warning will be displayed.

» CONNECTING TO A GPS UNIT

Nikon's GP-1 GPS (global positioning system) unit can be mounted on the hotshoe or clipped to the camera strap, and links to the camera's accessory terminal using a supplied cable. It allows information on latitude, longitude, altitude, heading, and Coordinated Universal Time to be added to image metadata. This information is displayed as an extra page of photo info on playback.

When the camera has established a connection and is receiving data from the GPS, a 🅖🅟🅢 icon will be displayed in the Information Display. If this flashes, the GPS is searching for a signal, and data will not be recorded.

The **GPS** item in the Setup menu has three sections.

Auto meter off

If enabled, exposure meters turn off automatically after a set period *(see Custom setting c2)*. This reduces battery

drain. Reactivate meters by half-pressure on the shutter release before taking shots; otherwise GPS data may fail to record. If this option is disabled, the meters will remain on whenever a GPS unit is attached, and GPS data will always be recorded.

Position
Displays the current information as reported by the GPS device.

Use GPS to set camera clock
Self-explanatory, and should ensure that the time is always correct!

» CONNECTING TO A TV

The supplied EG-D100 cable is used to connect the camera to a normal TV or VCR. To connect to an HD device, you'll need an HDMI cable (not supplied). In other respects the process is the same.

1) Check that the camera is set to the correct mode in the Setup menu (PAL or NTSC [for standard TVs and VCRs] or HDMI).

2) Turn the camera OFF.

3) Open the cover on the left side of the camera and insert the cable into the appropriate slot (Video-out or HDMI).

4) Set the TV to the Video or HDMI channel.

Tip

Some Garmin GPS units can also be linked to the D800. This requires a Nikon MC-35 adapter cable.

5) Turn the camera ON and press the playback button. Images remain visible on the camera monitor as well as on the TV and you navigate images using the Multi-selector in the usual way. The D800's slide show setting *(see Playback menu, page 80)* can be used to automate playback.

Note:
Use of a mains adapter is recommended for lengthy playback sessions. No harm should result if the camera's battery becomes exhausted during the process, but it is annoying.

9 CARE

The Nikon D800 is a very rugged camera, but is still packed with highly complex electronic and optical technology. A few simple, and generally common-sensical, precautions should ensure that it keeps functioning perfectly for many years.

» BASIC CARE

Keeping the camera clean is a fundamental aspect of care. The camera body can be cleaned by removing dust and dirt with a blower, then wiping it with a soft, dry cloth. After exposure to salt spray, wipe off carefully with a cloth dampened with distilled water, then dry thoroughly. As prevention is better than cure, keep the camera in a case when not in use.

Lenses require special care. Glass elements and coatings are easily scratched and this will degrade your images. Remove dust and dirt with a blower. Fingerprints

and other marks should be removed using a dedicated lens cleaner and optical-grade cloth. Again, prevention is better than cure, so the use of a skylight or UV filter to protect the lens is advisable, and lens caps should be replaced when the lens is not in use.

The playback monitor is best protected by keeping the monitor cover in place. If the monitor itself needs cleaning, use a blower as above, then wipe the surface with a soft cloth. Do not apply pressure.

› Cleaning the sensor

Strictly speaking, it's not the sensor itself but the low-pass filter in front of it that concerns us. Specks of dust on this will appear as dark spots in the image. Again, prevention is better than cure, so change lenses with care, sheltering the camera from any wind. In really bad conditions, such as in sandy or dusty environments, it's best not to change lenses at all. Even so, unless you never change lenses, some dust will eventually find its way in.

SPRAY AWAY ⌄
Sand, dust, dirt and salt spray are all potentially harmful to the camera; prevention is better than cure. *105mm, 1/500th sec., f/11, ISO 200.*

Spots which do appear on images can be removed using software tools like the Healing brush in Adobe Photoshop. In Nikon Capture NX2 this process can be automated by creating a Dust-off reference image (see page 107).

SPRING CLEAN ⌃
Cleaning the sensor is strictly for the confident!

Fortunately, the D800 has a self-cleaning facility, which vibrates the low-pass filter to displace dust. This can be activated manually at any time or set to occur automatically when the camera is switched on and/or off. Choose options using **Clean Image Sensor** in the Setup Menu.

Occasionally, however, stubborn dust may still appear on the low-pass filter, and it may become necessary to clean it by hand. Do this in a clean, draught-free area with good light, preferably using a lamp which can be directed into the camera.

Make sure the battery is fully charged, or use a mains adaptor. Remove the lens, switch the camera ON and select **Lock mirror up** for cleaning from the Setup menu. Press the shutter-release button to lock up the mirror. First, attempt to remove dust using a hand-blower (not compressed air or other aerosol). If this appears ineffective, consider using a dedicated sensor cleaning swab, and carefully follow the instructions supplied with it. Do not

Warning!

Any damage to the low-pass filter from misjudged manual cleaning could void your warranty. If in doubt, consult a professional dealer or camera repairer.

use other brushes or cloths and never touch the low-pass filter with your finger. When cleaning is complete, turn the camera OFF and the mirror will reset.

› Coping with cold

Nikon specify an operating temperature range for the D800 of 32–104°F (0–40°C). When ambient temperatures fall below freezing, the camera can still be used, but aim to keep it within the specified range as far as possible. Keeping the camera in an

9

COLD CASE
A hard frost offers wonderful photographic opportunities but low temperatures can be challenging for cameras. *24mm, 1/80th sec., f/11, ISO 200.*

insulated case or under outer layers of clothing between shots will help keep it warmer than the surroundings. If it does become chilled, battery life can be severely reduced. In extreme cold, the LCD displays may become erratic or disappear completely and ultimately the camera may cease to function. If allowed to warm up gently, no permanent harm should result.

› Coping with heat and humidity

Extremes of heat and humidity (Nikon stipulate over 85%) can be even more problematic, as they are more likely to lead to long-term damage. In particular, rapid transfers from cool environments to hot and humid ones (air-conditioned hotel to sultry streets) can lead to condensation within the lens and camera. If such transitions occur, pack the camera and lens(es) in airtight containers with sachets of silica gel, which will absorb any moisture. Allow equipment to reach ambient temperature before unpacking, let alone using, it.

› Water protection

The D800 is reasonably weatherproof, so it can be used with reasonable confidence in light rain. Still, keep exposure to a necessary minimum, and wipe regularly with a microfiber cloth—one is always handy to wipe off any accidental splashes. Avoid using the built-in flash and keep the hotshoe cover in place (this is easily lost or forgotten!). Double-check that all access covers on the camera are properly closed.

Take extra care to avoid contact with salt water. If any does occur, clean carefully and immediately with a cloth lightly dampened with fresh, or preferably distilled, water.

Ideally, protect the camera with a waterproof cover. A simple plastic bag will provide reasonable protection, but purpose-made rain-guards are available, e.g. from Think Tank (HydroPhobia). True waterproof cases are generally very expensive (sadly, Aquapac's reasonably-priced DSLR case is too small for the D800).

› Camera cases

In all conditions, some sort of case is highly advisable to protect the camera when not in use. The most practical is a simple drop-in pouch which can be worn on a waist-belt. Excellent examples come from makers like Think Tank, Camera Care Systems and LowePro.

DROP-IN POUCH ⌃
A padded hip bag like this combines good protection and easy access.

KEEPING DRY ⌃
You can find lots of good images in the rain, but even a tough camera like the D800 needs protection. *70mm, 1/500th sec., f/9, ISO 800.*

» GLOSSARY

Aperture The lens opening which admits light. Relative aperture sizes are expressed in f-numbers *(see below)*.

Artefact Occurs when data or data produced by the sensor are interpreted incorrectly, creating flaws in the image.

Bit depth The amount of information recorded for each color channel. 8-bit means the data in the file consist of 28 or 256 levels of brightness for each channel. 16-bit images recognize over 65,000 levels per channel, which allows more freedom in editing.

Bracketing Taking a number of otherwise identical shots in which just one parameter (e.g. exposure) is varied.

Buffer On-board memory that holds images until they can be written to the memory card.

Burst A number of frames shot in quick succession; the maximum burst size is limited by buffer capacity.

Clipping Complete loss of detail in highlight or shadow areas of the image (or sometimes both), leaving them as blank white or completely black.

CMOS (complementary metal oxide semiconductor) A type of image sensor used in many digital cameras, including the D800.

Color temperature The color of light, expressed in degrees Kelvin (K). Confusingly, "cool" (bluer) light has a higher color temperature than "warm" (red) light.

Diopter Unit expressing the power of a lens.

dpi (dots per inch) A measure of resolution—should strictly be applied only to printers *(see ppi)*.

Dynamic range The range of brightness from shadows to highlights within which the camera can record detail.

Exposure Virtually synonymous with "an image" or "a photo": to make an exposure means to take a picture. Also refers to the amount of light hitting the image sensor, and to systems for measuring this *(see also overexposure, underexposure)*.

Ev (exposure value) A standardized unit of exposure. 1 Ev is equivalent to 1 "stop" in traditional photographic parlance.

f-number Lens aperture expressed as a fraction of focal length; f/2 is a wide aperture and f/16 is narrow.

Fast (lens) Lens with a wide maximum aperture, e.g. f1.8. f/4 is relatively fast for long telephotos.

Fill-in flash Flash used in combination with daylight. prevents dark shadows with naturally backlit or harshly side-lit subjects.

Filter Glass or plastic placed in front of, within or behind the lens to modify light.

Firmware Software that controls the camera. Upgrades are issued by Nikon from time to time.

Focal length The distance (in mm) from the optical center of a lens to the point at which light is focused.

Focal length multiplication factor In DX crop mode, the image area of the D800 is smaller than a 35mm film frame, so the effective focal length of all lenses is multiplied by 1.5.

fps (frames per second) The number of exposures that can be taken in a second. The D800's maximum rate is 4–6fps.

Highlights The brightest areas of the scene and/or the image.

Histogram A graph representing the distribution of tones in an image, ranging from pure black to pure white.

ISO (International Standards Organization) ISO ratings express film speed. The sensitivity of digital sensors is strictly described as ISO-equivalent.

JPEG (Joint Photographic Experts Group) A compressed image file standard. High levels of JPEG compression can reduce files to about 5% of their original size, but not without some loss of quality.

LCD (liquid crystal display) Flat screen like the D800's rear monitor.

Macro A term used to describe close focusing and close-focusing ability of a lens. A true macro lens has a reproduction ratio of 1:1 or better.

Megapixel (see pixel)

Noise Image interference manifested as random variations in pixel brightness and/or color.

Overexposure When too much light reaches the sensor, resulting in a too-bright image, often with clipped highlights.

Pixel Picture element; the individual colored dots (usually square) which make up a digital image. One million pixels = 1 megapixel.

ppi (pixels per inch) This measure of resolution should be applied to digital files rather than the commonly used dpi.

Resolution The number of pixels for a given dimension, for example 300 pixels per inch. Often confused with image size.

RGB (red, green, blue) Digital devices, including the D800, record color in terms of the brightness levels of the three primary colors.

Sensor The light-sensitive image-forming chip at the heart of every digital camera.

Shutter The mechanism which controls the amount of light reaching the sensor by opening and closing.

Spot metering A metering system which takes its reading from the light reflected by a small portion of the scene.

TIFF (Tagged image File Format) A universal file format supported by virtually all image-editing applications.

Underexposure When insufficient light reaches the sensor, resulting in a too-dark image, often with clipped shadows.

White balance A function which compensates for different color temperatures so that images may be recorded with correct color balance.

» USEFUL WEB SITES

NIKON-RELATED SITES

Nikon Worldwide
Home page for the Nikon Corporation
www.nikon.com

Nikon UK
Home page for Nikon UK
www.nikon.co.uk

Nikon USA
Home page for Nikon USA
www.nikonusa.com

Nikon User Support
European Technical Support Gateway
www.europe-nikon.comsupport

Nikon Info
User forum, gallery, news, and reviews
www.nikoninfo.com

Nikon Historical Society
Worldwide site for study of Nikon products
www.nikonhs.org

Nikon Links
Links to many Nikon-related sites
www.nikonlinks.com

Grays of Westminster
Legendary Nikon-only London dealer
www.graysofwestminster.co.uk

GENERAL SITES

Digital Photography Review
Independent news and reviews
www.dpreview.com

Thom Hogan
Real-world reviews and advice
www.bythom.com/nikon.htm

Jon Sparks
Landscape and outdoor pursuits
photography
www.jon-sparks.co.uk

EQUIPMENT

Adobe
Photoshop, Photoshop Elements, Lightroom
www.adobe.com

Apple
Aperture and iPhoto
www.apple.com

Sigma
Independent lenses and flashguns
www.sigma-imaging-uk.com

Think Tank Photo
Back packs, camera cases
www.thinktankphoto.com

PHOTOGRAPHY PUBLICATIONS

Photography books, *Black & White
Photography* magazine, *Outdoor
Photography* magazine
www.ammonitepress.com/camera-guides.
html
www.thegmcgroup.com